D0867321

# PICASSO'S MASK

Other books by André Malraux

*Felled Oaks*
*Anti-Memoirs*
*The Metamorphosis of the Gods*
*The Voices of Silence*
*Saturn, an Essay on Goya*
*Man's Hope*
*Man's Fate*
*The Royal Way*
*The Conquerors*
*The Temptation of the West*

# PICASSO'S MASK

TRANSLATED AND ANNOTATED
BY JUNE GUICHARNAUD
WITH JACQUES GUICHARNAUD

# ANDRÉ MALRAUX

HOLT, RINEHART AND WINSTON
NEW YORK

Copyright © 1974 by Editions Gallimard

English translation copyright © 1976
by Holt, Rinehart and Winston

Published simultaneously in Canada by Holt, Rinehart
and Winston of Canada, Limited.

Library of Congress Cataloging in Publication Data
Malraux, André, 1901-
Picasso's mask.
Translation of La tête d'obsidienne.
1. Picasso, Pablo, 1881-1973. I. Title.
ND553.P5M3313   759.4   75-5469
ISBN 0-03-013751-9

Originally published in French under the title
*La Tête d'obsidienne*

First published in the United States in 1976

Designer: B. L. Klein

Printed in the United States of America
Page 273 is a continuation of this page.

Like *Les Chênes qu'on abat* . . . (*Felled Oaks*) and
*Roi, je t'attends à Babylone* . . . , this book is a
fragment of "Le Temps des limbes." The first
part was published as *Antimémoires* (*Anti-Memoirs*);
the second will be entitled "Métamorphoses."

*To Gaston Palewski*
*who was Picasso's friend*
*and whose friend was Picasso*

# LIST OF ILLUSTRATIONS

# PICASSO'S MASK

# I

I WAS BRINGING MY NOTES ON THE SPANISH Civil War up to date: the last springtime in Barcelona.

"The Ramblas at an early hour when the avenues are still empty. People passing by in the cold morning, people who no longer walk as men do in peacetime. Shop windows now filled with nothing but wretched toys or series of rare and expensive stamps (stamps can be easily carried); jewelry shops displaying small velvet stands empty of jewels; shirtmakers all selling ties for mourning; bird-sellers with their signs: 'Out of bird food'; the endless waiting for defeat. More people come by. At the entrance to the Rambla of Flowers, where most of the stands have disappeared, idlers carrying guns circle round the man who mimics animals, and who now mimics the whining of bullets. On the booksellers' tables a new book advertised as 'just published': it was *Tartufe*.

"Then an astounding blaze of blossoms.

"The union had ordered that all the flowering bushes in the area be cut down; a double hawthorn hedge (which has never before been seen in a city), sparkling like frost, covers the middle sidewalk as far as the eye can see, and oblique shadows disappear in the streets, with hawthorn bushes like chandeliers as they carry them back to foodless, fireless houses."

The telephone rang.
"Mme Picasso is on the phone, sir."

She was calling from Mougins. The newspapers had carried stories on the legal problems involved in Picasso's estate. I told her that I should be happy to help her if I could.

"Me? No . . . ," she said. "It's rather a question of helping France." She wanted to leave Picasso's personal collection of old paintings to the state, thus complying faithfully with his instructions. I had no idea of what difficulties she might come up against, but was rather sure they could be dealt with. She invited me to see the paintings. That appeal which seemed to come from the Barcelona hawthorns, that face I had never seen but which was familiar to me from her portraits, that voice imbued with sadness . . . I told her that we all knew how problems may stir up grief, and that we were anxious to protect her from them. "I'm very unhappy," she replied in a dull, touching, simple voice. I called her "madame." "Won't you call me Jacqueline?" she asked, in the same distant voice.

At the airport in Nice, a mob of photographers. They were awaiting someone or other for the opening of a festival and were wondering whether I'd gone back to my job. Misunderstanding, cleared up. Jacqueline* was waiting for me behind a large airplane. She resembled her portraits: the pretty Arlesian type, a Roman medal with an aquiline nose. Her face was as gently sad as her voice. Her widow's weeds were like a veil of crêpe drawn over the memory of her multicolored portraits.

We dashed out. "To Mougins, Nounours," she told

* In 1954 Picasso met Jacqueline Roque in Vallauris and painted portraits of her all that summer. She soon became his companion. They were married in 1961. (Tr.)

the chauffeur. By her use of the nickname "Nounours," or "Teddy Bear," I recognized the relationship Picasso had always had with those who served him. His maid had seemed to be a confidante; his secretary, a disciple or a famulus. In all those around him he had provoked a feeling of brotherly superiority; and that, I think, was the feeling he most enjoyed.

Jacqueline told me how they had prepared for the retrospective show at the Grand and the Petit Palais, which I had had organized in 1966.

"We made our big decisions in the evening. Pablo always worked late; afterward we'd go to the kitchen and eat something, and it was then that he would make decisions. I talked to him about the exhibition, and he said no. An hour later, before going to bed, he said: 'If that's what you really want, go ahead, but I'll have nothing to do with it.' And he stayed in bed for a week."

Her ironic affection took her back to the past. The curves of the road made the hills of Provence seem to swing over the Mediterranean. I had lived in Roquebrune at the end of 1940, after my escape.

The tenderness provoked by death makes one love the people who experience it, and Jacqueline was consumed by her grief.

"On April 10, when I came to Vauvenargues* with Pablo, it was snowing. Wasn't that a coincidence? It never snows here on April 10, but on that particular day there was so much snow we couldn't make it all the way."

April 10 . . . She meant: When I returned to Vauvenargues with the coffin.

* In the fall of 1958 Picasso bought the Château de Vauvenargues (14th–16th centuries) in the foothills of the Mont Sainte-Victoire, near Aix-en-Provence. (Tr.)

Mougins. A gate. A private road. Flowers, cypress trees: There it was, Picasso's house, Notre-Dame-de-Vie.* The house was hidden. A door, no doubt a side entrance; then a small, long, dark passageway.

We were going to see Miguel. He was a former officer in the Republican army—another inheritance from Picasso—who was helping Jacqueline: with sorting out the paintings, with the moving, with the lawyers. The delicacy of Spaniards with delicate features, a kind of gentleness that surprised me in a man whom I had heard of only in the context of war; sad, oppressive warmth. In order not to talk about Picasso, we talked about the fighting at Teruel.

Jacqueline and I went into a room where a table had been set for two.

"With Pablito, we used to lunch here."

It was not a dining room: just as in the Grands-Augustins studio,† all the rooms were rooms-for-paintings. In the light of southern France, softened by blinds, canvas after canvas, a Negro mask on the floor. Stuck with paint onto a canvas which it hid, a poster of Picasso's first exhibition in Avignon, depicting a musketeer called *Man with a Sword*. Probably chosen by Picasso from among the two hundred paintings assembled in 1970.

"Where do the musketeers come from? *Las Meninas*?"

"No; they came to Pablo when he'd gone back to studying Rembrandt."

* After making frequent visits to Mougins, a small village a few miles inland from Cannes, Picasso, in 1961, decided to settle there and bought an old farmhouse called Notre-Dame-de-Vie, which he converted to his own uses. (Tr.)

† Working in Paris and in need of enough space to enable him to paint a mural for the Spanish Pavilion (which turned out to be *Guernica*), Picasso, in 1936, found large quarters in a seventeenth-century building on the rue des Grands-Augustins. (Tr.)

**4**

A narrow space between the paintings, the path taken by Picasso: a veritable tropical forest, with all the bamboo uprooted and trampled by elephants that had passed through and disappeared. Had he made drawings on the tablecloth? He had painted the plates: three broad carmine brushstrokes.

"Everything here is handmade and homemade," she said ironically.

On the walls, photographs of Picasso. Directly across from us, a life-size, attentive face, a very good likeness. Jacqueline whispered to him: "You see, Pablito, your friend has come." To the left of the door, large color photographs: Picasso in the shade, wearing a garnet red robe; Picasso dressed as a Roman—stocky, leaning on a lance, his legs spread apart; others that were older. A painting of the Rose period, similar to his *Portrait with Palette*.

My feelings weren't those that are traditionally provoked by death. Jacqueline's affection, her using his first name or diminutive, reminded me that I had never known Pablo the private person, or his feelings; I had known only Picasso.

A drawing depicting Jacqueline. An elongated painting, a panorama of roofs and chimneys. I asked: "Are those the roofs of Barcelona?"

"You recognize them?"

"I think I recognize the scene: the line projected against the dawn, when our planes were coming back . . ."

I think I had also seen a reproduction of it in black and white that gave the impression of a small painting—which it isn't—and of gray, whereas it anticipated the Blue period.

In the next room, nothing on the walls, but the same

sense of encroachment given by the backs of canvas stretchers. Another poster of the musketeer. On a wicker armchair, a small piece of cardboard on which Picasso had written: "If you think you haven't botched your picture, go back to the studio and you'll see that your picture is botched."

"One day," she explained, "he was going out and left that for a friend. He said that ever since, he'd kept it for himself; that it was a good piece of advice.

"He often liked me to be there when he was working. He hadn't worked in this room for a long time, but the armchair's still here . . ."

She bent down toward the canvas stretchers and hesitated. "Would you first like to see his collection of paintings?"

The corridor again. It had changed, because my eyes had become accustomed to an accumulation of paintings. I found the bare walls, even though we were in a corridor, like those of a house under construction. We then entered a large bright room, but one that was by no means empty.

Face to the wall, in the light, some fifty paintings. Placed on the edge of the stretchers, two small portraits by the Douanier Rousseau, a *Figure* by Derain; and looking down from above, the Douanier's life-size head of *Yadwiga*.

"She looked out at you the same in the antique shop, hidden by bad academic paintings. Pablo would pass by every day. When he finally had the twenty francs to pay for her, she was gone. But the secondhand dealer had her in *his* shop."

I remembered the Douanier's tomb, with Apollinaire's

poem engraved on the stone. It was Brancusi who had done the engraving.

To the right, a few large paintings were visible. One of the most beautiful Matisses, the *Still Life with Oranges*. I had seen it in the Grands-Augustins studio, between a dreamlike and architectural *Impasse* by Balthus and the Douanier's *Parc Montsouris*.

"Yes, Pablo always had it with him. We used to keep looking at it. It changes all the time."

And, indeed, the vertical red stripes of the background and the fabric, the pale salmon color of the fabric sprinkled with violet flowers, the pink of the window, the gray of the cup, and the yellow of the lemon were in endless discourse, one with the other.

I thought of Matisse's chapel, of Father Couturier, who used to say, "If Christians enriched their lives with the same virtues that Cézanne did his paintings, the world would be better off." It was he who had convinced Matisse to undertake the chapel; and when he posed for the linear figure of Saint Dominic, Matisse had told him: "Without a halo, there's no way I can make him look like a saint instead of merely a figure." One summer morning they had opened the locked chapel for me. I was still too obsessed with Romanesque art to feel at ease with that supreme style, but I had just returned from afar, and it welcomed me like France herself. . . . One day Picasso came to visit the chapel. He bought some postcards from the grumpy nun. One of the visitors said: "It's Picasso." The nun looked at him. "Well, well, M'sieu Picasso," she said, "since you're here, I have a thing or two to tell you. All the people who come here give their opinions, saying this and that. One day M'sieu Matisse got fed up. 'Sister,'

he said, 'there's only one person who has the right to criticize me, do you understand! That's Picasso.' Except, of course, for the good Lord. You ought to tell that to all those people!" Picasso gave her his wide-eyed look: "And why doesn't the good Lord do it Himself?" Hélène Parmelin* told the beginning of the story, Picasso the end.

"Matisse," said Jacqueline, "was very fond of his still life. He wanted to get it back from the dealer. But it had been sold. When he learned that it was Picasso who'd bought it, he wept."

Memories, not information; a disconsolate past permeated everything she said. Next to the *Oranges,* another still life by Matisse, with a black background squared off with lines engraved in the thick paint; an ocher and sepia head by Derain, done prior to the First World War. Also brown, a superb small Le Nain: a peasant woman, standing at some distance from a group, unreal but ponderous as a caryatid. A *Château noir* by Cézanne—clear, porous, and mat as a pastel.

"It's not varnished?"

"No, Cézanne forbade Vollard† to varnish his paintings."

She turned around a small *Bathers* by Cézanne, varnished. It was almost an entirely different type of art.

---

* The model for Picasso's portrait *Madame H.P.,* the wife of his painter friend Edouard Pignon, and a close friend of Picasso's and Jacqueline's, Hélène Parmelin has written several books, including *Picasso: Women; Cannes and Mougins* (Paris, 1964) and several novels. (Tr.)

† Ambroise Vollard (1868–1939), a publisher, writer, and famous art dealer in Paris, made his reputation by showing the works of young avant-garde painters, and was best known for sponsoring Cézanne. Vollard first exhibited Picasso's paintings in 1901. (Tr.)

Another small stretcher. Matisse's *Marguerite* of 1908: flat colors, and the same sinuous line as in the drawings he had done to illustrate Mallarmé. Two more Matisses, very youthful ones, landscapes of the Jura; a bunch of flowers, not on a stretcher. A figure by Corot; and another Corot that was surprising: the head had not been painted in, or Corot had blotted it out. A Van Dongen *fauve*. Some monotypes by Degas, who had illustrated Vollard's edition of Maupassant's *La Maison Tellier*. Many paintings of that collection had been sold to Picasso by Vollard or given him in exchange for something. A small eighteenth-century still life covered with dust: red meat against a dark background.

"Well," I said, "Goya?"

She laughed and blew off the dust: Chardin. It was indeed Goya's meat, although painted many years before it, but the black background was not Goya's.

Two Braques. She turned around a masterful canvas of the analytical Cubist period, almost flaxen.

"Now I'll have the large ones turned around," she said, leaving the room.

I looked at the flaxen canvas. The analytical Cubism was in search of the other variety. A sharp ridge ordered the "composition" and framed the facets, as if vying with Penrose's *Head*,* a triangle of colored stripes. That particular Braque dated back to the months when the two friends had painted together. It might well have been a very alluring Picasso. Who, at the time, would have thought that Braque would die in the presence of his

---

* Sir Roland Penrose, one of the founders of London's Institute of Contemporary Arts and a Surrealist painter, was a close friend of Picasso, about whom he wrote several books, including *Picasso: His Life and Work* (New York, 1958). (Tr.)

reconciled canvases, and Picasso, among those corrosive *Man with a Sword* pieces for the poster advertising the exhibition at the Palais des Papes?

Picasso had spoken to me of Braque at the time he was finishing *Guernica*; he had just stopped painting, and all the tension in his face had disappeared. He had shown us—José Bergamin* and myself—the drawings placed against the large canvas (in the studio it had seemed enormous): "I'd like them to move right up and put themselves in the canvas, climbing up all by themselves, like cockroaches!" We had talked about Spain and about painting; he had become more revealingly confidential than I had ever heard him.

"Everybody always talks about the influences that the Negroes had on me. What can I do? We all of us loved fetishes. Van Gogh once said, 'Japanese art—we all had that in common.' For us it's the Negroes. Their forms had no more influence on me than they had on Matisse. Or on Derain. But for them the masks were just like any other pieces of sculpture. When Matisse showed me his first Negro head, he talked to me about Egyptian art.

"When I went to the old Trocadéro, it was disgusting. The Flea Market. The smell. I was all alone. I wanted to get away. But I didn't leave. I stayed. I stayed. I understood that it was very important: something was happening to me, right?

"The masks weren't just like any other pieces of sculpture. Not at all. They were magic things. But why weren't the Egyptian pieces or the Chaldean? We hadn't

* A Spanish philosopher and essayist who was born in Madrid in 1894 and founded the review *Cruz y Raya*. (Tr.)

10

realized it. Those were primitives, not magic things. The Negro pieces were *intercesseurs*, mediators; ever since then I've known the word in French. They were against everything—against unknown, threatening spirits. I always looked at fetishes. I understood; I too am against everything. I too believe that everything is unknown, that everything is an enemy! Everything! Not the details—women, children, babies, tobacco, playing—but the whole of it! I understood what the Negroes used their sculpture for. Why sculpt like that and not some other way? After all, they weren't Cubists! Since Cubism didn't exist. It was clear that some guys had invented the models, and others had imitated them, right? Isn't that what we call tradition? But all the fetishes were used for the same thing. They were weapons. To help people avoid coming under the influence of spirits again, to help them become independent. They're tools. If we give spirits a form, we become independent. Spirits, the unconscious (people still weren't talking about that very much), emotion—they're all the same thing. I understood why I was a painter. All alone in that awful museum, with masks, dolls made by the redskins, dusty manikins. *Les Demoiselles d'Avignon* must have come to me that very day, but not at all because of the forms; because it was my first exorcism-painting—yes absolutely!

"That's also what separated me from Braque. He loved the Negro pieces, but as I told you: because they were good sculptures. He was never at all afraid of them. Exorcism didn't interest him. Because he wasn't affected by what I called 'the whole of it,' or life, or—I don't know—the earth?—everything that surrounds us, everything that is not us—he didn't find all of that hostile. And imagine—not even foreign to him! He was always

11

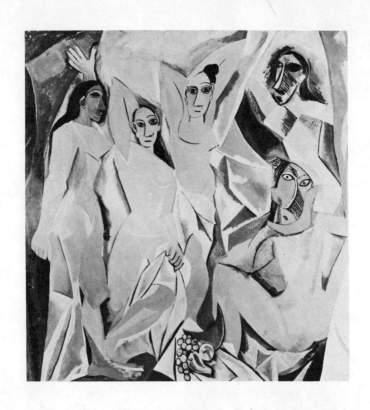

1. Picasso. *Les Demoiselles d'Avignon.* 1907.
Museum of Modern Art, New York.

at home . . . Even now . . . He doesn't understand these things at all: he's not superstitious!

"Then, there was another matter. Braque reflects when he works on his paintings. Personally, when I want to prepare for a painting, I need things, people. He's lucky: he never knew what curiosity was. People stupidly mistake it for indiscretion. It's a disease. Also a passion, because it has its advantages. He doesn't know a thing about life; he never felt like doing everything with everything. . . ."

As if she were answering my memories, Jacqueline, who had come back accompanied by Nounours and saw me standing in front of the picture, said: "Pablo was really fond of that one. But he felt that Braque didn't like combat in art. . . . God, did they have rows!"

I know. But there still remains this fraternal picture, which Picasso might have signed. . . .

I saw nothing by Léger. All three of them, like many others, had taken their start from Cézanne. While Léger was illustrating my *Lunes en papier* for Kahnweiler,* he showed me a large canvas, a sequence of dark green masses, and his *Wedding*, which was much freer and had a splash of raspberry in it that I still like. "It was my taking leave of Cézanne," he explained. After having exploited the ephemeral theory of the representation of objects from every angle, the Cubists had together discovered the fertility of the sign.

Nounours began to turn the large canvases around. Two portraits by Miró, one by Modigliani. The Doua-

---

* Daniel Henry Kahnweiler, born in Germany in 1884, was a Paris art dealer who specialized in the works of Picasso, Derain, Vlaminck, Braque, Juan Gris, and Léger. He also wrote several works on art and artists, including *La Sculpture de Picasso* (Paris, 1949). (Tr.)

nier's large *Yadwiga* was now freed from the stretchers that had hidden it all the way up to the neck. And there was his *Foreign King Visiting the World's Fair*. I didn't see his *Parc Montsouris*.

"In the Grands-Augustins studio the *Oranges* were between Rousseau's *Parc* and a Balthus."

"They left the Balthus in another room," she said. "I should have it brought here, but it's very big. The *Parc Montsouris*—I don't remember."

A large Renoir, surprising: the woman's legs had the arbitrary importance of the limbs of the "fat women" Picasso had painted in Rome, and about which he used to mutter, "It's because of Michelangelo!"

A large Le Nain. I recognized the black ox as soon as Nounours turned it around; it had been in my father's dining room in Bois-Dormant. It had belonged to an aunt by marriage, who had sold it, through me, to Kahnweiler, who in turn had sold it to Picasso. It's a small world. Nounours turned another stretcher around.

"Oh! That's not a good Courbet," said Jacqueline. "I don't know why Pablito ever bought it."

"Because of the horns?" It was the head of a kid—mediocre, indeed—which has an eye and, on the pelt, an elongated splash extending it—both as black as the unreal horns, which have an affinity to those of Picasso's bulls. And there were other horns: when Jacqueline turned the stretcher around, I saw in back of it a ceramic piece that depicted a laughing satyr.

"I thought that none of his own works were included in his collection?"

"Yes. The ceramic piece was there; they didn't take it away—it's extremely heavy. Now you've seen everything. Do advise me. The administration has asked me

14

if I would agree to have the Le Nains put together with the other Le Nains, the Matisses with the other Matisses . . . Yet he had always said that his pictures should remain together . . ."

"You can't disregard his stipulations. The Louvre doesn't receive a Picasso collection every day, and more would be lost than gained if it were dispersed. The Cézannes are beautiful, but Picasso probably loved them together with the others. Also, the large canvas by Renoir is a very specific Renoir, with its affinity to the massive women of Picasso's Roman period; the figure by Corot, with an empty space where the head should be, has no relation to any other Corot; nor has the small Le Nain; what gives meaning to the Courbet are the horns of Picasso's bulls. . . . And the only Chardin, which looks like a Goya because of the dust, was clearly Picasso's very own!"

"Anyway, he wanted to dedicate the collection 'To Young Painters.' He really was bent on that. If they disperse it . . . And another thing: I mean to give his Negro pieces to the Musée de l'Homme; but I wouldn't want them to separate those either."

"Give them in accordance with the terms he stipulated for his collection of paintings. In any case, the Musée de l'Homme is far freer than the Louvre."

His masks would really constitute an anthology, like "Picasso's Picassos." Which his collection of paintings would not. They made me think of the furniture we keep after several moves: some because we like it or in memory of the friends who gave it to us; the rest because it just happened to be there. The Cézannes, the Matisse, the Braque, the Derain (around 1923 we believed that Picasso's rival was less Braque than the Derain of *The*

*Last Supper* and *Chevalier X*) were no doubt bound up with certain times in his life; but no painting evokes the period of *Les Demoiselles d'Avignon*. True, the Negro sculptures had taken refuge in corners or under the furniture. As for their successors, were Balthus and Miró among the elect by choice or merely out of friendship?

The absence of two painters he loved "in another way from the others" surprised me. "Neither a Goya nor a Van Gogh?"

"There weren't any to be found . . . Maybe Pablo didn't look very hard. Would he have liked to see them here? I don't know."

"Yet, Cézanne?"

"Vollard had Cézannes; Pablo made an exchange. Cézanne he admired; Van Gogh he loved."

I had known which famous paintings I would find there. But somehow I had imagined them surrounded by a kind of museum of unknown arts. Perhaps because, in his studios, he used to mix his early paintings together with those he had just completed; or perhaps because I didn't have a clear understanding of the dialogue between his own sculptures and his fetishes or his very ancient statuettes. The earliest of the paintings I had just looked at was a few centuries old; the Lespugue* *Venus*, which he had shown me at his Grands-Augustins studio, dated back twenty or thirty thousand years. . . .

His collection did not resemble him in any way. It might have resembled Cézanne's. (With a few exceptions—the Negro pieces, for example.) But had he been

---

* Near the village Aurignac, in the Haute-Garonne, where, in 1860, prehistoric bones were discovered in a grotto. The prehistoric ivory *Venus* was found in a cave in Lespugue by the Comte René de Saint-Périer. (Tr.)

seeking works that would resemble his? Jacqueline was certainly right. Thirty years ago he had told me: "What I like and what I want to have at home are two quite different matters. I am a painter; I'm also an art lover who gives myself advice when I paint; it's always bad." He sometimes painted with an eye to his collection, and sometimes against it. What does the serenity of his Matisse, even that of the *Château noir*, have in common with his incurable conflict with what he called "nature"? As he put it: "Obviously, nature has to exist so that we may rape it!" How many times did he tell me, either joyously or in anger or in surprise, "Painting makes me do just what it wants me to."

His collection consisted of paintings by others. But how unimportant compared to everything he had revived or made acceptable, from the fetishes to Sumer, by way of Oceania!

His laughing satyr seemed to be laughing at all those paintings. That kooky ceramic piece conveys the fact that the unity of a painter's works is a unity of style. Picasso's successive periods follow one after the other within his own style, like outbursts within rage: his style is that very sequence. I spoke to him one day about hashish, for the spiritual effects it provokes had interested me greatly in Cambodia and in Siam, countries that have compulsory religious service.

"I took some once," said Picasso, "at the Bateau-Lavoir studio.* Disgusting! For hours I was convinced that I would always paint the same way."

* An oddly shaped, dilapidated building on the southwestern slope of Montmartre, consisting largely of lofts and cellars, which was christened the "Bateau-Lavoir" by Max Jacob in the early 1900s and was well known in those years as one of the centers of Bohemia. In 1904, after several visits to Paris from Spain, Picasso settled into a studio in the Bateau-Lavoir, where for five years he lived and worked. (Tr.)

17

Continuity of style is hell.

He grumbled: "Down with style! Does God have a style? He made the guitar, the Harlequin, the dachshund, the cat, the owl, the dove. Like me. The elephant and the whale, fine—but the elephant and the squirrel? A real hodgepodge! He made what doesn't exist. So did I. He even made paint. So did I." His condemnation of continuity of style was more profound and more obscure than his remark: "I have no real friends. I have only lovers! Except perhaps for Goya, and especially Van Gogh." But what had Goya and Van Gogh attempted throughout their lives, and all those whose paintings make up his collection—as well as El Greco, Rembrandt, Velásquez, Delacroix, and Courbet, against whom he measured himself—if not to probe deeply into their art? Derain during his best period, Matisse, Rouault, Braque, and Chagall all took their bearings from their latest creations, climbed their staircases step by step. Matisse's creations or Chagall's developed by way of the same processes as those of Piero della Francesca or Rembrandt. They didn't quite know what they were undertaking when they began a painting, since every painting "becomes" by the very fact of painting it. But the floors under construction depended upon the floors that had already been constructed. Even when their power failed them, they knew it. Picasso alone wanted to replace the next floor by a ladder or by a swing—in order to fly? "My little girl skipping rope, the sculpture—since she was skipping, how did I keep her up in the air? I pressed the rope down on the ground. No one ever noticed." After all, who but Picasso, after his *Demoiselles d'Avignon*, dared prohibit plumbing the depths solely to control the sequence of his periods? The principle "One must do

everything, on condition that one never does it again" does not lead in the same directions as those taken by other painters. "Going further" doesn't either, in the sense in which Picasso understood it. "Further, but in one's own direction," replied Braque. "That's what I'm doing. Why would I try to put myself into one of my paintings? I'll always be there, since it's I who paints it." He could have added, "and who transcends it."

I thought of *The Large Plough*, in the presence of which Braque died. How does the word "art"—whose meaning is in fact distorted by aestheticism—express both Picasso's creative act and that of his rivals? What relationship is there between his last exhibition at the Palais des Papes, that of Braque at the Louvre, that of Rouault's unfinished canvases at the Salon Carré, and Chagall's *Biblical Message* in Nice? Braque's fundamental harmony with the cosmos ("cosmos" means order)—his pictures lovingly bound up with painting—has not been reduced to silence by the most intractable voice that art has ever known. All of Picasso's works would be a thunderous howl if his paintings didn't elude that howl by the very fact of their creation. A torture scene by Goya no longer belongs to torture scenes; it belongs to painting.

After Braque's death it seemed that his spirit returned to put his studio in order. Here, at Mougins, an irrepressible genius was watching over the images heaped up by his having swirled through life like a tornado—a pile of leaves blown together by the hurricane of death.

"Where did his sculptures go after the exhibition at the Petit Palais?"

"A number of them are here. Would you like to see them?"

The two narrow levels of the long room, empty of furniture, were connected by steps. Behind the windows, with the light filtering through, indistinct shadows of statues silhouetted against the radiant daylight outside, beyond a motionless and inextricable profusion of bronze, stone, plaster, and varnished materials over which the gilded *Cat*, its tail in the air, kept watch at my feet. Below, the same swarming mass, larger and unbroken, like a *piano nobile* under a row of garrets. Out of it loomed a plaster cast of Michelangelo's *Captive Slave*. I was well aware that they were Picasso's sculptures; and I had seen them in a state of disorder when they were brought to the Petit Palais. But the bases were awaiting them; and once out of the truck in which they had been set up in rows each one would become a piece of sculpture. They emerged straight out of life, as if Picasso would create more of them the next day. Whereas at Mougins the mingling of forms emerged from a violent death, whose sorcery would raise that multitude at the Last Judgment which belongs more to him than to the earth. I thought of Saul prostrate on the ground while an octopuslike shade climbed into the cave of Endor: "The shade of Samuel . . ." I also recalled the starry serpent that unwrapped its invisible coils in the grottoes of India at the moment Siva married the fish-eyed goddess. The intoning of the *Bhagavad-Gita* and the distant cries of the great birds of the Sea of Oman (here the crisscrossed chirpings of sparrows filled the room, as I had heard them fill the Rameseum)* mingled in the darkness, where the three colossal faces of the most renowned *Mahesamurti* of India reigned over

* A temple erected in honor of Ramses II (d. 1225 B.C.?) at Thebes. (Tr.)

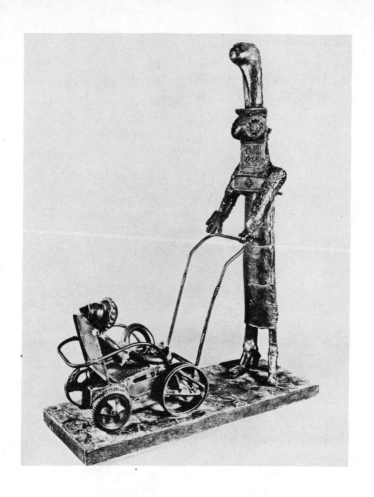

2. Picasso. *Woman with Baby Carriage*. Bronze. 1950.
Private collection.

their people from the other world. Here at the very top of the quivering heap reigned the woman pushing the baby carriage. Separated from it—and almost overlaid with bronze bristles, shards, plowshares, and horns from Negro masks—she became the spirit of the throng, torn from its raging sleep. With one arm broken, the other stretched forward—the Delphi *Charioteer* without his chariot, or a Kouros with no offering—and with the solemn crook of her somewhat Oriental hairdo above her insect eyes, it was impossible to know whether she was watching over those chasm stones and those thistles tangled by some wind from the beyond, or if, on the contrary, she had just been born from them. A scaffolding of painted sticks—at once a geometrical décor and a marionette in a puppet show for child-demons—was like a diagram among those rough or convulsed forms. It is called *Character*. Those were not strange forms (almost all of them were familiar to me) that gradually emerged from that haunted place; in spite of the white *Slave*, they had none of the surrealistic strangeness that is always subject to the fanciful spirit it invents or captures. Picasso's strangeness derives from the fact that his figures are always doing battle with Creation. They are in no way connected with devils, or the obsequies of Love against a background of flame, or contemplative manikins, or lunar landscapes, or soft watches and burning giraffes, or silent cities forsaken by unknown civilizations. Nor does Picasso's strangeness spring from the gripping encounters of objects, for the objects he brought together don't represent even an unknown world: they are the expression of a world that can exist only through sculpture. The breasts of the *Little Girl Skipping Rope*, made of baskets, are no longer baskets; the (real) shoes are

22

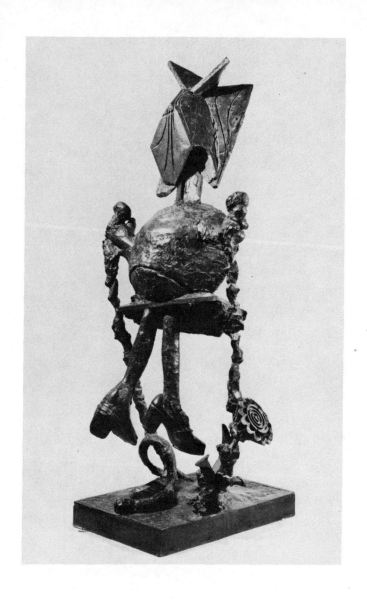

3. Picasso. *Little Girl Skipping Rope*. Bronze. 1950.
Private collection.

no longer shoes. "I often used pieces of newspaper in my collages, but not to make a newspaper." The little girl belongs not to a world of the fantastic (which of Picasso's works really does?) but to a world that art alone can create. The spectacles of Surrealism imitate that which does not exist; Picasso's forms invent it.

What could be more alien to spectacles than those smooth stones and those rocks, or those sea urchins, all related as elements in the great ocean depths? People from one and the same planet, sculptures of Picasso in the same way as the most diverse animals are animals of life. The planet of "I shall create forms that did not exist—that would never have existed—without me." Their stridency is louder than the orchestra of earth forms. One work resembled the cast of a hand; another the cast of a leaf; the head for Apollinaire's monument was that of Dora Maar;* the cat was almost a cat. Were the bronze flowers almost flowers? In front of a large piece of plywood one lone buttercup rose out of a milkman's can, directly across from the *Slave*, like a mock-up for a monument to the death of sculpture.

Gradually the forms became more distinct, not because my eyes had become accustomed to them but because my mind, upon recognizing them, had freed them from their tangled mass. The most famous stood out from the copper jungle because they were taller and because almost all of them appeared to be black. They are statues; what are the others? Did Picasso consider his *Man with Sheep* (which, most carefully prepared,

* In 1936 Picasso was introduced to a young, intelligent, dark-haired girl, with beautiful eyes, named Dora Maar. A painter herself and an experienced photographer, she soon became Picasso's favorite model and remained his constant companion until 1945. (Tr.)

he chose for the square in Vallauris)* as the *Guernica* of his sculpture? Was his *Pregnant Woman* vying with the Lespugue *Venus*, of which he had had a cast made? The *Figure with a Vase* was no less carefully wrought. Jacqueline had placed a metal cast of it on the funereal lawn of Vauvenargues. She showed me a photograph of it: the building itself, with its harsh stone walls and the squashed turrets of a Spanish castle, had become a mausoleum. She wanted to fill it with his canvases; and what other tomb would have been so dear to his heart? Here all the large nudes similar to the *Figure with Vase*—but so unlike nudes!—surrounded the *Man with Sheep*, sliced off at the waist and separated, by carnivorous flowers, from his legs lying nearby. Outside, an undamaged metal cast threw its shadow into the room. In the Museum Without Walls a Picasso room was ready, even then, to welcome them.

Around them fluttered memories of the *Glass of Absinthe*, the Manager from Cocteau's *Parade*,† paper figures, the *Sculpture with Plant and Horn*, and the *Radiator*. And most especially, that whole jungle before me, tangling my feet in its intertwining fangs, similar to that of the Scythian plaques on which birds of prey

* A small town in the South of France where, in 1947, Picasso first took up ceramics in the Madoura factory, owned by Georges Ramié and his wife. The following year he bought a small villa nearby and devoted himself to ceramics, bringing new prosperity to the town. In 1950 Picasso made a gift to Vallauris of a bronze cast of his *Man with Sheep*, which was set up in the central square and has been a great tourist attraction ever since. (Tr.)
† A "Realistic Ballet" by Jean Cocteau, with sets and costumes by Picasso and music by Erik Satie. *Parade* was performed for the first time in 1917 by Diaghilev's Ballet Russe, with Léonide Massine as choreographer. Among the characters in *Parade* are three Managers. (Tr.)

tear convulsive tigers asunder. It climbed up to attack the statues, which were not nearly so encumbered. There seemed to be more bouquets than heads, because they so resembled each other—as if the heads had been thrown into thistles and nettles. Although some of the heads had had their noses torn from their brows at the roots, and had eyes like half-globes, and sculpted masses like the heads on Gallic coins—huge commas, pickles, curving pears—they were nevertheless sculptures. Sculptures like the large white forms standing straight in the clear shadows of southern France after first having been in his Boisgeloup studio,* destroying all balance—first and foremost, that balance which life so often owes to the symmetry of leaves, and to the trunk that brings order to the madness of branches. There were also ironic figures: the *Bust of a Warrior*—with a scrubbing brush for a helmet, which but for the overtones of creation, would have seemed to jeer at sculpture, at its subject matter, even at its creator, since it was snickering at the Roman heroes Picasso was not to paint until thirty years later. Then there were delegates from the unknown. For example, the casts of the *Woman with Baby Carriage*, which had so shaken me when I first saw it exhibited at Kahnweiler's; of the *Little Girl Skipping Rope*—groundless, weightless, a sardonic negation of statuary. The original of each one—whether of wood, plaster, or cardboard—examined its black cast as we look at our own shadows. The varnish on the skipping girl made her into a large, threatening toy.

* In 1931 Picasso bought a small seventeenth-century château in a village called Boisgeloup, not far from Paris. He had his press for etchings moved there and converted the larger coach houses on the property into sculpture studios. (Tr.)

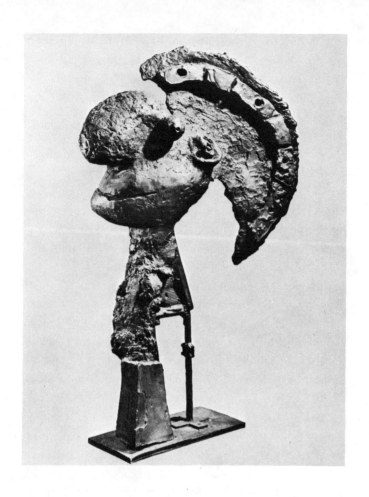

4. Picasso. *Bust of a Warrior*. Bronze. 1933.
   Private collection.

Picasso's toys: there were a few of them in front of me; many others I remembered. What hadn't he played with? They never laid bare his creation; they hid it. The bicycle seat with handlebar horns, and the ibis-scooter, were not the keenest forms of expression of the genius who created the *Woman with Baby Carriage* or the *Woman with Leaves*, any more than the readymades were blueprints for Marcel Duchamp's paintings. Picasso played at making a woman out of an empty packet of cigarettes; he played at making readymades because they sprang from a glance that was akin to the glance he cast over all objects; and even so, he glanced at them only to capture them. It was the fierce bouquet of death that countered the inexhaustible proposition of life with sixty years of victorious or harried answers.

Life used to surprise him. When out walking he would interrupt a conversation to tear off a branch or pick up a pebble. He was not in search of a model; rather, he was in search of what he "could make of it." Which, since he rarely elaborated upon his percussive remarks, perhaps meant: "I am trying to find out how this object could help me shatter the world of painting, or of sculpture." The branch reappeared in the *Woman with Leaves* in complicity with geometric volumes. He had taken the pebble with him not to admire it but to engrave it. His well-known "I don't seek, I find" perhaps expresses more astonishment than pride. Yet he sometimes did seek—in the traditional sense of the word. We know his studies for the *Man with Sheep* and the successive states of the *Woman with Leaves*. But he also used to say that painting made him do what it wanted him to. And sculpture as well. The branch, all by itself, got chummy with one of the "objédérébus" (his way of

28

saying *objets de rebut*, or cast-off objects) that he cherished. "You couldn't leave a piece of string lying about without his making something out of it!" said Jacqueline. "Sculpture," he declared, "has several souls." No doubt metamorphosis was the first of them.

"I don't see *The Reaper*."

*The Reaper* is the bronze statue, so often reproduced, which has only one eye right in the middle of its head, represented by the imprint of a mold for making sand pies. A forked branch forms the trunk and legs, and a vegetal stump wields a scythe down toward the ground, with the gesture of Death.

I had wanted to have it placed on the promontory of the Ile Saint-Louis as a monument to Baudelaire's *Fleurs du Mal*.

But no, it was probably at La Californie,* in Cannes. . . .

Among the toys and objects that Picasso called involuntary sculptures, *The Reaper* would reign in the same way as the tall *Woman with Baby Carriage* reigned, at Mougins, over its population of forms wrenched out of life. Surrounded by silent pieces, it would howl. It is in no way akin to readymades, but it is akin to his well-known *Death's Head* (or *Flayed Head*), over which I had almost fallen in the darkness of his studio—a rock forsaken by the ebb tide of life. In some inexplicable way the carnivorous flowers resembled the smooth skull.

---

* In 1954, when Picasso could no longer bear being harassed in Paris, he decided to move to the South of France. In the hills of Cannes he found a large, rather pretentious villa, La Californie, which he bought, stripped of all its furnishings, and transformed into a workshop, as well as a place to live and store his belongings. (Tr.)

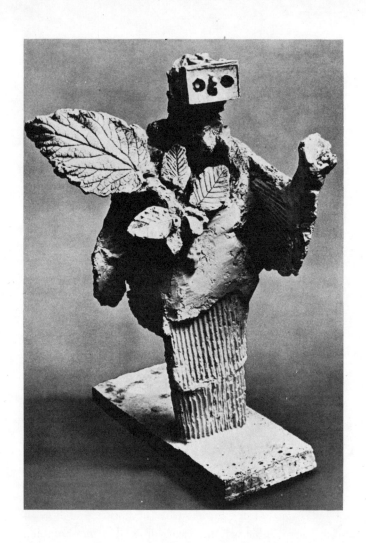

5. Picasso. *Woman with Leaves*. Plaster. 1943.
Private collection.

Flowers and skull were mingled on the same planet with the antivegetal vegetation which thrusts up through the cement its metallic population of arched sunflowers, capsules, bristles, and mushrooms with curved ears, like the brambles of coral which would beleaguer large stones studded with starfish. All that bronze vegetation seemed like the soul of the stones, leaving them uncovered. Its harrow-shaped thorns and its smashed petals were an expression of life just as contorted muscles are an expression of life, as the invisible stroke which makes branches crack and lacerates leaves, transforms a tree into faggots because no god can make faggots grow—faggots that invoke the stake, as all those scoriae and firebrands had once invoked the stake. A will to create that was all the more fierce because it did battle with Creation itself, and knew it.

Yet never breaking the sign's allusive bond with Creation, which derived from his paintings. The ultimate allusion: the two Vallauris versions of *Woman*, 1948. Threatening ideograms of battle, bronze emblems more buckled by fire than the Hitlerian eagle after the capture of Nuremberg—devastated symbols of Picasso himself, like the bronze of his fist, clenched in strength or in torture. It would also happen that the magic sign, whether in painting or sculpture, called up its adversary outside the work: when, in the garden of La Californie, Picasso set up his large ceramic pieces—flat sculptures, delineated designs, which bore within themselves alone their raison d'être—they seemed to harass the trees in order to drag them into their universe.

Smaller models of them were hardly distinguishable from the other sculptures. For the secret language of all those works is that of their unity. The constancy of

doing battle implies at least a kinship among forms of battle. Those particular works resembled one another by the very fact of their not bearing any resemblance to the others. Of course, the presence of the Museum Without Walls could be felt throughout the place. Picasso reacted to the discovery of art works as he did to the discovery of objects and feelings. Like a squirrel, he would bring a leaf into his store of provisions: he would welcome into his canvases the doves from his Paris studio or from his garden in Cannes; he also welcomed them into his sculpture, along with his monkeys, his bull's skull, his glass, and his owls. He appropriated to himself all the leaven of metamorphosis, and changed a child's toy car into a monkey's skull. But he never appropriated either the fetishes or the ancient gods of ancient epochs; he did not introduce an elongated Etruscan figure into a piece of sculpture; rather, he fought with it. The rivalry was murderous, and miles from the subtle manner that Braque used in illustrating Hesiod. Did he do battle even with a leaf? I know he did. (God also is a very great creator of forms, "although he has no style.") At first, in vain. It was not enough for him to transform it into an object in order to possess it; yet out of tenaciousness, he managed to do just that in his *Woman with Leaves*. He was magically spellbound by all that is immemorial, for historical forms are missing from his sculpture, despite that white *Slave*—more like a Chirico figure than a statue by Michelangelo. Had it run aground at Mougins because it was a Michelangelo or because it was a slave? "Michelangelo was a shackled hero," Picasso used to say. Less than he himself was. I thought of the Viking whom the Christians threw into a barrel of vipers, shrieking his war

song as he raised his arms—lashed by serpents—to the sky. I also remembered Picasso's discovery of the old Trocadéro, at the heart of the universal Musée de l'Homme, which is what our Museum Without Walls has become. His sculptures evoke the multitude of sacred figures which assault us *because* we do not know what they signify. The Egyptian kas, or "doubles," which are no longer among the dead; the Sumerian gods we don't believe in; the gods of India, of the Far East, and of Mexico; the fighting wild beasts of the nomadic horsemen; the saints to whom we no longer pray; the masks and fetishes that are no longer spirits. But the sculptures of the Acropolis, the Chinese grottoes, the Romanesque churches, and the tomb in Florence recognize their royal companions in the Sumerian basalt statues of Gudea, which were at once worshipers, gods, and temples. Picasso's magic creations correspond to the tribal arts, to the Mexican and prehistoric idols; and the statue that watches over them is not a monumental Chaldean prince; it is the totem torn from its baby carriage, a god in the shape of an instrument of torture.

Did he know he was vying with the sacred? The tangle of the bronze thistles on the stonelike heads, and the way they negate outward appearances as violently as the Sumerian fertility figures or the nail-studded fetishes, proclaim that the act of negation derives not only from sculpture itself but also from witchcraft—the witchcraft of fetishes or fertility figures.

The artist depicts man in accordance with the gods. The Royal Portal of the Chartres cathedral is more Christian than the Christians who prayed to its saints. The circular gathering of the Kores in the Acropolis is more Greek than the agora ever was. The multitude of

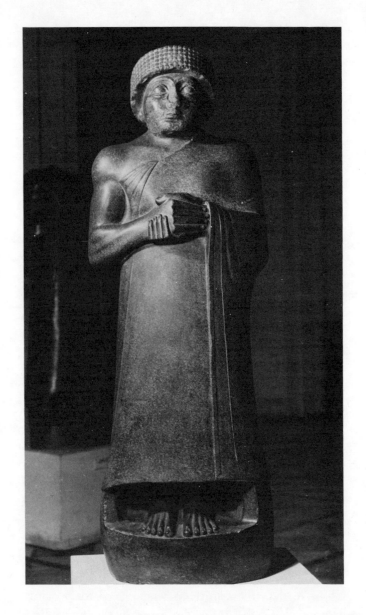

6. Neo-Sumerian art. A standing *Gudea*. Ca. 2150 B.C.
The Louvre, Paris.

kas are more Egyptian than Egypt itself ever was. So
that they might express the supreme values of their
civilizations, the sacred arts subordinated outward ap-
pearances. Yet they did possess or transcend them; they
did not destroy them. Picasso, too, rejected the world of
outward appearance and replaced it with that of his
creation. But what Christ gave rise to his icons? Who
among the dead gave rise to his fetishes? He was a man
possessed by a sacred spirit of which he was unaware.

Standing nearby was a statue by Manolo, bequeathed
to Picasso out of friendship. (I think I still have two of
his bas-reliefs somewhere.) Intruding but revealing.
Manolo, Maillol, the Cubist sculptors—even Giacometti
—believed in "sculpture" and wanted their works to
become a part of its Museum Without Walls. Picasso
wanted to get there before them; he also wanted to
destroy it. All great artists destroy within themselves
the works of their direct masters; Picasso's true master—
the rival that was to be destroyed—very shortly became
the Museum Without Walls itself. That is why many
of his sculptures of around 1930 were no longer related
to sculpture, in the sense of planes and volumes, but
rather to the sculptures of Picasso, a closed world to
which young sculptors now relate, as others did to the
Museum Without Walls, as their ancestors did to Clas-
sicism. What our contemporaries call "immortal sculp-
ture," from the Sumerian forms to Henry Moore's, has
no access to it. There we encounter little more than the
enigmatic freedom of certain tribal figures: Eskimo
masks, Dogon masks, New Britain or Papuan masks,
Mayan silex artifacts, and Zapotecan urns.

Jacqueline looked dreamily at the varied jumble of
sculptures. Several of the pieces appeared to be unknown

ancestors. A violet African mask thrust its dusty horns under the *Little Girl Skipping Rope*, as if trying to flee. But that *Little Girl* and the *Woman with Leaves* were foreign even to the geometrical African forms that had taken refuge there, and to the weird world of Oceania; Picasso's mind had also wanted to free itself of the forms that had once been inspired by spirits, and to rely on itself alone, on its very own magic.

"Look here," said Jacqueline.

She had just found a cast of *The Reaper*. I had remembered it as much smaller, for in photographs it looks like a showcase bronze. I had also forgotten that the half-sphere hollowed out by the sand-pie mold, suggesting the reaper's head, had a tiny face in the middle.

"Was the face part of the mold?"

"Oh no: he added it. He almost always changed everything once it was started. At first there wasn't any scythe there either. He used to say, 'It came to me just like that.' "

"In the old days I had watched him work out certain ideas because they could only have been his own, and others because they stemmed from way back. The scythe obviously suggests death; that's why this particular figure, enlarged, seemed to me so fitting for Baudelaire."

In the *Death's Head* the holes for sockets were countered by a living toothless and lipless mouth—only one sneering line. And the fetish pushing the baby carriage, its child with legs knotted like a hair bow and its eyes like those of an enormous fly, belong in the same realm as the tiny face lost in the ribbed middle of *The Reaper*'s head.

"He was very sensitive to extremely ancient forms," I said, "forms that have persisted from civilization to civilization: the skull, the bull of the Sun, the horse of

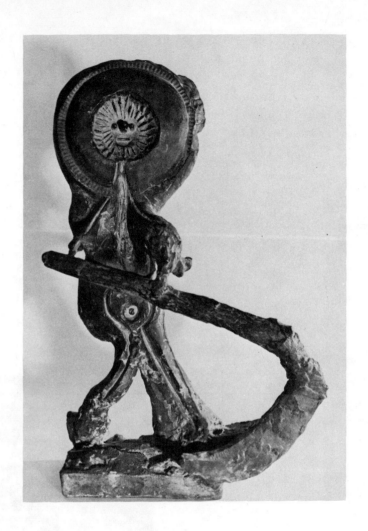

7. Picasso. *The Reaper*. Bronze. 1943.
Private collection.

Death . . . The last two are in *Guernica*. He was delighted when he put together a bicycle seat and handlebars, but he was even more delighted when he made a bull out of them. He didn't like the ibis-scooter nearly so much. You know they discovered dream books in Babylonia and in China."

She questioned me with her eyes.

"They include a kind of inventory of dreams, which they interpret. It's all very reminiscent of Freud. Especially when it comes to nightmares. Civilizations bury themselves, one within the other. Of course, a Babylonian sculptor wouldn't have understood Picasso at all, who rediscovered his demons and his fertility figures; but we dream about the same octopuses and the same spiders as the Babylonians did. And the spider of nightmares is one of the most ancient animals on earth."

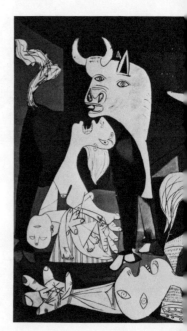

8. Picasso. *Guernica.* 1937.
   Museum of Modern Art, New York.

Before *Guernica* was taken, in 1937, to the Spanish Republican Pavilion at the Paris World's Fair, I had told Picasso, "We don't believe very much in subject matter, but you must agree that this time the subject matter will have served you well!" He replied that, indeed, he didn't believe very much in subject matter, but he believed in themes—so long as they were expressed symbolically: "The *Tres de Mayo* can be an expression of death; so can a skull—it's been used for ages—but an automobile accident wouldn't do." What he considered themes (and I quote) were birth, pregnancy, suffering, murder, the couple, death, rebellion, and, perhaps, the kiss. Although such themes are generally embodied in forms characteristic of the times, one encounters them in almost every period. Nobody could be ordered to express them, but when any great painter encountered them, he was inspired by them.

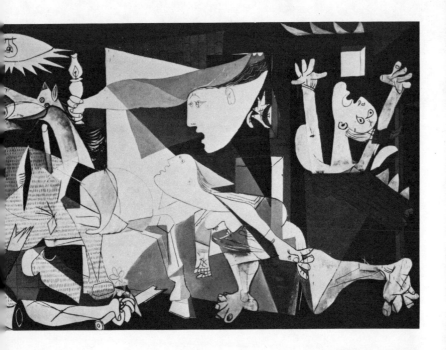

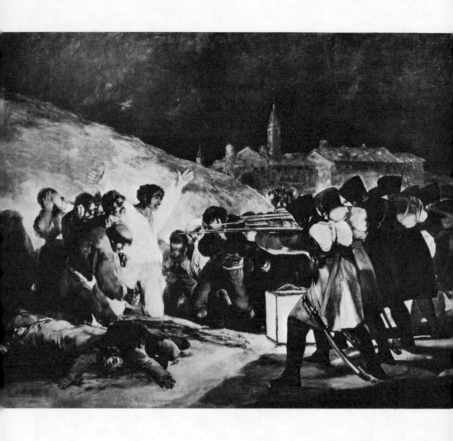

9. Goya. *The Shootings of May 3, 1808*. 1814.
The Prado, Madrid.

"They have been in existence far longer than civilization." *Guernica* had led Picasso to study Goya's *The Shootings of May 3, 1808.* "The black sky isn't a sky, it's blackness. As for the lighting, there are two types. One that we don't understand. It illumines everything like moonlight: the sierra, the belfry, and the men shooting, who should not be lighted from behind. But it sheds far more light than the moon. It hasn't the same color. Then there's the huge lantern on the ground, right in the middle. And what does that illumine? The guy raising his arms, the martyr. If you look at it carefully, you'll see that it sheds light only on him. The lantern is Death. Why? No one knows. Not even Goya. But what Goya knew was that it had to be just like that."

"That painting," I remarked, "always gave me the impression of being under a spell. A spell, I suppose, cast by something supernatural. Especially during the Spanish Civil War, because the man raising his arms symbolized our pals. I wasn't thinking about the lighting; I was thinking about the gesture—those arms raised like a large V. Since then we've seen General de Gaulle make the same gesture; and Churchill, with his fingers. During the Civil War, V didn't yet mean victory. But arms raised up like that—we knew them well; they are the arms of crucifixions, in which the cross is a forked tree . . ." He interrupted: "I've got here the skeleton of a bat, with its wings stretched out. It's very pretty, very delicate. I hadn't noticed that it too is a crucifixion—a terrific crucifixion . . ."

# II

Jacqueline led me into another room.

Heaps of canvases, as threatening as the heaps of sculptures. A virtual exhibition, stacked as they were, side by side, against the walls, leaving a narrow passageway between them. And fifteen times as many canvases were hidden behind them, like pages in an album with covers by Picasso. I began to flip through them. Those he had painted before 1966 had been shown at the Grand Palais. I had seen them there, as I had the sculptures at the Petit Palais. There they had seemed concerned with the viewers; here the heaps of canvases were fast asleep.

Almost all the paintings of 1972 had been sent to the Palais des Papes in Avignon. The virulence of those that had been brought back to Mougins did not attack the Picasso Museum in Barcelona; rather, it isolated the museum as much as his death had done. A whole world separates the *Musketeers*, and the impassioned ideograms that followed *The Painter and His Model*, from the museum dedicated to Cubism and the works peripheral to it—a world filled with the paintings I was pulling out, one by one, and with those I remembered, from "*Ma Jolie*," the woman with a zither or a guitar, to *Guernica*, which is still in New York. The collages, which had been greeted like geometrical eruptions, were more in the tradition of Cézanne and Seurat than the

42

Ingres-like portraits or that of Olga.* The still lifes—from those of 1912 to the still lifes with candle and the de-lineated objects, painted after the war—have taken on an imperturbable unity, filling the canvases or dominating them. I thought of all the works stored in museums. Of those in the Louvre, where Georges Salles, its director, and I once watched the white patches in Cézanne's *Douleur* begin to show again from under the brown varnish that had been applied by the donor in order that it correspond to Cézanne's earlier canvases: the typical "museum varnish," pouring out of thick sponges. Of those stored in the old Trocadéro, where dummies in exotic costumes stared at some sort of hanged dead bird attached to a wire with clothespins, and which had been Montezuma's diadem. Of the cellar in the Acropolis, where the curator—who had grown impatient while wait-ing for the keys—angrily turned around the *Brooding Kore* that was being punished in a corner, her face to the wall. One after another, we turned round the canvases that constituted "Picasso's Picassos"; and the exile of *Guernica* reigned over that collection under attack from the intricately entangled *Musketeers*, the splashed paint-ing of the great nudes of 1969, the last of Picasso's forms that seem to twist the pictures as well as the lines, the exploding profiles similar to those on Gallic coins, all the contorted *Mardi Gras* and *Musicians*, the shards of the *Toreadors*, their petrified mosaic luxuriance, and the heads of his *Meninas*, those paintings called "studies," but which are quite the opposite of studies.

* A dancer with the Ballet Russe and daughter of a Russian general, Olga Koklova had attracted Picasso's attention during rehearsals for *Parade*. They were married in 1918, and moved to a fashionable flat on the rue de La Boétie in Paris. In 1935 they separated for the last time. Olga died in 1955. (Tr.)

43

10. Picasso. *Head of a Menina* (1). (M. A. Sarmiento.)
10/10/1957. Picasso Museum, Barcelona.

"Picasso really wanted to settle some score with those! I never saw him work like that!" said Jacqueline.

He had painted or sculpted numerous true studies. By that I don't mean the kind of works which, in the past, were attempts at copying the model or, more especially, those which today, whether in pencil or paint, are attempts at understanding "how it was done," what one can do with it, or how it may be introduced into a work in progress. What I mean is: the states of a work of art. It isn't true that Picasso "never sought." The *Woman with Leaves* started as a rectangular head, to which Picasso successively added a stem and a crinkled-paper body, before completing it with beech leaves and fluting. We know the successive states of the *Man with Sheep* and those of his sheep itself, as well as some of his basic sketches for *Guernica*, not to mention the lost drawings (he had considered illustrating my *L'Espoir* [*Man's Hope*]) or the studies of fauns for his *Pastoral*. *Guernica* is a work that was developed in the traditional sense, and its successive states record its development.

But if we speak of "studies" for *Las Meninas*, it is due to a misunderstanding. The small frenzied canvas I was looking at is not the study of a model for purposes of copying it or for understanding it or for introducing it into the large composition. Picasso had *first* painted the large composition, then his supposed studies; and they were not modeled either on his own composition or on Velásquez's painting. The studies for the Infanta Marguerita (the full-face view), subsequent to the entire monochrome—I think the others are in Barcelona—abstract her to the point of depicting her by merely a few strokes of color, which were not meant to be either expressive or suggestive. And that pictorial ideogram was in no sense a preparatory study for the same Infanta

45

11. Picasso. *Las Meninas*. 10/3/1957.
Picasso Museum, Barcelona.

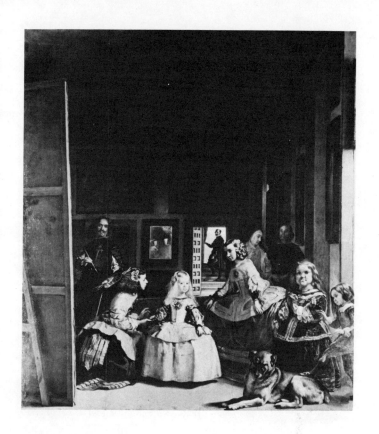

12. Velásquez. *Las Meninas*. 1656.
The Prado, Madrid.

Marguerita of the large multicolored composition as a whole, which Picasso was to paint a month later, after he had done far more colorful infantas (and, aside from these, his pigeons and his window), some groups with the dog, and the first painting of the whole in color, in which Marguerita has no resemblance to the Margueritas that had preceded her. But she foretells those that were to follow.

The true studies, the preparatory states, are related to the works that constitute the Picasso Museum. Isolated, *Las Meninas*, on the contrary, anticipates the challenging heads of Avignon, the break with that museum. Those hundreds of heads have no *Guernica*.

In the side room that we walked through, a few canvases of the Blue period were leaning against the walls; others, not on stretchers, were lying on a table like posters. A portrait of Casagemas, the friend of Picasso's who shot himself in 1901. On his blue temple, in the middle of that whole display of blue, just one crimson patch: blood.

In the dining room there was a self-portrait of the Rose period. Also a small group of figures of the Negro period. One of them, strained like a threatened scorpion, evoked all the claws of Picasso's future works. Jacqueline placed it on the table:

"He liked that one. It brought back more memories than the others. One day we were returning from a bullfight, where we had been given presents; he picked it up with both hands and said to me: 'Famous, of course, I'm famous! Lollobrigida! What does it all mean? It was at the Bateau-Lavoir that I was famous! When Uhde*

* Wilhelm Uhde (1874–1947), a German art critic and collector, showed interest in Picasso as early as 1907 and greatly admired his works. Picasso painted his portrait in 1910. (Tr.)

came from the heart of Germany to see my paintings, when young painters from every country brought me what they were doing and asked for my advice, when I never had a sou—there I was famous, I was a painter! Not a freak . . .' "

She didn't imitate his voice, but from the other side of death I could hear his curious accent—an accent that was so untraditional, with Parisian *u*'s mixed in with closed *e*'s with every *s* doubled, with no *jota*, but with *j*'s pronounced as *y*'s. His "je n'étais pas une bête curieuse" ("I was not a freak") became "yé n'étais pas uné bett curioss." But, like him, Jacqueline repeated: "I was a painter," not "I was an artist"—a word he used only derisively. His "I was famous" reminded me of one of our last conversations. I had just told him that I was going to have the Bateau-Lavoir preserved as a historical monument.

"Heavens! If anyone had told us that when we were there!"

"Didn't you in any way foresee your fate?"

"That depends . . . When we were twenty we were sure that painting meant us—sooner or later—but that we wouldn't be acknowledged until we were dead. Like Cézanne. Like Van Gogh, who had sold one canvas— only one!—for a louis d'or. Then he committed suicide. At the Bateau-Lavoir, Fernande's* girl friends used to tell all the very ugly models: 'Why don't you go and pose for Picasso!' Did you know Manolo? He was no

---

* Soon after Picasso's arrival at the Bateau-Lavoir he chanced to meet a beautiful, green-eyed girl who came regularly to get water from the basement tap—Fernande Olivier. After some time she moved in with him, and remained his companion for six years. Fernande was the first girl to whom Picasso became seriously attached. (Tr.)

fool. And he was a good sculptor. Well, when he was faced with *Les Demoiselles*, he said to me: 'Really! Imagine your relatives waiting for you on a platform of the Barcelona station with mugs like that!' We thought that if we lived to be very, very old, maybe it would turn out all right. . . . But you see, we didn't have to live to be that old! When Braque said to me: 'Do you realize? We each have a car, and a chauffeur!' he was as surprised as I was. . . . Yes, being successful seemed to us incredible."

I asked Jacqueline, "Was he still amused by himself as a myth?"

"Sometimes he was. You know how he liked to have a good time. When people bored him, he'd start to play at being a toreador."

He had indeed liked to have a good time. It was only among my Spanish friends that I heard his sorcerer's laugh. He had collected scorpions and owls. Once he told me, in regard to the cats he was sculpting, "They're not quite right, because cats are like women: their hair has to be messed up." Sometimes the joking was cut short. When I showed him photographs of some Sumerian terra cottas that were very like his sculptures, he said joyously: "There's a time in life, after you've worked very hard, when forms come to you just like that, when pictures come to you just like that, you don't have to bother about them at all!" And then, a moment later: "Everything comes just like that. Death too."

I almost began to remember out loud. . . . In any case, death was there.

It was clear from the heaps of paintings I was examining that Picasso had only two manners. The first is the collection of canvases that made up the Picasso Museum:

the Blue period, the Rose period, stage sets, and Cubism; the second, all the others and most of the sculptures. *Les Demoiselles d'Avignon* and *Guernica* belong to both. In those, the division between Cubism and the convulsive works corresponded to the break between what Picasso had inherited from Cézanne and what he had inherited from Van Gogh. "Pity us," wrote Apollinaire, "we who are enduring this endless quarrel between Order and Adventure . . ."

That quarrel was far more evident in the ground-floor room. From the *Glass of Absinthe* right up to 1929, Picasso had sculpted many a piece that deferred as much to Cubist sculpture as his pedestal tables in front of windows did to painting in the manner of Cézanne; and even some of his bas-reliefs conceded more to painting than to sculpture. Only a few of them were in the next room, where they were covered by the underbrush of bronzes. Sculptors were then aiming at making works as monumental as the Chaldean statues of Prince Gudea, the statue-columns, and a few art forms of the early ages; indeed, monumentality was the supreme goal of Maillol, just as it was for the Cubist sculptors and Manolo—the type of sculpture that the Germans called tectonic, and the French *construite*, or architectural. Picasso, who had long respected the painted picture—a genre that had never been questioned either by Cézanne or Van Gogh—took little interest in monumentality; and it remained foreign to what Negro art had brought to his works. In no time his Cubist sculptures gave way to claws and to iron. That is why his most provocative canvases there in Mougins seemed to proliferate gradually, whereas the sculptures from Boisgeloup I had just seen

51

seemed to spring forth from space. The break between the Picasso Museum and the virulent forms that sometimes paralleled and then followed it would have been far more violent had the forms not seemed bound to it (as well as to the large sculptures) by the small aggressive canvases of the *Meninas*, by *Las Meninas* itself, and more especially, by the influence that his large "Confrontations," then called "Massacres," had upon his thirteen years of creative production.

Thirteen years, from *Les Demoiselles de la Seine* to the *Rape of the Sabines*. Yet Picasso had begun the Confrontations much earlier with his drawings inspired by the Grünewald altarpiece. Christ on the cross he replaced with curiously sacrilegious bone rosaries.

"Has anyone ever painted a crucified skeleton?" I asked him.

"Don't think so. Note that when I drew the bones I rounded off the ends. At the Paris Museum of Natural History I realized that bones are never sculpted; they're molded. It's funny."

Everything that surprised him he called "funny." Later on, he painted his *Bacchanale*, after Poussin's, in honor of the Liberation. I saw it at the end of the war—framed, precious—in his Grands-Augustins studio, where he was joyfully gathering dust among his masterpieces, the bicycle seat with handlebar horns, and the many versions of his *Still Life with Candle*, whose delineated forms make them powerfully imposing, in the same way as leading does stained-glass windows. A few days before, when I had asked Rouault what he thought of Poussin, he was chillingly evasive. When I asked Picasso whether he considered Poussin a great painter in the same sense that he thought Goya and Velásquez great painters, he

replied: "No, not in the same sense. But you see, it makes absolutely no difference." How true. Around 1910, Moréas* had greeted Picasso regularly at the Closerie des Lilas† with the same old question: "Well, now! Monsieur Picasso, do you still think Velásquez really had talent?" That was told me by André Salmon‡ in 1923. I thought of it that day, fifty years later, looking at the square *Meninas*; I also thought of the studio in which a giant head of Dora Maar had been disputing with the giant heads from Easter Island—a studio for nomads which was probably very like that of the Bateau-Lavoir. I thought of Fernande. When I was about twenty I was having dinner on the Place du Tertre with Max Jacob. She was at the next table with the actor Roger Karl. I told Max that she was very beautiful. "Yes," he replied in a rather tight-lipped way. "She's forty!" Behind us, Utrillo, Suzanne Valadon,§ and the Sacré Cœur. And the small church Saint-Pierre-de-Montmartre, where my parents were married . . .

Picasso would always leave his *Bacchanale* in the stu-

---

* Jean Moréas (1856–1910), a French poet of Greek origin, at first belonged to the group of so-called "decadent poets," but in 1890 reverted to a classical style. (Tr.)

† An enchanting café in Paris, situated on the Boulevard Montparnasse, which became known in the early 1900s as a gathering place for intellectuals. It was there that Paul Fort, director of the review *Vers et Prose*, would meet every Tuesday with such writers and painters as Moréas, Apollinaire, Max Jacob, Picasso, and Braque. (Tr.)

‡ A French writer, born in Paris in 1881, who was managing editor of *Vers et Prose* and was best known as a poet, but who also wrote novels, essays on art, and a volume of memoirs. (Tr.)

§ Utrillo's mother (1867–1938), who, after having worked as a dressmaker, an acrobat, and a model for many well-known artists, became a rather eminent painter. Her works were known for their independence of style and their singular lack of femininity. (Tr.)

dio (he had taken other canvases into his bedroom), but never talked about it. Had he meant to test his visitors? Heirless, alone among the controlled still lifes, facing the ironic bicycle-seat-with-handlebars, it seemed like a subtle and secret game.

The game changed when he painted *Les Demoiselles de la Seine*. His transcription of Courbet's painting recaptured Cubism's power of shock. His concise, angular style interpreted the two girls as he had interpreted Hélène Parmelin and Paloma* in his *Portrait* of them and, with a freer hand, El Greco's *Portrait of a Man*. Painters were nevertheless surprised by the tangled leading of that stained-glass-window canvas, which showed little concern with Courbet's palette. Picasso's transcription of *The Women of Algiers* took them aback even more. He hadn't even used Delacroix's painting as a guide for his own version; he had made it into a canvas all his own, as different from Delacroix's as a Cubist still life is from a guitar. Georges Salles, who was then Director of the Louvre, had suggested to Picasso that, on a day when the museum was closed, he bring around any of his canvases he wished to study against famous paintings. Picasso began by having a *Still Life with Candle* placed near the large, diagonal Zurbarán; then, almost as if he were playing a game, he had his *Aubade* and the paintings he planned to give the Musée d'Art Moderne placed near *The Women of Algiers*. He spent a long time studying Delacroix. "My God, what a painter!" His own *Women of Algiers* was born that day. I remember him,

* Born in 1949, Paloma is the daughter of Picasso and Françoise Gilot, his model and companion from 1946 to 1953. (Tr.)

short and swarthy, next to tall Georges Salles with his long white hair. I thought of the day that Salles had taken me to see his fortune-teller. Beneath the portrait of her grandfather, the last sultan of Turkey, she cast the shadow of Bucephalus across the Iranian desert at sunset. Every kind of sorcery was at home there. When I saw his *Women of Algiers*, I recalled his violent words: "Obviously, nature has to exist so that it may be raped!" Yes. And painting as well.

The critics talked about rivalry; but rape was to be brutally visible in his metamorphosis of *Las Meninas*. All the more brutally in that, this time, Picasso was tackling one of the most famous paintings in the world.

Picasso was not, of course, the only great painter to engage in dialogue with his predecessors. He undoubtedly knew Rubens' "copy" of Titian's *Charles V and the Empress Isabella*, which ostensibly transformed Venice into Antwerp. (During the Spanish Civil War and the bombing of Madrid it trembled on the office walls of the Revolutionary Writers' Committee.) And without any question he knew the Cézanne paintings that were copies of Sebastiano del Piombo's *Christ in Limbo*, Van Gogh's copies of Delacroix's *Pietà*, and Matisse's Jan de Heem.

But were they all in fact "copies"? Cézanne never set out to copy the *Christ in Limbo*, nor did Van Gogh the *Pietà*. Rather, each in his own way set out to paint the *tableau vivant* suggested by the picture. For what purpose? Since they were painters, the *tableau vivant* itself was of no great interest to them. The staging of Delacroix's *Pietà* is indifferent. Why not Michelangelo's? But Van Gogh wasn't inspired by Michelangelo; he was by Delacroix. Was it because he wanted to "paint better"

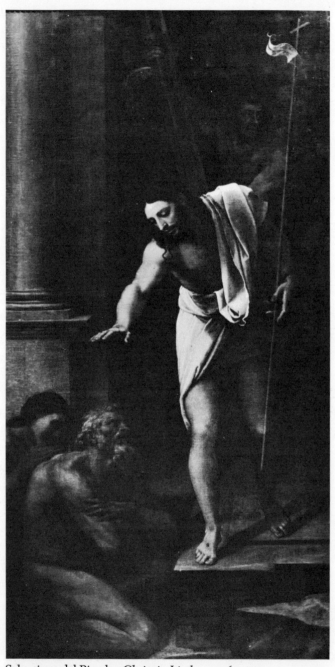

13. Sebastiano del Piombo. *Christ in Limbo*. 1536–1539.
The Prado, Madrid.

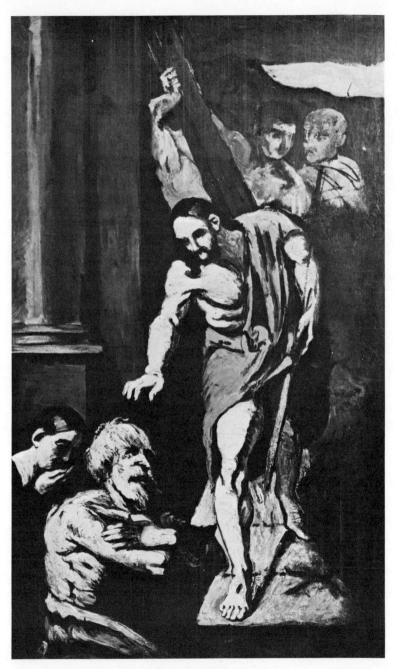

14. Cézanne. Copy of the *Christ in Limbo*. Before 1870.
Private collection.

than Delacroix? And did Cézanne want to paint better than Sebastiano? No. They didn't want to paint better; they wanted to paint differently. They had no intention of trying to improve upon the model in its own domain; their intention was to question the domain itself.

Christians both, Van Gogh and Cézanne wanted to limit the Christ of their models to color alone. And they knew it. Regarding *Olympia*, Cézanne wrote: "The whole of our Renaissance dates back to that painting." And although they had known nothing about Manet's personal Christ, they did know that when he painted *Olympia* he was vying with Titian's *Venus of Urbino*. And he would have vied in the same way with Velásquez's *Las Meninas*—by subjecting them solely to the realm of the pictorial, by stripping Venus of her divine status, not to turn her into a lady named Olympia but to paint a picture. Painting had been the most powerful means of portraying gods and dreams; it had brought Venus back to life. Then, weary of having triumphed over poetry and being the rival of music, painting discovered the specifically pictorial world and was to renounce all others.

Why had Mougins reminded me of Manet's adventure—Manet, who had discovered modern painting almost without realizing it, and who had let his successors learn what they might from *Olympia*? One of the paintings that Jacqueline had turned round for me to see was *The Lovers*, which Picasso had signed: "Manet, 1920," in large letters, parodying a child's handwriting.

The works that Picasso had chosen to confront (except for the latter, actually Manet's *Le Déjeuner sur l'herbe*), belong in part to transfiguration and, as a whole, to atmospheric shadow, to the somber or bronzed fog that

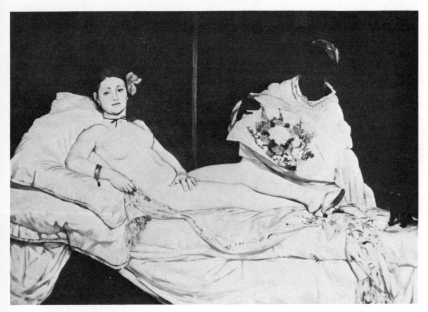

15. Manet. *Olympia.* 1863.
    Musée du Jeu de Paume, Paris.

16. Titian. *The Venus of Urbino.* 1538.
    The Uffizi, Florence.

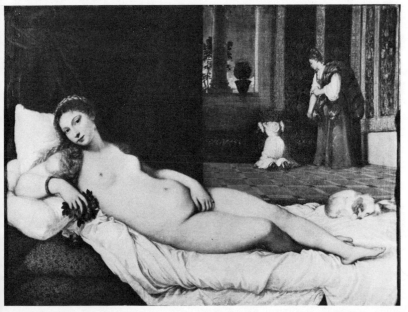

had reigned supreme ever since distance had been discovered—to the shading that was born with Van Eyck and died with Courbet, and which no school on earth had ever known, with the exception of four centuries of Western art. Clearly, Picasso saw both *The Women of Algiers* and *Las Meninas* as paintings, not poems. And it was upon the pictorial world itself that he wanted to impose the transmutation that Manet, Cézanne, and Van Gogh had imposed upon the poem implicit in European shadow. If Van Gogh didn't want to "paint better" than Delacroix, Picasso was even less interested in "painting better" than Velásquez, in making a color more subtle or stronger. His intention was to proclaim, faced with the power of the pictorial, the power of painting—a power he had been aware of for thirty years but had nevertheless almost always subordinated.

Manet's rivals and disciples had found pictorial power in all the masterpieces he himself had assimilated and then transformed, for a Rembrandt by Manet would have been as different from *Supper at Emmaus* as Picasso's *Déjeuner sur l'herbe* is from Manet's. But Manet discovered his power in the museum, to which he gave unity. Picasso didn't discover his power; he invented it. Any painter can decipher the *Venus of Urbino* and find an *Olympia*, or decipher Chardin's *A Smoker's Articles* and find a Braque; but no deciphering of Velásquez would ever yield Picasso's *Las Meninas*.

Cézanne vied with Sebastiano del Piombo, using the pictorial power they had in common, not the power of poetry, which Sebastiano had considered essential, and which had not concerned Cézanne. As for Picasso, he had been no more concerned with Velásquez's palette than with Delacroix's or Courbet's; he countered the ad-

17. Picasso. *The Lovers* (signed "Manet"). 1919.
Private collection.

mirable harmony of *Las Meninas'* shadows and blues with his own flaglike reds, in the same way as he countered the Infanta with his geometrical little girls. "And I too am a sorcerer." It was no longer the pictorial power that was in question: it was the demiurgic power.

Velásquez's painting exists on the same level as the *Meninas* themselves; the painting on which Picasso was working had to exist on that same level and to the very same degree, but without the ambiguity of Velásquez, whose masterpiece conformed both to the world of painting and to the world of illusion. Why first seek out Delacroix and then Velásquez? In order to reveal the demiurgic dialogue, just as Manet had revealed the pictorial dialogue by seeking out Titian. Picasso had changed nothing in the masses of *Les Demoiselles de la Seine*; Courbet's whisper could still be heard. But in the case of *Las Meninas*, the renowned painter with whom he had begun conversing remained silent. Having rejected not only the *tableau vivant* but the painting itself, Picasso kept only one of its elements: the creative act. He proclaimed its liberation. Before the war I had written: "Soon his path will be lighted only by the torch he holds in his hand, even if his hand burns." Cubism had tried to become legitimate; Picasso's painting is no longer legitimate: it is contagious.

During one of my leaves, when Picasso was at work on *Guernica*, we talked about the way Goya had come to terms with death—death as my comrades were experiencing it, not death as Goya had portrayed it, and about which Picasso had spoken to me regarding *The Shootings of May* 3. I mentioned how surprised I was at how painters who seemed to know death, such as El Greco and Van Gogh, indicted, as it were, those who over-

looked it, such as Chardin or Cézanne. "Yes," he replied, more to himself than to me. "There is life, and there is painting . . ." His tone of voice implied: faced with life, there is nothing but painting. Braque also had told me that, shortly before he died.

What was that huge, bad academic Second Empire painting, that nude stretched out under foliage—a poor man's Courbet? It turned out to be the canvas in front of which Picasso had voluptuously stretched out a giggling Jean Marais* for a photograph to be taken by Brassaï of Picasso himself. He was holding a palette (he almost never used a palette), carefully touching up the nude's hip. Title of the photograph: *L'Artiste-peintre*, or *The Professional Painter*.

Portraits of Jacqueline; and more portraits of Jacqueline. The one Picasso had sent me for the poster advertising the Grand Palais exhibition (I had replied, saying that it reminded me of a seated caryatid) was facing a completely red *Portrait of Picasso*, painted by somebody else. One of his owls, one of his doves. Yet another *Jacqueline*. I had just seen portraits of almost all his women.

Picasso never spoke much about his own life, but did about life in general when he talked about painting. How intrigued I had been about his relation to life, somewhat earlier, when I was looking at the bronze flowers! Ever since he had done *Les Demoiselles d'Avignon* (and it was Avignon that was soon to put on his last

---

* A French actor, born in 1913, and trained by Charles Dullin, Marais became a close friend and protégé of Jean Cocteau. One of his first important roles was that of Michel in Cocteau's play *Les Parents terribles* (1939). Since then he has divided his time between the stage and the screen. (Tr.)

18. Picasso. *Jacqueline in a Rocking Chair.* 10/9/1954.
Private collection.

exhibition), he had never ceased pitting himself against life.

"You Chinaman, you know the Chinese proverbs. One of them says the best thing I ever heard about painting: 'We must not imitate life; we must work as life does.' Work as life does. Feel the branches grow. One's own branches, of course, not life's! That's what I'm doing now, right?"

To Delacroix, nature had still been a "dictionary"; in nature he had still found forms and colors to put into his own paintings, even those that merely gave him an idea of what precisely he was groping toward. But the never-ending quarrel Picasso picked with nature became ever more complex. When he had shown me his *Bacchanale*, he had also shown me the bull's head made of a bicycle seat and handlebars. "Not bad, eh? I like it. What I really ought to do is throw the bull out of the window. The kids who play down there would pick up the pieces. One of the kids would be missing a seat and handlebars. He'd fix his bike up like new. When I'd go down, the bull would be a bike again. Painting isn't done to hang on people's walls!" When he was at the Bateau-Lavoir he had once bought some fetishes wearing glass-bead necklaces. Then their necklaces disappeared. "The fetishes were completely naked!" One night some of Fernande's girl friends had come to dinner wearing the glass beads around their necks. He was delighted. Listening to him talk, I remembered the drawings he had placed at the bottom of *Guernica* so that they might climb up like cockroaches.

Another *Menina* opposite a *Jacqueline*. Picasso had obviously not been endeavoring to perfect the Infanta Marguerita's face, which he had painted sixteen times,

or to destroy it, as has been said far too often, and indeed as he himself said. Had he been trying to exhaust what he could extract from painting? Like a drug, every last *Infanta Marguerita* would call for another, which in turn . . . And the unpredictable surfeit would come, in the same way as a painting completes itself; for painters feel, and don't decide, when their pictures are finished. The day before New Year's Eve, 1957, Picasso had given up *Marguerita*, and in a style that said "farewell," painted a gracious *Isabella* who had come from somewhere else, a stranger to the crisis that had given rise to her companions, and whose bow indicated their departure.

"I'm leaving her just like that."

He painted no more infantas.

Yet he was not to give up his Confrontations. They entered into his art as the landscapes had before them. But the proclamation he had made with *Las Meninas* was never repeated. His dialogue with *Le Déjeuner sur l'herbe* led him beyond all those that had preceded it— led him elsewhere—because the demiurgic power now countered the pictorial power alone, which was altogether separate from the poem. No longer would any escort of satellites accompany his canvases. Instead, they would coexist with those apparently structureless forms which were to infiltrate his paintings like a triumphant fifth column—the taut twistings and arcs in his drawings of spirals and hooks that were to develop into those of his *Men with Swords*.

He had first introduced those forms in his series *The Painter and His Model*, which was not derived from a specific painting but dealt with one of its major themes. That series, which preceded, paralleled, and followed *Le*

*Déjeuner sur l'herbe*, played the same role as had Manet's painting and *Las Meninas*, for Picasso again rejected both the *tableau vivant* and the pictorial realm. Perhaps his dialogue was made a part of what he called "themes," such as Death. He had started work on the theme of the Couple much earlier, in his large, solemn sepias, which I had seen on the rue des Grands-Augustins: one standing nude, another stretched out on a bed. What had become of them? At the time, he had told me, "Art is never chaste!" Before and after *The Sabines* that theme was linked to *Le Déjeuner*. I looked down and, at my feet, saw a small *Painter and His Model*—a rather joyful picture (which was not always the case). It was not a matter of forms, or of colors, or of volumes, or of light . . . Some isolated figures had already appeared on the scene—figures that were there, directly next to the small *Painter*: a *Mardi Gras*, the musketeer that Picasso had chosen for the Avignon poster, a *Toreador*. They were to invade the Palais des Papes and chase out all the others.

But not yet. Here were *The Rape of the Sabines* and the warriors. To have a dialogue with those, Picasso had reverted to the Poussin of the *Bacchanale*; but Louis David was neither Velásquez, nor Spain, nor Poussin. Had Picasso, then, decided to amuse himself with "props from antiquity"—with swords, lances, and bristly crested helmets? He had named his characters warriors. They had, in fact, broken into his studio when he, at the invitation of the Salon de Mai, was musing upon Delacroix's *Entry of the Crusaders into Constantinople*. *The Rape of the Sabines* was to have been called "Battle."

One of his 1962 warriors seemed to bring back to life the *Helmeted Head*, or *Bust of a Warrior*, sculpted thirty

years earlier. And that head, which consisted of a kind of embossing and a brushlike plume, and which I had seen in the sculpture room next to the *Cat*, anticipated the musketeers. Picasso had brought an enigmatically mocking tone into play—and it lasted for a long time. One slaughter followed another, until the feast of irony came to an end the next year with a tricolored slaughter. But to herald the end of that massacre there was no warrior to lift his sword in salute, as the last infanta had brought the Margueritas to an end with her bow.

Yet Picasso had not given up the pursuit of his most dangerous adventure. There were a few more obstinate versions of *The Painter and His Model*. The isolated figures chased out all the others; the time of *Mardi Gras* had begun. From then on, the true Confrontation was to be the age-old confrontation—that of the painter with the human face.

After the war, in his Grands-Augustins studio, Picasso had gathered together a throng of aggressive *Figures*, which were recent works, as well as traditional portraits of his children painted twenty years earlier and in carnival costumes; if he wasn't fracturing forms, he felt he had at least to disguise his models. He had told me, in a tone of voice generally reserved for talking to himself, "I must absolutely find the Mask." His meaning was clear more from his tone of voice than from his words. Although he was perfectly capable of formulating exceptionally forceful turns of phrase, he sometimes expressed his thoughts by allusion. For years I had heard him say, stressing the words, "Naming, that's the point! In painting, one can never manage to name objects!" At least he had named *Guernica*. . . . I thought of everything he had

formerly extracted from an emotive suggestion, assumed that by "Mask" he meant a more complex totality, but one of the same nature: the emphasis that a great style confers upon the human face.

"It would be worth it," I replied. "I don't believe that in over forty or fifty centuries what you call *the* Mask was ever found by artists any more than nine or ten times. Perhaps in Mesopotamia? Certainly in Egypt. Greece. Rome—in imitation."

"That doesn't count."

"Romanesque sculpture, especially at the end. Gothic? Renaissance sculpture, perhaps, but then there was painting as well, and we can't speak of a Tuscan portrait in the same terms as we can of an Egyptian ka. The sculptors had seen the living people they sculpted 'doubles' of; they had never seen Venus or the saints."

"Once they started painting portraits, it was all over."

"The Classical face . . ."

"The deities and all that? They had been invented long since."

"Antiquity had invented idealization, but don't forget that the Italians invented expression in the eyes. . . . The statues didn't look."

"Paintings don't look. It's color. The Venetian and Spanish painters invented terrific color. A mask? Effigies, nothing more. The Romantic mask? Still more effigies."

"Perhaps there's no such thing as Romantic painting either: Delacroix got excited about Venice through Rubens, just as Ingres did about Raphael . . ."

"Still, there was Goya! And Corot? No: he painted figures, not the Mask."

He laughed.

"Cézanne—no: only the volumes of the head. Van

Gogh—he painted himself. Or else he painted a picture: the *Portrait of Dr. Gachet*, *L'Arlésienne*. Terrific. He never did the Mask. . . . Picasso doesn't do anything at all."

On the floor, leaning against the walls, were eighty canvases. Struck by the facts, he looked at them in surprise, as wide-eyed as those Pierrots he had once painted. In conclusion he remarked, "What one *will* do is more interesting than what one has already done."

There were doves in the studio, and the Afghan hound, Kazbek. The wartime morning was beautiful. We couldn't hear the very few gas generators. Françoise Gilot came in and showed me some drawings. Suddenly I was back in Mougins, with Jacqueline, looking at hundreds of canvases, and Picasso dead. He had not discovered the Mask. He had discovered something else . . .

That's what those tormenting canvases told me, almost repeating aloud the inscription of Thebes: "Listen to the procession of the dead, buzzing like bees . . ."

Here was the room in which he had painted. A table covered with paint pots (very few tubes)—the table on which his empty pots had piled up. "He never threw anything away, right to the end." The same table he used for painting on a horizontal surface: "This paint drips!" Just barely enough space to paint; and the path he had left between the orderly heaps of canvases.

"There it is . . . ," said Jacqueline, dreamily, "the studio of the greatest painter of the century. . . . Funny, isn't it?" Those words, so often used by Picasso, seemed to echo his voice. The Grands-Augustins studio had been a shelter for an undisturbable and scrupulous disorder, through which Picasso used to walk like a cat. But, after all, he had lived "on the warpath." One day Gorki told

me ironically: "My culture? The culture that comes from books? I used to sneak out at night and go into the library of some of my aristocratic women friends. I'd read, and when there was no more moonlight to read by, I'd slip out." Picasso had done much of his painting by sneaking out to get into his own place.

The canvases of the Blue period and the Rose period (except for the self-portrait in the dining room) seemed to have been painted by someone else. Connected, perhaps, with a few doves, owls, and fauns, out of affectionate pity. He would say of the painter facing his model, "That poor guy . . ." Canvases which, devoid of mockery, were irremediably distinct from those Jacqueline was beginning to turn around—the musketeers and toreros of his last manner.

Some enigmatic passion contorted those altogether figurative paintings. Miguel came in to get Jacqueline; people were waiting for her to give them instructions. She left the room. Miguel turned the paintings around, one by one, while we talked about Spain. To my surprise, war did not sit well with death, but did with those paintings. Still more Avignon figures or some very like them; I recognized those that had been shown in the 1971 exhibition. Musketeers, warriors, painters and models, women with birds, Rembrandt-like characters and cupids, smokers, men in helmets, men with swords, Harlequins, toreros, Mardi Gras, and flute players gradually filled the room, encircling me. Yet more *Jacquelines*. They were keeping watch over the heaps of figures. One night, when I was in Indochina, an opium blight completely devastated the opium factory in Saigon; in the morning a tide of bacteria swept through the front gate, swarmed into the street, and moved on inexorably, inch

19. Picasso. *Harlequin.* 12/12/1969.
Private collection.

20. Picasso. *The Flute Player*. 9/30/1971.
Palais des Papes, Avignon.

by inch. . . . The characters from the Masquerade, who had entered this place in the same way, were awaiting their fellow creatures. In a room nearby, *Couples*, *Kisses*, and dwarfs overwhelmed the old canvases and those face to the wall. Although Jacqueline had sent two hundred of them to the Palais des Papes, the figures that peopled them were still conquering all the others—just as, on the floor below, the carnivorous flowers and the insect-eyed totem loomed over the other sculptures.

The extravagant pieces engulfed all the figures, as in a Temptation of Saint Anthony. Yet there were far more women with birds, couples, and kisses. And they were scarcely less disguised, with their imitation eyes and false noses. A large felt hat, very like a decorative flourish, was costume enough for most of the others. Indeed, the Masquerade was so unified that people with little knowledge of Picasso's art thought they had discovered a new manner applied to new subject matter. And one that connected it with his earliest works—the Carnival linking up with the *saltimbanques*, and the Harlequin totem, with those of the Rose period.

Over that gigantic Carnival reigned the frequently depicted Minotaur—the black god of the multicolored bullfights. The figures in disguise encountered one another, grouped together, and refused to separate again. Even at the time of the Salon de Mai, Picasso had sent over a row of them: *Twelve Canvases in One*. At the Palais des Papes those images, which had been created for painting and belonged to painting alone, were drawn into life by the viewers, who transformed them into characters. But they could no more become characters than the bronze lacerations could become flowers, or than the totem, with its machinelike striated eyes, could become

a mannequin wearing plumes. The visitors exhausted themselves trying to conceive them as a bold manifestation of imaginary characters. But there were no characters in the exhibition; there were devastated and devastating signs, which were a manifestation of something quite other than mere characters. At Mougins that same Saturnalia became a Saturnalia of painting itself. For over a decade Mardi Gras had lasted the whole year through: it was Picasso's bout with his own creation that had given rise to the Masquerades. They were bewitched, but bewitched by painting.

In his struggle with all previous forms, including his own, until he reached the age of sixty ("But, of course, of course, I imitated everyone! Except myself."), he had not gone to such extremes. At least in his paintings, for his sculpture invoked that fettered throng which thrashed about like the sculptures themselves and occasionally resembled them. While Picasso was painting *Las Meninas* he had often been interrupted by his white pigeons and the landscapes of Cannes, which offered themselves up to be painted. In 1969, when he was painting flowers, he reverted to the bronze bouquet of 1943, whose thorny pistils he had transformed into claws. The painting was right there. It showed that Picasso had struggled no less with his former canvases than he had when he painted his figures, but he was in command of his creation of flowers, whereas he still wanted to do battle with his creation of men.

Adjoining the room we were in was a large balcony, once a bedroom, the outer wall of which had been removed. We walked onto it. Jacqueline, who had now returned, went about setting up some of the Masquerade figures.

"**Pablo** wanted to have this made into his studio. While waiting, he brought canvases here as the work progressed. Even before it was finished, there was no space left."

That frenzy of creation reminded me of a Martian invasion, and also of the way the opium blight had invaded the street in Saigon. "When things were going well," murmured Jacqueline nostalgically, "he would come down from the studio saying, 'They're still coming! They're still coming!'"

I had seen that throng of figures at the Palais des Papes in Avignon two years earlier. And he was alive. . . .

# III

AT THE PALAIS DES PAPES IN AVIGNON
the ranged throng of canvases vied with the throng of
visitors, not because every canvas portrayed figures, but
because all jumbled together—just as the figures were
within each canvas—they marked out a continuous
swarm of Stations of the Cross at the base of the ca-
thedrallike vaults. Ah, those low walls of Notre-Dame-
de-Vie! A procession five hundred feet long filled the
Gothic hall, where Picasso's "tarots" laughingly watched
the provincial throng, shot through with hippies and
Japanese women; the paintings, hung so close together,
constituted a unified world, like Giotto's frescoes in
Padua. Picasso was being reproached for not having
painted another *Guernica*. But why would he have
painted more large compositions? That hall itself was
his "Last Judgment."

Ageless cries and shouts, which echoed in from the
courtyard, where the Théâtre National Populaire was
rehearsing a Cretan tragedy, seemed to be acclaiming
the Minotaur. There were toreros, musketeers (each
one called, in the catalogue, *Man with a Sword*), and
the whole of Picasso's early Carnival. *Couples, Kisses.*
The last act—at that point—of Picasso's battle with
painting. The last sound of his voice was a solitary
sound, to the shrieking accompaniment of the howling
Cretans. The period of passionate enmity to his work was

over. But since the tarots had come to occupy his life as they would a conquered city, he had painted face to face with death. And painting face to face with the next world, even be it nothingness, is not the same as painting face to face with this one, even be it painting.

For those spellbinding figures, like the figures of a few other great painters, seemed to be illuminated by the approach of death. The last Titians, the last Rembrandts, the last works of Hals . . .Hals had sensed that he was about to die. Titian hadn't, in spite of his age; he died of the plague. Rembrandt had simply not known. But Death knew: it chooses, at sixty or eighty, those whom it is going to gather in because it waits for them. Could the fearlessness with which Picasso lived out his last adventure be accounted for by the possibility that what he had heard was not his voice alone?

What, at the time, had he thought of posterity? Metamorphosis, from which his genius derived, might also destroy him. Would he conquer the future as he had conquered the present? Metamorphosis would perhaps sweep painting out of existence, but Cubism had become *Guernica*, as well as the last great Western school of painting—at a time when the earth knew no other. The power of creation that had conquered the earth was perfectly capable—why not? "of conquering two or three centuries. . . . After that, one never knows . . ."

"Sensational, of course," said one painter to another, "but they aren't paintings!" If he had meant it in the sense that *Guernica* was a painting, he was right. Even if he had meant it in the sense of Picasso's Cubist works, he was right, for Cubism contributed greatly to making

those paintings unintelligible. Yet I had heard Picasso say in the past, looking at one of his canvases, "Anyway, it's a painting!" But when he looked at the earliest of these works, he had said, with the anguished resolution of a last banco, "It's not me who chooses now."

Fate would choose. He had elected impulse to be his guide, or impulse had elected him. All true states of an art work (like those of *Guernica* or the *Man with Sheep*), every stage of development—even the elaboration of chaos—introduce the developed work into the traditional world of art. But for those two hundred tarots no states are known.

Still, that assurance was not enough. I was listening to small revolutionary groups, easily identified by their uniform: blue jeans and long hair. I had seen them in the rue des Teinturiers, near the water mills which in the past had dyed the red trousers of the French infantry. Upon entering the exhibition I had heard some hippies discussing the *Couples*. They had understood the sense of rebellion that had motivated the paintings; they had also understood that it wasn't the same as their own. The hippies were dreaming of India, of Buddhism, and of early Christianity, communal and musical. The group I had now run into did not consist of hippies. The tough mug of the tall boy I was listening to would have seemed rather brutal had it not been for his hair, which was frizzed up into a halo; his short beard had no resemblance to Christ's, but was the type sported by the Leather Boys. He was quoting to his chums someone's reply to an inquiry launched by *Combat* at the time of Picasso's retrospective show at the Grand and the Petit Palais. "What in hell can that mean to you, a guy who now spends his time on the Riviera

having kids and painting pictures?" "But don't forget," answered a short, curly-haired, blond boy, "he belongs to the Party." "Are you still interested in those Stalin-loving shits? Wasn't May '68 enough for you? Party or no Party, he's now part of the establishment, so let's drop it! I personally came here just to see how depraved he'd got, that's all. Screw painting. I'm even fed up to the teeth with action painting! Pollock sprinkles paint over his canvases and ends up a millionaire. Pretty clever!" I knew that tone of voice: violent, mocking, but weepy. He had had it with Pollock and Picasso. Not so very long ago, people who groaned like that became jailers in the end. "Pollock," replied the short blond, "ended by committing suicide." "What else could he have done? The only solution is to paint a master-piece so you can burn it in public!"

Which made me think of art works that had disap-peared. Montezuma's gold shield, which had been sent to Charles V, then seized by privateers from Dieppe, then sent to François I, then, later on, stolen from Fontainebleau and most probably melted down. The painting by Apelles—not the rotten one with such real-istic grapes that birds came to peck at them, but the one everybody admired, even though it consisted of nothing but three barely visible lines. "It disappeared when the Caesars' palace caught fire . . ."

"And why must it be burned in *public*?" asked the canny little blond.

"An attitude like Marcel Duchamp's—okay; but the readymades really belong in a junk shop! He and Pollock aren't even aggressive anymore, so what good are they?"

"Since you're luckily not such an ass as to attack ag-gression, you might realize that Picasso knew a thing

or two about it! Who ever beat him in that line? And he was at it a good bit earlier than Réquichot!"*

Another student—calm, rectangular, and wearing glasses—added: "Réquichot's dead; he brought it on himself. His *Reliquaires* is good. And what about a guy who goes to the slaughterhouse every week with a chum to bring back heads of cattle and pose them like the nude women of the Belle Epoque—great! Dust, garbage, slime, Faulkner's idiots, ashcans. It's the ashcans that count— to shove our society into them right up to their kissers! There, on the walls in front of us, where are they? Where are the ashcans? Good old Picasso, he's got it made, don't fool yourself!"

"Still, we're here," answered the little blond. "You all say that it's to see his depravity—fine. But we never go to see other painters' depravity!"

It was Picasso's aggression that had linked him for so long to the youth movements: Dada, Surrealism, the New Brutalism, the occupying of the Sorbonne. But the heirs to his forms rejected his spirit; and the heirs to his spirit refused to accept his forms.

"We never go to see other painters' depravity! Since that's the real question, it might be a good idea to begin by asking it. We've no reason for being here, and still we're here. Why?"

The striking words of the boy who had just spoken, slowly but not affectedly, carried weight. His gray suit set him apart from his picturesque friends, as if he alone

* During his short career Bernard Réquichot (1929–61), a painter and writer, progressed rapidly from one genre of painting to another —from Cubism to geometrical abstractions (consisting of painted- canvas cutouts pasted onto painted canvases), then to action painting, and finally to collages made up of fragmented painted animals. He committed suicide at the age of thirty-two. (Tr.)

were in disguise. Not to mention his slightly hooked nose, his very black hair, and his diamond-shaped mask, like those of Mexican figures.

"We're disgusted with this society. And with that of the Little Fathers of the People too. We're all for the Revolution—but only while it's going on. Don't mix the chaff with the wheat. Whether or not they're figurative, whether or not they're abstract, all these works, basically, are paintings. Even Pollock's are. The really new schools in the world today, at the Biennale, are schools of mockery and aggression. Their ancestor is Picasso, far more than Kandinsky or Mondrian. You were saying, Couturier . . . ?"

"I say that I don't give a damn about abstracts! The test of what counts is profanation. What in hell is Picasso capable of profaning?"

"Man himself, my boy. As the old fools would say."

"Couturier's a pain in the ass!" said a rather pretty blonde, dressed like a fanciful gypsy. "We're all beginning to sound bourgeois. Do you want me to show you my rear end?"

"Don't do a thing, Houppe: we'll take your word for it. I was going to add that when it comes to mockery, no one has been better at it than Picasso." He laughed like a bear trap. "We go along with Couturier when he says that 'the solution is to paint a masterpiece so that we can burn it.' But, pray, don't let's go back to Surrealism and its juries! A mania for judging is the first symptom of the neurotico-bourgeoisie."

The word "pray" was not used in the sense of prayer; it was an order. He was a pretty good Saint-Just, that boy, with his bear-trap laugh. Couturier clearly seemed ready to weep.

". . . and its juries, and its president of the jury who judges paintings-for-burning—which reminds me of that well-known lady who was not . . . Masterpieces will also be burned. Inevitably. In people's minds, of course. Do you know why the *Mona Lisa* is smiling? Because all those who planted moustaches on her face are dead.

"One thing alone is important: to refuse duration. In 1968 the journalists with political platforms were flabbergasted when we told them: 'Once you start to reason, you've already become a bourgeois.' They're slow movers. One doesn't haggle about the moment, Couturier. Your chums have too great a belief in mockery. Let them dream about reviving *la Fête*.* Or cataracts of neon (variables, all variables!), or even lighted towers. Even . . ."

"After the lighted towers, museums won't be any more than archaeological sites!"

"Or catacombs, my boy. And lots of things happen in catacombs. So I'll continue, if you don't mind. They can all dream of *la Fête*, towers, or shredded and defaced posters, or any other form of art that's based on chance. But if what you mean is that Picasso's done for, if what you mean is that art ought to give up the ghost— or, if not, what's the point of your remarks?—you should espouse the moment. With no thought of divorce. As Breton said, 'Beauty will either be convulsive or it will not be at all.' Much ado about nothing. The moment will burn up painting, or painting will go on kidnapping the moment. Burn paintings and they'll come back and

* Used, since the so-called "events" of May–June 1968, by young leftists and anarchists to describe the collective manifestations— cultural or countercultural—that provoke revolutionary joy and exhilaration. (Tr.)

tickle the soles of your feet if you don't burn duration along with them. We begin with duration, aggression or no aggression, and we end with posterity. *Dixi.*"

He was unaware of the fact that the only people who understand the imperious logic of suicide are those who will obey it. I walked away. If he had only known to what extent every generation of adolescents is alike. But he clearly had higher standards than the tracts and the little magazines. Was he really all that ready to debunk his ancestors? He was still sensitive—and where could he have been more so than there at the Palais des Papes?—to the unappeased pursuit of some negative of the sacred, which was very like his own guardian demon. He was right to say that the moment alone is capable of forgetting or conquering a style of painting whose strength lies in its two victories over the world of appearances: timelessness and creation, the two links between the art of the living and the art of the dead. But he was wrong not to realize that everything that surrenders the art of the living to the art of the moment—and even to the transitory—brings grist to the mill of the Museum Without Walls. All those tarots, revived by Picasso, had a vague resemblance to the boy's carnivalesque friends, and were surrounding me like spectators at a bullfight on those tiers of seats that Picasso had painted on the raised rims of his plates. (It was on one of those plates that I had seen his last Minotaur.) Despite the howling Cretans, the paintings with which he had surrounded the nave, in his own bleak and convulsive fashion, filled it with their own orchestra: merry-go-rounds and lottery wheels, Stravinski, *canto jondo.* I remembered that Picasso used to whistle only one tune—an air from *Petrushka*; and I was looking at a *Man with a Sword* panel.

21. Picasso. *Character with Bird*. 1/13/1972.
Palais des Papes, Avignon.

That day at Mougins, in Notre-Dame-de-Vie, I found another one, whose head exploded like a clover leaf, and which was called *Character with Bird*. I said, "It's the most extreme of them all."

"It was his last," replied Jacqueline. "He painted it a year ago, but then he reworked it. He almost never reworked them."

The light portions of the head were painted a dull pink. It was the last rival of the *Man with a Sword* that had been reproduced on the poster for the 1971 exhibition. A bird was perched on his shoulder. As Jacqueline explained, Picasso had discovered those musketeers in an album on Rembrandt during his last illness. Encounters that are repeated over a five-year span are not chance encounters. One of those moustached men in the previous exhibition was called *Character à la Rembrandt*. None of those characters, despite their hats, were vying with the characters in *The Night Watch* any more than the *Bathsheba* at the Louvre was vying with those in Mougins. And what a strange dialogue it was: in Picasso's colored drawing, Bathsheba had become Jacqueline, and the maid, the figure of a man who was more or less the deputy of the poor painter in *The Painter and His Model*. Was it Picasso himself? What did either his art or his life have in common with Rembrandt's? Unless . . .

Rembrandt had no precursors: we should stop seeking, in the few painters who were good at chiaroscuro, any anticipation of the haunted shadow in his works. It had never been done before Rembrandt, in spite of the equally haunted shadow in the works of Georges de la Tour; and with Rembrandt it disappeared. Once his period of purgatory was over, he remained altogether

detached from the trends of other schools, in an invulnerable solitude. Neither Manet, nor Impressionism, nor Cubism ever diminished his glory.

Nor did the resurrection of the primitives—of the greatest styles in the Museum Without Walls. Victor Hugo, who preferred above all the little girl in *The Night Watch*, knew even then that Rembrandt's lyrical light was not "lighting." We have discovered enough different styles of painting, not counting our own, to know that Rembrandt thought it essential that his have a new power, and had worked at that goal ever more avidly. From self-portrait to self-portrait he pursued his tragic dialogue. Quite alone, he seemed to expect that painting would reveal the secret of the world, and that even in his most despondent works he would find justification to go on demanding it. But for him the secret of the world was called God.

Rembrandt was no doubt the first painter to consider his art an adventure. In the light and shade that were his invention he discovered a way of communing with the mystery at the root of life, and sacrificed everything to that language of his own, which no one heard even then. He created an otherworldly light; he was called "the Owl." So that men could finally see it, he probably had to disappear; but he waited. Not for any sort of "progress" or belated justice. The point was that his power could germinate only in death. Painting is not what people think it is. They too will die.

I once made a speech in Stockholm to launch a series of events in Europe commemorating Rembrandt. Directly after I had said: "And when evening fell on that lonely studio, filled with nothing but his cumbrous

masterpieces—nothing more—he looked into a mirror full of shadows, saw his sorrowful countenance, cast out everything in it that derived from the earth alone, and flung into the face of lost glory the Cologne portrait which explodes into insane laughter. . . . The striking of the angelus mingled with the evening sound of oars paddling through the canals, and . . ." All the bells of Stockholm began to chime; the King of Sweden rose, then the entire audience; and in the night the clocks struck nine in a salute to Rembrandt.

He did not fall into any of the categories of Dutch painting, over which he reigned supreme. Similarly, Picasso doesn't fall into any of the categories of our own. He had rediscovered the torment of Sisyphus and its fertility. Right before my eyes his tarots were carrying on a dialogue with all the figures that derived from sources of which we are unaware. Sardinian art had become yet another Giacometti; the art of the Cyclades yet another Brancusi. The Celtic heads of Roquepertuse are very similar to the mask sculpted by Picasso in 1907, just as certain fetishes from New Ireland are to the *Woman with Baby Carriage* totem; just as the small Gallo-Roman altar in the Musée de Saint-Germain is to the torn bits of paper that make up Dora Maar's lapdog; and just as the Sumerian fertility figures are to the heads Picasso sculpted in Boisgeloup. The same liberating power that links *Les Demoiselles d'Avignon* to Cubism, *Guernica*, and *Las Meninas*, as well as the tarots that were besetting me from all sides, also linked the Sumerian heads to the Sardinian idols, the prehistoric Venus to the fertility figures, the Gallic coins to the terra cottas of pre-Buddhist Japan, the idols from the Cyclades to the Dogon masks, and all the works

with painted figures from the New Hebrides (whose stridency has never been equaled by any of our painters) to the fiber masks from Oceania, which in fact have no relation to sculpture. What we were being exposed to was the cry of discovery and the coherence of the works themselves. "To push on further and further—and to make it work . . ." Now, these creations of Picasso are not unified by any specific style (at least not yet), but each of them has a specific style. At the time of his retrospective show at the Petit and the Grand Palais, his most recent enemies had kept saying that he took his forms from here, there, and everywhere. In the depths of the bush in Oceania, where skeletons of Japanese soldiers are still hanging on branches, masks carved by men of the Stone Age—before reaching American museums—were waiting for one of Picasso's former sculptures to give rise to his last tarots.

Beyond the balcony a luminous summer—an Impressionist summer—quivered over the Mediterranean hills. I was thinking about Picasso's collection. Not one Impressionist painting, not one painting in which light plays any part. Not even in the admirable Cézanne, not even in the large Renoir. I could see in my mind's eye the living light of stained-glass windows, the becalmed light of Van Eyck, the light of Venice, the emotionally charged light of Rembrandt, the flickering, reflected light of the Impressionists . . . But Picasso's works were confined to candles, lighthouses, and the sun—the sun of bullfights, the sun of Cannes, as harmonious as Goya's golden grounds or black skies. His two masters— Van Gogh and, in point of fact, Cézanne ("He was our father, our Protector")—had made a clean break with

89

"happy" painting. Whenever Manet, Renoir, and the Promeneurs painted twilight, their canvases darkened, as stained-glass windows darken with the coming of the nightfall of God.

I returned to the room (what is the word for rooms inhabited as much by canvases as by people?) where Miguel had done what he could to turn more paintings around. To the left, isolated characters; to the right, some *Couples* and a few *Kisses*. As my mind grew accustomed to, and soon obsessed by, those paintings, the Carnival vanished. Faced with the power of creation, all phantasmagoria is reduced to secondary importance. And confronted by the great fact of death passing through, as Picasso himself had passed through life (his disorder seemed to be a living presence; his paintings seemed to be turned around just for the time being), recalling his sculptures all entangled like thistle tops tossed by the wind, one got the impression that the paintings released their characters into some realm of the unknown—a realm not of the Masquerade but of the tarots.

They were a continuation of Picasso's works from the time of *Les Demoiselles d'Avignon*—hypnotized heirs of that painting, more than they were of Cubism. Heirs also of the dislocations that had been invented by Picasso for over thirty years, after the geometrical and sometimes expressionistic entangled forms symbolized by the *Weeping Woman*. And even if I had not seen any of the *Man with a Sword*'s companions, I would have sensed the fact that he had not been an isolated creation—just as all painters had sensed that the first plaque from the Steppes (which was then called Scythian) hadn't been, and that neither had the first Chinese archaic bronzes or the first fetishes.

22. Art of the Steppes. *Animals Fighting*. Sarmatian period.
Third century B.C. to second century A.D.
Hermitage Museum, Leningrad.

23. Art of the Steppes. *Horse and Wild Beast*. Han period.
Third century B.C. to third century A.D.
Metropolitan Museum of Art, New York.

All the Scythian plaques, from the royal monsters in Peter the Great's treasure-house to the belt buckles, all of them depict animals fighting. An age-old motif, permeated with the spirit of the Mesopotamian lion and of the Mexican eagle and serpent. The art of the Steppes broke with the continuity of individual forms very early on; for example, a bird of prey's talons are, at the same time, the claws of a wild beast nearby, just as Braque and Picasso were to inscribe the profile of a face within the face itself. The maker of bronzes wanted to invent a sign for slaughter that was ravaged as much by the spirit of slaughter as by fire. If we compare two plaques from the Steppes that are not only centuries but thousands of miles apart, we find that the power they have in common derives specifically from the way they express that distortion, which, when controlled, acts upon us as strongly as symmetry; we find also that that sign of the molten bronzes existed prior to the bronzes themselves, that it gave rise to them—just as Greek idealization evokes images of its gods, or as gesticulation evokes Rubens' groups. The tarots, which seem to derive from nothing more than impulse or chance, belong to one and the same family.

Just as the people of the Steppes contributed claws and talons to the definitive thrust of their convulsive ideograms, Picasso invented propeller-shaped nostrils, networks and swords, and knotted strips which are unknotted or confuted by the lines that surround them. It was the period of his felt hats with flattened flourishes, the period of the ironic ubiquity of the ∞, the Greek sign for infinity. His most revealing canvases were the *Couples* in profile, which I saw grouped at the right—the heads of a man and a woman, their lips intertwined

24. Picasso. *Man and Woman.* 9/7/1969.
Private collection.

25. Picasso. *Kiss* (1). 10/24/1969.
Private collection.

to form one single sign, and the kiss extending or developing the sign into faces and bodies, in accordance with some illusory chance, which, in fact, the sign controls. The art of the Steppes had, as its basic pattern, clutched talons; the Chinese archaic bronzes had the *tao-ti*—a magic ideogram of the tiger; and Rubens had gesticulation. Picasso's basic pattern is more complex, because in his tarots the knots and the explosions follow in turn, one after another, and sometimes converge. The *Kisses* are sinuous and entangled; I had just again seen the *Character with Bird*, whose head consists of a sharp-angled clover, its leaves spread apart, within which the eyes and nose are placed willy-nilly. Those tarots seemed to be asking: how could one portray any other type of man—while at the same time asserting that they themselves don't portray him. Often a character derives from the basic pattern, just as the profiles and nudes derive from the sign of the kiss. Splotches too originated from frenzied brushstrokes, from lines that don't structure them and that seem to have been drawn for the purpose of fragmenting the image they suggest. Such corrosive graffiti are as much a negation as they are allusions. When did any painter fight painting—and doubtless himself as well—so fiercely as that?

"It's not me who chooses now." Certain of Picasso's tarots are not at all paintings; others are not merely paintings—just as the Negro masks (and, indeed, the Romanesque Virgins) are not merely pieces of sculpture. Nor are they in any way like Chinese characters, which symbolize everything. Is it possible that the last throng of figures flung against the walls by one of the greatest inventors of forms that history has ever known is a population of tarots which was not intended to mean

anything because it was composed of protesting shrieks? The *Couples* developed around the sign of the kiss, but those tarots are themselves signs. Of what? Of the unknown which they reveal.

Picasso had begun by sculpting traps for the future, and perhaps for posterity. To him the masks at the old Trocadéro were not just ordinary sculptures; they were weapons. *Les Demoiselles d'Avignon* and his canvases of the Negro period had had to wait for an audience; they also created one. The tarots are the same sort of traps, but more dissembling than *Les Demoiselles* and surely more than *Guernica*. Heirs of the totem with baby carriage, each one corresponds to an impulse, just as doses of drugs correspond to the needs of a morphine addict. The tarots don't even refer back to Picasso's early paintings, except in the case of the "fractured canvases," which anticipate their coming; indeed, they refer to nothing but the foreknowledge of their power.

The fact that their meaning is even more disconcerting than their forms is due to the paradoxical notion that an artist actually knows the unknown he discovers. The artists of all the great religious styles discovered the religious forms of the scenes they depicted. The icons conveyed to the Byzantines the Orthodox unknown; the statues in cathedrals conveyed to Catholics the unknown within themselves. But the Romanesque sculptors had not translated the Gospels into any known language: they had discovered a language that would express those elements in Christianity that art alone could express. Art had first to discover that language before it was capable of speaking it.

The happy sun was painting a white canvas on the blind above the solidly aligned tarots. Looking at that

iconostasis, I heard a child cry out—just as, high on a hill in Guatemala, I had once heard the distant clamor of life as I watched an idol being gradually covered over by pine needles in the same happy sun, in the everlasting tranquillity of an afternoon lulled to sleep by the heat.

"Listen to the procession of the dead, buzzing like bees . . ." I thought of the Grands-Augustins studio: "Picasso doesn't do anything at all." I thought of the Afghan hound, of the distant sounds produced by gas generators. The war.

"I must absolutely find the Mask . . ."

What he called the Romanesque mask was doubtless what the Romanesque sculptor made of a face in harmony with its God: with that which it venerated in God and with that in God it would never know—with that which, according to theologians, "belongs to God qua God"—in other words, with what is sacred. The Negro mask was in harmony with what the black sculptors feared, loved, and had no knowledge of in the spirits they depicted. That, word for word, was what Picasso had said. Once I had intrigued him when I told him that, for artists, "beauty" (a term that irritated him) had played a rather similar role over several centuries: it had appeared only in the guise of spectacles, bodies, and works of art, just as light appears only in the guise of that which it illumines. His reply was in the form of one of those obscure aphorisms, one of those cabalistic antidefinitions, of which he was so fond. Pointing at his *Cat and Bird*, he said: "The cat eats the bird; Picasso eats the cat; painting eats Picasso. . . . It nibbled away at da Vinci; Negro sculpture eats up the Negroes—it all comes to the same thing. The only difference is that

they didn't realize it. It's always painting that wins in the end." What he called "painting" was not any relationship between colors or even the creation of forms. He used the word "painting" because he didn't ever use the word "art" any more than he did "beauty." Painting had captured beauty just as it had captured religion and, in prehistory, "whatever it was, we don't know." Picasso was satisfied by the certainty that, like the cave painters, he had captured something.

The Romanesque sculptors had wanted to give expression to the revealed unknown, whereas Picasso gave expression to a form of the unknowable that nothing would ever reveal. All he knew, or would ever know, about it was his own feeling in regard to it—the feeling he had about a prayerless and communionless unknowable, a living void, like that of the wind. Such art is the art of human limitations—talons thrust into mankind, as the talons of the birds of prey in the Steppes were thrust into the bodies of wild beasts. It is the art of our civilization, whose spiritual void Picasso sneeringly expressed, just as the Romanesque style expressed fullness of soul. In Picasso's studio I had never seen any Romanesque figures or Asiatic sculptures, but I had seen his fetishes and masks prick up their antennae. If, in his Negro period, he had cut the spirits out of his Bateau-Lavoir fetishes, but not their subterranean souls, didn't his tarots (figures in disguise, just as his children are in their conventional portraits) speak to him in what Buddhism calls a language of abysmal space—one that had not bewitched his Cubist Harlequins? While he was at work on the tarots, would he have accepted, as he had at the old Trocadéro, the notion that the Negro mask was a head that sculptors had made to harmonize with

the African unknown? The *Toreador* and the mocking, threatening *Couple* in front of me also belong to a race of figures that Picasso himself had made to harmonize with an area of the unknown. In his opinion, they represent what our unconscious might recognize, what the diver was able to bring up from the lowest depths. Painting was to bring up, from the depths of the unknown, all that is so alien to man that he is unaware of it, but close enough to him so that he can recognize it.

I suddenly understood something I had been trying to work out ever since Miguel had turned the figures around: that it is the African mask that, though it doesn't exist, endows all masks with a soul; that it is the Romanesque mask that, though it doesn't exist, endows all the figures on the Royal Portal of Chartres with a soul; that although the Mask that obsessed Picasso doesn't exist, its people do, and it was they who were surrounding me. I thought of the Mexican statues the Spaniards had taken for demons. Torture, sex, blood, the night—grinning emblems, with a death's-head at the right of them and a burst of laughter at the left; the fertility god, its geometrical signs painted on the skin of its victims; two-headed and four-eyed statuettes; the cave of La Venta, where a haunted figure springs up from the ground, carrying a child in its arms. I thought of the large idols that also derived from the lower depths and that expressed no more than the struggle between the Mexican soul and a magic spell. The emblem suggested to me by those supernatural styles, which are equivalent to golden backgrounds, was not a work that conveyed one of man's successive souls, as did the Egyptian and Romanesque masks; it was the blazon of

art fighting against its own power, the plaque of the Steppes, the knot of wild beasts—man's entanglement with the unknown that assailed him. But what artist could ever be capable of discovering the mask of a civilization that has no notion of its own values? The tarots don't evoke a mask that disposes order; they convulsively agitate for its destruction. The god of negative signs is not a negative mask; it is the negation of the mask. Those paintings are by no means the satellites of some *Guernica* in which Franco would be replaced by God; they are not just another *Las Meninas*; those nomads never looked forward to any dominion except their triumphant occupation of the Palais des Papes. Gazing at the tarots that had been turned around by Jacqueline and Miguel, I recalled the exaltation of the personnel at the Grand Palais as they prepared for the Picasso retrospective show. Out of the hundred or more exhibitions organized from 1958 to 1968, only three times had the work continued into the night: for Picasso, for Romanesque sculpture, and for the arts of Mexico.

What sort of wizardry had cast a spell over those men and women, from the mechanics to the curators, none of whom were painters? What was the meaning of the aura given off by the Romanesque statues, the resurrected Mexican art, and Picasso's works? No one knew what was to follow the tarots, not even Picasso himself. Except Death.

From the garden outside came the strains of a violin; a record, I supposed. One day I had told Yehudi Menuhin and Nadia Boulanger that when the Asians heard our great musicians they got the impression that the deepest emotion felt by the Europeans was nostalgia.

"Would you agree, Nadia?" asked Menuhin.

"I don't think so."

"I don't either! I'd say it was praise."

What a ring it had, that word of benediction, in the company of all those rebellious figures! Giotto and the sculptors of Romanesque tympana and of the grottoes in India and China had invented forms unknown until then because they were inventing forms of praise. Cézanne's works have the effect of resurrecting figures from all the great religions. But Picasso brought the figures of tribal art back to life, and those fetishes from Africa and Oceania are not figures of praise. His works, which are so imbued with anger and suffering, even with pity—are they also imbued with praise? What about the works of the two ancestors he worshiped, Goya and Van Gogh? Occasionally he bestowed praise upon the latter, absentmindedly. But the secret leaven of his own painting was beyond anger and praise: its source was his constant questioning and the tireless dispute he had had with the universe of the works that had been obsessing him when he said, in an innocent tone of voice: "What will painting do once I'm gone? Surely it will have to go over my dead body? It couldn't bypass me, right?" Not only *Guernica* but his very last tarot, not only his most well-wrought but his most spontaneous works—all had been destined for that universe, which embraces them even if they repudiate it, even when they transform it. It gave rise to them. A satire of the French language written in French belongs to French. And the most enraged accusation of painting, written in paintings, belongs to painting. If Picasso's major works don't end up in a French, Spanish, or American Louvre, they will end up in some twenty-first-century Skira's Louvre Without Walls—or in my own.

26. Photograph of Picasso's studio in 1944.

# IV

IT HAD BEEN IN THE GRANDS-AUGUSTINS studio that we first spoke of the Museum Without Walls —the day Picasso was to show me the eighty canvases that happened to be assembled there, probably because of the war.

"Haven't you noticed anything?" he asked straight off.

"No."

"I cut off my forelock!"

Yet the expression on his face hadn't changed: he still had the same otherworldly eyes set in a mask of an astonished clown.

He showed me a few landscapes, composed in a manner very like the still lifes he had been finishing during my previous visit. All but one of them had been stacked away—the one depicting a radiator. I had never before seen any landscapes of his. I was gripped by these for the very same reason I had been gripped by his rather recent sculptures, the *Flowers*, and then, somewhat later, by his Confrontations: every attack of his in a new domain changed his means of attack and revealed their precedents.

"Do they surprise you?" he asked. "It's true, I'm not a landscape painter. These particular landscapes came to me just like that. I spent a lot of time walking the quays during the Occupation. With Kazbek . . ."

Kazbek, his Afghan hound, was usually stretched out somewhere in the studio. When the Germans would inquire about his race, Picasso used to answer innocently, "A dachshund from Charente."

"I never painted Kazbek. It's what you see here—the trees along the quay, Notre-Dame, and the statue of 'Le Vert-Galant'—which began to take shape. I didn't paint anything based on the motif itself. I painted what came to me and left it like that. . . . What do you think of them?"

The palette he used—that is to say, the range of hues and the way he related them to each other—was so different from the one I had known that I was amazed. I didn't mention anything about the main thrust of his landscapes, which at that point I had merely relegated to the realm of slashing enticement. Would I have been less surprised had I discovered a few figures painted during the same period? No, I was familiar with those. His *Vert-Galant,* with its trapezoid tree trunks and sea-urchin foliage, grasped the banks of the Seine on the fly, as it were, between its knives. Akin to a few of his Cubist Harlequins; quite the opposite of his hooked flowers, which later on seemed to have been painted as banners for some native tribe. An heir to what had once been a state of peace, under the small, benevolent silhouette of Henri IV . . . Almost happy, those sharply pointed landscapes . . . Not to be trusted.

In the studio on the floor above, Picasso had gathered together a throng of arbitrary figures that had been peripheral to his art for twenty years without conquering it. Here, one after another, were the rediscovered heirs to *Les Demoiselles d'Avignon* and his Negro period, with eyes where the ears ought to be, breasts where

27. Picasso. *Le Vert-Galant*. 6/25/1943.
Private collection.

28. Picasso. *Bouquet.* 10/27/1969.
Private collection.

the knees ought to be—the Martian children of his *Figures at the Seaside,* his *Lovers* of 1920, his *Woman Asleep* (that bristling sign, all hooks, which Kahnweiler had kept for thirty-seven years), his extraordinary *Crucifixion,* with its strings of shoulder blades and thighbones, his *Weeping Woman,* and all the forms that anticipated those which his genius-in-chains was later so lavishly to produce; also recent figures akin to them—*The Blue Hat,* his portraits of Dora Maar, the *Child with a Lobster,* the *Woman with Artichoke*—all of which the newspapers had already labeled "Monsters." Assembled in one place, those paintings, which, at first described as "humbug" or "moronic," and then called "provocative" and "gratuitous," in fact revealed what his tangled profiles within full-view faces had—within the category of distortion—in common with his splintered *Crucifixion.* All of them were works carried to an extreme. If anyone had asked him yet again, "What are those?" he would have replied, "Paintings." Before that day I had seen only three or four of them, and knew a few others from photographs.

That particular group had no connection with any other of his works that had been exhibited. Since the beginning of the war—even since the Spanish Civil War —I had seen very few paintings. At Picasso's, only still lifes. Hardly any of his sculptures were known at the time, and they were not to be exhibited until twenty years later, at the Petit Palais. As far as I was concerned, and those of my friends who hadn't visited either his studio or Boisgeloup, the last and most masterful expression of his genius was *Guernica.* At first I got the impression that those eighty canvases pointed to a new manner; yet they had been painted with long intervals between each one since 1919. By assembling them all

29. Picasso. *Woman with Artichoke.* 1942.
Private collection.

30. Picasso. *Woman Before the Mirror.* 19??.
Private collection.

in one place Picasso had isolated the virus of his art—the virus, not the leavening agent, for certain of his major works (and above all *Guernica*) belonged to another world, if not to another style of painting altogether. No one could have known that those fragments of meteorites would become the heralds of his tarots.

"Not bad, eh?" he said.

"Hardly. They're like a punch in the belly. Do you know what they remind me of? Of *Les Demoiselles d'Avignon*. Also of certain photographs of your sculptures. They're the terra incognita of your art."

"Why not? Painting is freedom . . . If you jump, you might fall on the wrong side of the rope. But if you're not willing to take the risk of breaking your neck, what good is it? You don't jump at all.

"You have to wake people up. To revolutionize their way of identifying things. You've got to create images they won't accept. Make them foam at the mouth. Force them to understand that they're living in a pretty queer world. A world that's not reassuring. A world that's not what they think it is."

(I recalled the story of his first visit to the old Troca-déro: "I myself think that everything is unknown, that everything is an enemy!")

"I didn't know that these figures had existed for such a long time," I remarked.

"I painted the *Lovers* right after the First World War. The *Woman with Artichoke*, just last year. All those over on the right, a few months ago."

He smiled ironically, looking worried.

"What do they mean?"

Every time he got that naïve expression on his face— his miller-straight-out-of-a-comedy look, Braque used to

call it—an expression he was particularly fond of when he wanted to mystify people who questioned him, he was apt to reply with questions: "How can you expect a woman to paint a good still life including a packet of tobacco if she doesn't smoke?" And then, with his arms stretched out and his hands open: "Since they say I draw as well as Raphael, why don't they let me draw in peace?" But also: "Have we absolutely decided to talk about painting? Ah, if only I were a professional!" And continuing, suddenly serious, and rather wearily: "All the same, before I die, I would like to sense exactly what color is . . ."

"You know what those works mean better than I do," I replied. "They want to say what nothing else could say. That's what they're shouting out, all together."

I added, in admiration, but with a touch of bitterness: "They're also saying, 'Written on the prison walls.'" And finally I remarked that, over the years, those intransigent works were creating a world of painting that had never before existed—one obviously very different from the architectural and Cézannian world of Cubism.

"Cézanne's Louvre," he said, "probably wasn't very different from mine. What *is* very different are the works that aren't in the Louvre."

He knew about all the works that had been resurrected at the same time as he had been having exhibitions—from Romanesque sculpture to Mexican sculpture, from Negro masks to the primitives, from prehistoric painting to all the possible forms of aggression. Along with his works, all of artistic creation, dating back to the cave paintings, was being discovered; indeed, that entire adventure was parallel to his own. I showed him some enlarged photographs of Gallic coins and Sumerian fer-

31. Mesopotamian art (?).
Fertility Figure. Ca. 2000 B.C.
The Aleppo Museum.

tility figures, which were almost unknown at the time. They had just been sent to me. He looked at them, then saw them; instantaneously his face became an intense mask—the very same as when he was painting, the mask of a lizard inhabited by spirits. Why a lizard? His face was round. Because of his cheekbones? Because of his eyes with no whites showing—and so very black? A ray of light etched a clipped white moustache onto his face. Another mask. This one would have taken away the element of astonishment, of weirdness; it would have transformed him into a stocky little figure of a man. He

112

was examining the heads of the coins: shattered fragments of axes, small broken sticks, commas, balls; and a Sumerian fertility figure, vaguely akin to one of his sculptures, with its ringlike eyes within a corolla that formed its head. Joy slowly returned to his face, and it was again Picasso's. He handed the photographs back to me with the look of having found a treasure in his own garden.

"What are you going to do with these?"

It was then that he questioned me about the Museum Without Walls. My essay had not yet been published. Still, Picasso knew that it was concerned not with any Museum of Everyone's Preferences but rather with a museum consisting of works that seemed to choose us more than we chose them. What I told him, in sum, was this:

Reread Baudelaire and you'll be dumbfounded when you realize to what degree the museum, as we know it, has become different from Baudelaire's in a single century. I tried to draw up an inventory.

To begin with, all we have discovered since 1900: Asia, Africa, pre-Columbian America. All we have brought back to life: Byzantium and medieval art. For Baudelaire, sculpture began with Donatello.

Second, how those discoveries and those resurrections had been made available to us through photography. Which has also provided us with frescoes, stained-glass windows, medieval statuary—all of which is untransportable.

Then, the nature of the museum itself. The Louvre is not an enlarged gallery of antiquities: it is quite something else, and poses other questions. It is a place for art, whereas the gallery used to be a place for beauty.

"Away with those monstrosities!" as Louis XIV once exclaimed.

Nor is the Museum Without Walls—which can exist only in our minds, as a part of our memories—an enlarged version of the Louvre. Baudelaire's contained four centuries of art; the Museum Without Walls contains five thousand years of works that hark back to time immemorial, to the tribal and the prehistoric. Almost all the works of the early ages were created by men for whom the notion of art didn't exist. Their gods and their saints became statues; metamorphosis is the soul of the Museum Without Walls. The multitude of works created in every civilization known to man doesn't "enrich" the Louvre; it calls the Louvre into question.

With the creation of Manet's *Olympia*, painters became aware of a "pictorial statement" common to all schools of painting. In other words, the birth of the Museum Without Walls and the birth of modern art are inseparable, and the revelatory role once played by *Olympia* was now being played again by *Les Demoiselles d'Avignon*

I had got that far when I noted that Picasso was not at all displeased by my venture in "moving house," as it were.

"Yes," he said, "of course . . . What, exactly, is painting?"

Evening began to fall as we talked in that badly and strangely lit studio.

"What Braque's doing now," said Picasso, "is no longer very much like what I'm doing. For him the fight is over! But if I gave him my collection, he'd be very pleased, right? Why is it Derain, and not I, who collects Scythian plaques? They're very like me, and not at all like him!

Why did Matisse buy fetishes before any of us? What have they to do with him?"

"They're more in keeping with his paintings than his own sculptures are. The dealers know it perfectly well. All the great artists of a specific period have the same Museum Without Walls, give or take a bit."

I told him about Degas' meeting with Bonnat on the top of a double-decker bus, and how flabbergasted Degas was when he heard Bonnat listing his collection of old paintings, which today make up the Bayonne Museum. Bonnat, the most famous of conventional academic painters, and Degas, the boldest of the Independents, liked the same works. "Life's funny," Degas had remarked. "Ah well, each of us went his own way . . ." They both knew they would never see each other again, and parted with a warm handshake.

"When people want to understand Chinese," said Picasso, "they think: 'I must learn Chinese,' right? Why don't they ever think that they must learn painting?"

"You know perfectly well why. They think that since they're capable of judging the model, they can also judge the painting. They're only just beginning today to tell themselves that a painting isn't always a copy of the model. Because of you, and Cubism, and the arts they're now beginning to discover—the arts of the early ages, the tribal arts, etc. Those arts don't copy models either—or at least not very much. As soon as Gothic art stopped being explained away as clumsy, the entire old system was condemned to death. Nowadays the non-artists who visit the Louvre are the people who admire whatever makes paintings into good likenesses; the artists are those who admire everything that doesn't make them into good likenesses."

"People say, 'I have no ear for music,' but they never say, 'I have no eye for painting.'"

"Because they think, 'I'm not blind.' They don't believe they need to learn anything about likenesses or about beauty . . ."

"Which kind?"

"Idealization, I guess. They therefore judge lightly."

"People always judge when they don't know anything."

"That's the whole problem. As soon as modern art came into the picture, what did it in fact refer to? To . . ."

"To painting!"

"In other words, to the paintings and sculptures that inhabit us—what I call the 'Museum Without Walls.' But at the time when people believed they knew all about beauty and likenesses, they didn't know about the Museum Without Walls; they didn't even have any idea that it existed. When they'd go to the Louvre . . ."

"If they went there to find likenesses and beauty, they couldn't have seen the paintings. We always believe that we're looking, right? But it's not true. We're always looking through eyeglasses."

He spoke very impressively about the eyeglasses an artist's creation imposes upon the viewer. Not about "nature imitating art" but about the filter one is forced to look through the very moment one's eyes settle on an object; about the preconceived intention that made everybody believe that Marcel Duchamp's bottle-driers was a piece of sculpture because it was shown in an exhibition, and that Negro sculptors were clumsy because everyone had been assured that they wanted to imitate their neighbors or nature.

"Obviously, people must be forced to see paintings in spite of nature. But what, exactly, is nature?"

I remembered an answer he gave, long ago, to the type of reporter who thinks he's so clever and who had asked him: "Monsieur Picasso, should feet be painted rectangular or square?"

"I don't know. There aren't any feet in nature."

I replied: "Giotto, the shepherd, was very bad at drawing sheep, but when people realized that painters were no longer referring to nature, they weren't pleased at all. Modern art began with *Olympia*, and *Olympia* was the first painting that ever needed police protection."

"Are you sure of that?"

"Absolutely. And it's all the more strange in that the canvas isn't erotic. It has to do only with painting. Now, if all those who were so loudly protesting didn't like it, they simply didn't have to buy it. And, indeed, they didn't."

"People have always felt like destroying paintings they hate. And they're right. Funny they didn't do anything against *Les Demoiselles d'Avignon*."

"When the Connétable de Bourbon captured Rome, his archers chose as their target *The School of Athens* . . ."

"They didn't like Raphael, was that it? They were already Cubists?"

"For months all the characters—Plato, who was in fact a portrait of Leonardo da Vinci, and some other Greek, who was in fact a portrait of Michelangelo, and all the rest of them—had arrows stuck in their eyes. Great scene for a film."

"It doesn't surprise me. People don't like painting. All they want to know is which painters will be consid-

ered good a hundred years from now. They think that if they can make the leap and see ahead, they've won. They should all be art dealers. Yet we have no idea of how painting lives. Or how it dies. No one can talk about painting. I can talk about Van Gogh. Maybe. But not about painting. It makes me do what it wants me to: to press on, to press on further and further, to press on even further than that—and to make it work. But that's the problem—to make it work! . . . In relation to what?"

"To your own Museum Without Walls."

He considered for a while, then replied, "I suppose so. But not only to that."

I was less interested in debating the subject than in getting him to talk. Yet I asked him whether he didn't think that, after Manet, works of art forsook the domains they were created for—caves, temples, palaces, tombs, cathedrals, drawing rooms—and entered into a common domain where each one refers to all the others: the Greek archaic sculptures to the statue-columns, to Michelangelo's last *Pietà*, to Negro masks.

"People aren't pleased," he answered, "because what they want is a painter who, when he thinks about Kazbek, makes a copy of Kazbek. But the letters that make up the word 'dog' are not a copy of the dog!"

"Nor are Chinese characters; at least they haven't been for a long time."

"They name things. A painter should name things. If I do a nude, people ought to think, That's a nude. Not: That's Mrs. So-and-So."

"Or the goddess So-and-So. But the art lover wants a Picasso nude."

"It would be one in any case, if I manage to name it a nude. It's hard, of course. It's painting. In painting,

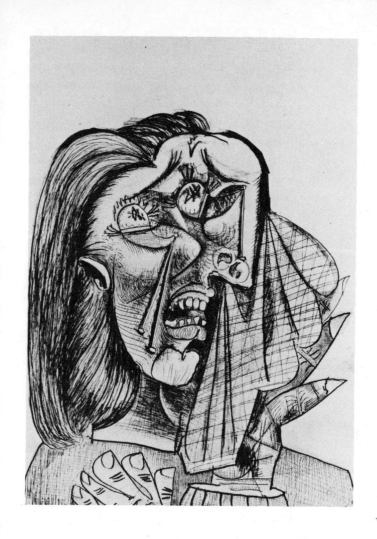

32. Picasso. *Weeping Woman*. Engraving. 1937.
Galerie Berggruen collection, Paris.

things are signs; before the First World War we called them emblems. What would a painting be if not a sign? A *tableau vivant*? Ah, yes, of course, if one were a professional painter! But when one is merely Cézanne, or poor old Van Gogh, or Goya, then one paints signs. You, Chinaman, don't you agree?"

The Cubists had understood very early on that the privileged means of painting is the affective sign. Picasso's personal freedom was rarely willing to free itself from it. It was necessary to his art, for it enabled him to vie with nature, and even to destroy it.

He made a gesture, pointing out the most arbitrary group of paintings placed against the walls. Sometimes contorted, sometimes geometrical, those figures—each of which was impelled by the same unrelenting struggle against what it signified—were linked by a characteristic that was common both to the knotted and to the angular figures: all of them seemed bound hand and foot by their frames. The frenzied right angle of the *Weeping Woman* was already famous; its freedom seemed to suggest a new style in the making, perhaps a new form of Expressionism. (Which implied a misunderstanding of Picasso.) But the fiercely free style of the canvases I was looking at was not marked by that tangled fury. In variable ways, over a period of so many years . . .

"Chinese characters," I said, "refer to a known significance; these particular paintings refer to an unknown significance, even though they're all portraits of Dora Maar. Anyway, to a Chinaman the world of the sign is respectable; it's something like the world of algebra to Westerners. They respect equations; but they know only two kinds of signs: children's drawings, graffiti, stick figures, etc.; and caricatures. You, today, are attacking

the human face in a far more worrisome way. No one dares to describe your faces in terms of childishness, snobbery, or humbug anymore."

"I know. But why?"

"Your paintings are worth too much. During the Resistance I worked with a doctor from the Lot region who told me: 'As for your Picasso, he doesn't exist; it's all snobbery, humbug; he admits it himself!' But this year: 'As for your Picasso, I do just as well, but he sells his stuff for millions, in every country in the world. I don't! So tell me that it's all well organized, that there are art dealers. Certainly, Colonel,* but it won't do. All that money, and he changing his style all the time! He could have gone on painting those blue things that are photographed all over the place—at least they were understandable! No, I'm not superstitious, but that boy's something of a sorcerer.'"

The word "sorcerer" pleased Picasso. It was in keeping with the trancelike states of some of his forms, his figures straight out of black magic, his power of metamorphosis. He loved bats; he had collected scorpions and small owls, and had put some of the owls into his canvases while awaiting the doves. He knew that his genius had a mysterious side to it; he was aware of his malarial fits of invention. One day, apropos of Lawrence of Arabia, I had told him that the myth of the "sacred monsters" was not without its mysterious side. "Yes," he replied, "but when they're painters, the mystery ought to lie in the painting." Yet he liked the fact that his witchcraft was somewhat out of his hands, and he was sorry that he

* During the Resistance, in which he played an active part, Malraux, as leader of the *maquis* in the regions of the Lot-et-Garonne and Corrèze, was known as "Colonel Berger." (Tr.)

so well understood my good old doctor friend, who so misunderstood him.

"Still, isn't it funny that all those people who don't understand a thing about my painting pay so much attention to me? Actually, it's also funny, all those people who do understand painting but aren't painters. Who are they?"

"For a start, those who need it? . . . If I went on, though, I think it would get rather complicated. For instance, bad painters like painting too."

"Not the same type of painting."

"Sometimes the same . . . Look at Bonnat! In any case, what I meant was that everyone now knows that your signs signify something. But what?"

"It knocks them out. What difference should it make to them? Still, my Cubist Harlequins are reproduced in magazines . . ."

"Because they're mistakenly thought of as decorations, especially for stage sets. But your Negro period . . . And these canvases here . . . !"

"People *always* begin by not understanding! Afterward it's only as if they understood! But that's great! Because personally I haven't the vaguest idea what they understand. When you're dead, fine. I'm not dead. Is it that they've got used to my work? No, there's more to it than that. Take Apollinaire, for example. He knew nothing about painting, yet he loved the real thing. Poets often have a sense for it. When I was at the Bateau-Lavoir, the poets sensed . . ."

The first time I ever saw Utrillo was at a Montmartre grocery woman's house, where Max Jacob used to lunch. Wild-looking he was, with a fantastic gorilla at his side. His vocabulary at that point was limited to two words.

Lifting his very heavy eyelids onto a desolate void, he asked me, "Painter, or poet?," sat down, and went to sleep.

I said to Picasso: "Yes, from that point of view, what about Baudelaire, who wasn't much of a musician but sensed what Wagner was about?"

"But don't you find that funny? When one starts a painting one never knows how it will turn out. When it's finished one still doesn't know. You might say that painting ripens until it's good enough to eat. Think of Cézanne, of Van Gogh. People don't understand that *I'm* Van Gogh, right? But it doesn't matter: we're in no hurry . . ."

He sounded as if he were joking; I believe he was only half joking. He was poking fun—at himself? More probably at everything, just as he seemed to be jeering at the human forms he gave to some of his figures. His jokes were grating.

"If Van Gogh," I said, "had died at the same age as Claude Monet, he would have died just before the war, in 1939. So that while he was still alive he would have been more famous in Japan than Raphael. But the belated triumph of cursed geniuses is one thing; the resurrections of the Museum Without Walls are another. For centuries the fetishes were nothing but funny little men."

"Still, they existed."

"For whom? The god of sculpture?"

"That's what we have yet to understand. No one has ever explained it. Suppose they were forgotten. No, not so fast! After all, Rembrandt, they say, copied Indian miniatures, right?"

"Yes. And Dürer carefully examined the Aztec statuettes he was shown in Antwerp. Yet for a good long time

33. The Lespugue *Venus*.
Aurignacian.
Musée des Antiquités Nationales,
Saint-Germain-en-Laye.

people had stopped *seeing* Classical antiquity; and for
five long centuries they never saw Romanesque sculp-
ture. When Théophile Gautier once passed through
Chartres, he didn't make the detour—of five hundred
yards!—to look at the cathedral. And the statue-columns
weren't buried, and the most famous art of antiquity
adorned the Hippodrome in Byzantium."

Mysteriously he held up his index finger: "I'm going
to show you something."

He led me into a small room nearby, took a bunch of
keys off his belt, and opened a metal cupboard. On the
shelves were his very elongated statuettes which were
then called *Cretan Women*, a violin-shaped idol from the
Cyclades, and two casts of prehistoric statuettes.

"The Lespugue *Venus*?"

"Yes."

One of the casts was of the mutilated statuette. The
other was one he had found of the restored statuette:
her bust, and her legs joined together, sprang forth sym-

metrically from the lusty volume of her rump and her belly.

"I could make her by taking a tomato and piercing it through with a spindle, right?"

There were also some of his engraved pebbles, some of his small bronzes, a copy of his *Glass of Absinthe*, and the skeleton of a bat. He took a *Cretan Woman* from one of the shelves and held it out to me. The photographs of her did not convey all the sharply cut detail.

"I made them with a small knife."

"Ageless sculpture . . ."

"That's just what we need. We also need painters who will paint ageless paintings. Modern art must be killed. So that another form may come into being.

"Everybody—but everybody—until now found the violin-shaped idols ugly. I personally don't find my own ugly. Nor do you. Nor do our friends. Yes, mine had been forgotten for a long time. I don't give a damn for the history of taste. In fact, I'm delighted that it was forgotten! Otherwise it would be immortal! But it's there for us. It's there. People say, 'We love everything that resembles us.' But my sculpture is not a bit like it—not a bit like my idol! Is Brancusi the only one who should love it? Similarities! In *Les Demoiselles d'Avignon* I painted a nose in profile within a full-view face. (It had to be put in sideways so that I could name it, so that I could call it 'nose.') Then everybody talked about the Negroes. Have you ever seen any piece of Negro sculpture—any one at all—with a nose in profile within a full-face mask? We all love the prehistoric paintings, but no one resembles them!"

At the time he was painting *Guernica* he had told me, in that very same studio, "It wasn't the forms of the

fetishes that influenced me; what they did was make me understand what I expected from painting."

He was holding the violin-shaped idol from the Cyclades and looking at it. His face, which generally expressed surprise, again changed into the intense mask it had become earlier, when he had looked at the photographs. An instantaneous transformation. Telepathic. (Braque had spoken to me about his "sleepwalking side.") He made no gesture; he went on talking. Neither the light nor the atmosphere had changed; there were still noises coming in from the street. But he was suddenly in a state of anguish and sadness, and it was infectious. I listened to him, and I heard some words he had once spoken at the time of the Spanish Civil War: "For us Spaniards there's Mass in the morning, bullfights in the afternoon, and brothels at night. What does that become all mixed up with? With sadness. A peculiar sadness. Like the Escorial. Yet I'm a gay sort of man, right?" As a matter of fact, he seemed gay because of a mixture of youth—almost childishness—and activity, which gave the impression that he was playing and having a good time. Except while he painted. However, within a few seconds the joyous sea had withdrawn from that face of shifting sand. He was saying:

"From time to time I think: There once was a Little Man from the Cyclades. He wanted to make this really terrific piece of sculpture, just like that, right? Exactly like that. He thought he was making the Great Goddess, or something to that effect. But what he made was that. And I, here in Paris, I know what he wanted to make: not a god but a piece of sculpture. Nothing's left of his life; nothing's left of his kind of gods; nothing's left of anything. Nothing. But this is left, because he wanted to

make a piece of sculpture. What's it all about, our . . . our necromancy? And that kind of magic power painters and sculptors have had for such a long time? When people believed in immortal beauty and all that crap it was simple. But now?"

"You didn't choose to love Cycladic sculpture. Or the Negro masks. Why is it that the works you love co-exist in your mind? I believe it's because of their common presence. I'm not altogether clear about it . . . You just said that this idol is there. I think so too. We don't think that of the Belvedere *Apollo*. Each person's Museum Without Walls consists of the works that are present to him. The statues survived because they were works of art; today they are works of art because they survived."

He had a very quick mind, but also a taste for reflection when it came to an idea he felt was concerned with his relationship to painting:

"That's interesting. . . . People can tell me anything they want about a painting which isn't there when I look at it; I couldn't care less. Those paintings are for historians. It's like friends: there are those we love and those who don't matter. Has my idol become a piece of sculpture? Yes. So has the fetish. Absolutely. And it won't stop with us, right? Sometimes I *see* the studio and everything in it. Just as I see things before I paint them, before I think of using them. What will become of it all? My early canvases have changed a lot. Not the colors—the canvases. The sculptures too. And I'm alive. Afterward . . . And what about Van Gogh? And Cézanne? As I told you, no one knows how painting lives."

He meant "art," but to him that word was taboo. The most important words in our vocabulary—"love," "death," "God," "revolution"—owe their power to meanings that

have been superimposed on them; to Picasso, "painting" belonged to that same category of words.

With the hand in which he was holding the small marble violin he pointed to his *Woman with Leaves*, standing in a corner. "The leaves were mighty surprised to find themselves in my sculpture, right?"

He spoke in the simplest way possible. Without pretension, and not in any way "sick." But he experienced metamorphosis just as mediums experience their trances. Indeed, the leaves had become a part of his sculpture. He had pictured his bull reverting to handlebars and a seat, and then taking off as a bike. He had spoken of throwing the stones he had sculpted back into the sea. "I wonder what the people who eventually find them will think?" He had collected the guitars lying about in the next room *after* he had painted his guitar pictures. When talking about his new canvases he would say, "They're still coming!" And about those he was finishing, "I'm going to leave them just like that." He spoke of his landscapes as if they had first been absorbed within him and had then emerged as paintings. After *Les Demoiselles d'Avignon* his works had become one inexhaustible metamorphosis. He literally lived in a state of metamorphosis. The *Woman with Baby Carriage* never became an "interpretation." When the journalists described Picasso as a sorcerer, they were rather hastily expressing what in fact was the profound and disturbing power he possessed and was perhaps exorcising. Actually, his works as a whole, given their very nature and their successive periods, are more haunted by metamorphosis than the works of any previous artist. I had not forgotten those cockroaches at the foot of *Guernica*.

Now his wide-eyed gaiety had returned. Ironic won-

34. Art of the Cyclades. Violin-shaped idol. Ca. 2000 B.C.
Museum of Archaeology, Athens.

derment was one of his most frequent facial expressions.
Detached from the Little Man from the Cyclades. Dis-
connected from all those centuries.

"My leaves—all right. They're 'domestic' leaves, like
Kazbek. But the violin isn't a leaf. Still, it's kind of a
leaf, right? The arabesque, the symmetry . . . I once put
pieces of a guitar into my paintings. So did Braque and
Gris. Then everybody did. I now wonder whether the

little sculptor really invented the violin. A terrific invention! If you bring the upper left of it into line with the lower right, cutting across at the middle of the notch, it becomes a nude, in profile! Invented? Discovered? I don't mean: Had it been done before him? I mean: Do we all have a violin within us, which he recognized, just as I recognized his piece of sculpture?"

"It's a little like what Jung calls an 'archetype,' which we know only from the forms it takes. Like mother of vinegar, as he explains it."

"I mean: Are there forms—sort of hazy forms, like the plan for a painting—which become clearly defined, which become reincarnated? Why? Because they correspond to something deep within us, something very deep? Because of the form itself or because it expresses something? You see: symmetry is form, but it's also our bodies, right?"

"Has anyone ever spoken to you about the image of the Virgin that appeared to Bernadette?"

"Which Bernadette?"

"The one from Lourdes. She saw the Virgin of the grotto. Then entered a convent. Many pious souls sent her all sorts of Saint-Sulpice figurines. She chucked them into a closet. The Mother Superior, dumbfounded: 'My daughter, how can you put the Holy Virgin into a closet?' 'Because it's not her, Mother!' Re-dumbfounded. 'Ah? . . . And what does she look like?' 'I can't explain it to you . . .' The Mother Superior wrote to the Bishop, who came to the convent with large albums containing all the well-known images of the Virgin—those from the Vatican. He showed her Raphael, Murillo, and so on. Don't forget that all this happened during the Second Empire, that she was a peasant girl—a shepherdess, I

think—who lived way out in the country and had certainly never seen anything *but* Saint-Sulpice-type Virgins or, at the very most, baroque versions of her. She shook her head no, and continued to shake her head no. As they flipped through the pages at random they came upon the Cambrai *Virgin*, an icon. Bernadette rose, her eyes popping out of her head, then fell to her knees: 'That's her, my Lord Bishop!'

"As I said, the Cambrai *Virgin* is an icon. Considerably touched up and adorned with a number of indistinct cherubs; but it has no movement and no depth—no illusionism. Merely the sacred. And Bernadette had never before seen an icon."

He thought for a moment. "Are you sure?"

"The Bishop's letters have been published. And who would have benefited from his lying?"

"A plot cooked up by the Cubists! . . . Still, I'd like to see her *Virgin*."

"It's still in Cambrai. I'll send you a photograph of it."

"When?" Suddenly he was in a great hurry.

"This week, I hope. It won't take me long to find it. I think I know where it is."

"Funny that the girl recognized her. . . . But come to think of it, how amazing too that the Byzantines ever invented her! . . . I've got to think about it. It's interesting. Very interesting. Where does she come from? Why do I love my prehistoric Venus? Because nobody knows anything about her. Magic, sure! I make magic too! I also love the Negro pieces, and for the same reason, but we're beginning to know—I mean, we think that . . ."

I started walking toward the studio. Picasso came along with me. He seemed to have tucked the Cambrai

35. The Cambrai *Virgin*. Fifteenth century (?).
Collection of relics and ornaments, the Cathedral, Cambrai.

*Virgin* away in a corner of his mind, and to be thinking aloud, as if he were now taking advice from the contorted forms we were looking at yet again:

"In our heads we have a museum which isn't the Louvre—no doubt about it. Which does and does not resemble the Louvre. But don't forget: it's only in our heads. That doesn't bother the intellectuals. On the contrary. But it does bother painters. The idea of a painting . . ."

"Rather—under the circumstances—the memory of one, or a reproduction . . ."

". . . is not a painting."

"The Museum Without Walls is by definition a place of the mind. We don't live in it; it lives in us."

"Still, it could actually exist, right? A small one. With real paintings. It should be tried. But how would you go about it? In our minds the period of a painting doesn't mean very much. But if you set up an exhibition? You can't group the paintings according to subject matter; that would be stupid. At random? But in the end we'd see them in sequence, right? If you eliminated history, what would the professional artists say? The Douanier Rousseau saw himself as one of the moderns, one of the 'electric' painters; he ranked me with the Egyptians. . . . Still, it would be worth the trouble. Van Gogh's Museum Without Walls: Millet next to Rembrandt, and Mauve;* do you know Mauve? We'd put in Van Gogh's ancestors, and we'd put in his descendants."

"Baudelaire's Museum Without Walls: no sculptors

---

* A painter from the Netherlands (1838–88) who created his own special world of light and shade, and is considered one of the "poets" of the misery of mankind. Mauve belonged to the school of Realism in The Hague. (Tr.)

36. Art of the Cyclades.
Idol. Ca. 2000 B.C.
Museum of Archaeology,
Athens.

before Puget,* except for Michelangelo; no Primitives.
His *Phares* begins with the sixteenth century."

Picasso stopped in front of the *Woman with Arti-choke*. A pure form of the arbitrary.

"Yes," he replied, "we've made some progress. . . . So
has your Museum Without Walls. . . . Because there's
where a painter finds the things he loves. They're all in
one place—you're right. Understanding Negro art is one
thing. Understanding Negro art in relation to the statu-ettes of Minorca—what are they called? Ibero-Phoenician?

---

* The French sculptor, painter, and architect Pierre Puget (1620–
94) executed many of his most successful works in Genoa and
Marseilles. His fame rests chiefly on his sculptures *Milo of Crotona*
and *Perseus and Andromeda*, as well as the bas-relief *Alexander and
Diogenes*, all now at the Louvre. (Tr.)

—and the *Lady of Elche*, and Cycladic idols (Zervos*
wants to write a big book on that type of sculpture—
an inventory), and the prehistorics, is something else
again, right? Especially face to face with the originals,
not photographs of them. What if one set up an exhibi-
tion? The sculptures that speak to us also speak to each
other. And they don't say the same things. Just like
paintings! Museum or no museum, we live with paint-
ings—there's no doubt! What would Goya say if he saw
*Guernica?* I wonder. I think he'd be rather pleased, don't
you? I live more with him than I do with Stalin. As
much with him as I do with Sabartès.† I paint against
the canvases that are important to me, but I paint in
accord with *everything that's still missing* from that Mu-
seum of yours. Make no mistake! It's just as important.
You've got to make what doesn't exist, what has never
been made before. That's painting: for a painter it means
wrestling with painting, it means . . . practicing paint-
ing, right? The paintings that come to you, even those
that don't, play just as big a part as your Museum With-
out Walls. We each have one, but we make changes in
it. . . . Even if only to paint against it."

* Founder of the review *Les Cahiers d'Art* in 1925, Christian Zervos
devoted almost an entire issue of it to Picasso in 1932, which included
reproductions of his works as well as articles on him in French,
English, German, and Italian by a large number of eminent poets,
painters, and critics. (Tr.)
† Jaime Sabartès, one of Picasso's oldest friends, first met him in
Barcelona in 1899. In 1935, when Picasso, in his half-deserted rue
de La Boétie apartment, was suffering from loneliness, Sabartès ac-
cepted his invitation to join him there as his secretary in order to
help him answer his mounting pile of correspondence and assist him
in his official chores. "Since that day," Sabartès wrote, "my life
follows in the wake of his" (Roland Penrose, *Picasso: His Life and
Work*, p. 253). (Tr.)

Many other painters, rather than say, "against the Museum Without Walls," would say, "confronting it."

"But isn't there also a small room in it that never changes?"

"Look, though: your kind of Museum, with its chummy ghosts, and my idol, and my Venus . . . none of that's based on any particular aesthetics—which is fine. The first thing people must be made to understand is that creation rarely has anything to do with aesthetics."

"The creation of the works we're in the process of reviving almost never did."

"You say that I didn't choose to love the Cycladic idol. True, I didn't. I know all sorts of Great Goddesses of life, all sorts of fertility figures, not to mention the one you showed me a little while ago. (Terrific!) The island sculptors were the only ones who ever found a way to transform them into signs. Generally they're fanciful more than anything else. Or symbolical. Somewhat like the Lespugue *Venus*: bellies. Mine—the one you saw—pleases me because of the violin. What a find! But on many of the islands the violin shape disappears. So my idol has no belly. It's a goddess, if you like—anyway, a magic object; it's no longer a fertility figure. All that's left are small, flat breasts and engraved lines for the arms. Better than Brancusi. Nobody has ever made an object stripped that bare.

"So you're right; I'm really forced to love them. I don't choose. But is there much choice on my part when I paint what I paint? In painting *as* I paint, and no other way—yes! But . . . while I work I'm always wondering what will make its way into the canvas, naturally. I begin with an idea; you can't start out with nothing. Some

vague idea. It has to be vague. If a painter isn't quite sure of what he wants, it's of no great importance. So long as he's very sure of what he doesn't want.

"I always know when I come out a winner. If I'm wrong, the future will tell. That's the future's job, right? To be continued in the next issue. With some canvases, we have children; with others it's impossible. Afterward the good ones become our guides. Canes for our old age! They keep coming and coming! Like pigeons out of a hat. I know, in some vague way, what I want, like when I'm about to start on a canvas. Then what happens is very interesting. It's like a bullfight: you know, and you don't know. Actually, it's like all games. I could say: I'm painting my complete works. That's for Zervos' catalogue. But for me . . . When I look at my hand, I know it's fate; it changes as life goes on, right? I want to see my branches grow. That's why I started to paint trees; yet I never paint them from nature. My trees are myself."

The comparison was clearly part of his mental universe, for one day he had told me that he wanted to "feel the branches grow. One's own branches, of course," not the tree's.

He went on: "I want to cut the branches too. What exactly is a painting, or a piece of sculpture? Are they . . . are they objects? No. What, then? Let's say they're things—that's more like it. Things within which whatever is sculpted or painted meets with its own destruction. The painter takes whatever it is and destroys it. At the same time he gives it another life. For himself. Later on, for other people. But he must pierce through what the others see—to the reality of it. He must destroy. He must demolish the framework itself."

His irony had disappeared. He was surely summing up a thought that was familiar to him, for he was speaking in an offhand way and using a precise vocabulary which reflected the lacerated thrust of his paintings.

"A painter must create what he experiences. *Cuidado*! Experiencing, experiencing—easy enough to say! It's not seeing in a particular way. It has nothing to do with interpreting. Look." He pointed at the trancelike geometry of the *Weeping Woman*. "Dora, for me, was always a weeping woman. Always. Then one day I was able to paint her as a weeping woman."

I thought of the only words of praise Leonardo da Vinci had ever written about his own painting: "One day I just happened to paint something that was truly divine . . ." It was the *Mona Lisa*.

"I was able to paint her as a weeping woman. That's all. And it's important, because women are suffering machines. And I'd hit upon the theme. As I had for *Guernica*. And not long after *Guernica*. You shouldn't have too clear an idea of what you're doing. When I paint a woman in an armchair, the armchair implies old age or death, right? So, too bad for her. Or else the armchair is there to protect her. . . . Like Negro sculpture. Innocent painting exists. The Impressionists—in any case, the Promeneurs—are an example of innocent painting. But not the Spaniards. Not Van Gogh. Not me. Sometimes the Dutch can be taken for Spaniards, right? Van Gogh, Rembrandt . . .

"Maybe the most important word is the word 'tension.' Lines shouldn't . . . shouldn't even vibrate anymore, shouldn't be able to anymore. But there's more to it than the line itself. You have to create as much distance as possible. The head that becomes an egg. That was per-

138

fectly understood by the sculptors from the Cyclades—not when they made their violins but when they made their idols, which are actually oblique eggs anchored down by a neck . . . The body, and plant life. That I did in my *Woman with Leaves*. Also, you have to confound people. Square heads, for instance, when they ought to be round."

Imperceptibly, his voice took on an ironic tone again —this time almost to the point of parody. I thought of Mallarmé's remark, "Therein lies all the mystery: in establishing secret identities by way of a two-by-two which corrodes and wears out objects in the name of an essential purity." But Picasso would have never used the word "purity."

"And to shift things about. Putting eyes in legs. And to be contradictory. Painting one eye in full view and the other in profile. People always make both eyes the same—have you noticed? Nature does many things the way I do: it hides them! But it has got to confess. When I paint I skip from one thing to another. All right. But they make a whole. That's why people have to reckon with me. Since I work with Kazbek, I make paintings that bite. Violence, clanging cymbals . . . explosions . . . At the same time, the painting has to hold up. That's very important. But painters want to please! A good painting—any painting!—ought to bristle with razor blades."

Most of these paintings I had never seen. Nor had I ever seen Picasso alone in that particular studio. I suddenly became conscious of my shape, of my military uniform, as if I were seeing myself. I also became conscious of Picasso's weird appearance, to which I had paid no attention until then: his raincoat, which was too long

and looked like a studio smock; his little conical cloth hat; his eyes, unrelated to his mask. I had recently been shown an American film in which an actor plays the part of Death, who is also dressed in a raincoat; he keeps waiting in the same place for travelers who are all about to die in the same accident. Picasso was lying in wait for his next paintings. Those in the studio he seemed to have conjured up like spirits. He could have looked like a tramp, but he in fact looked like a sorcerer.

I had often experienced that feeling of *déjà vu* in the past. A sound of barking came in from the street.

"What does that mean: to work? To keep pressing on further and further? To make corrections? But how would you go about it? You lose your spontaneity. Matisse believes in stripping his work bare. When it comes to drawings, the first sketch is always the best. And there's nothing wrong with an unretouched painting. Nothing whatever.

"After all, you can only work against something. Even if it's yourself. That's very important. Most painters make themselves a little cake mold; then they make cakes. Always the same cakes. And they're very pleased with themselves. A painter should never do what people expect of him. A painter's worst enemy is style."

"Is it also painting's worst enemy?"

"Painting finds a style once you're dead. Painting always wins out."

I thought that styles had played a huge role in the history of art. But I assumed he didn't want to talk about what we call styles (I remembered what he had told me about the Mask); he wanted to attack constancy—the cake mold. The fact remains that all his great rivals were obsessed with probing ever more deeply into their

art; he alone was possessed by a passion for metamorphosing his own—a passion that was strangely consistent with what he had told me about the Cycladic idol, and which I kept turning over in my mind: "There once was a Little Man from the Cyclades. . . . He believed he was making the Great Goddess, but what he made was a piece of sculpture, and I, here in Paris, knew what he wanted to make." Right next to me in the badly lit studio was that little man wearing a pointed hat—his brother. I asked him whether he remembered Van Gogh's extraordinary remark: "When it comes to life and to painting, I can perfectly well do without the Good Lord. But as a suffering creature I cannot do without something greater than I, something that is my life—the . . ."

"'. . . power to create.' He was right. Van Gogh was right, wasn't he? The need to create is a drug. There's invention and there's painting; they're not the same thing. Why is it always necessary to invent? In a thousand years, all that stuff . . . ! But what can you do about it?"

I had often heard him ask ironically, "What can you do about it?" or "How would you go about it?" The words were consistent with his wide-eyed mask. Yet there, in the half-light, he sounded serious.

"Van Gogh," I said, "wasn't speaking about posterity. I assume that what he called creating meant giving life to what would not have existed without him."

"That too. There have always been Little Men who wanted to sculpt in their own way, and no other. People cut them down. But they grew again. Like a woman's love for children.

"Later on, there were professional painters who made paintings, professional sculptors who made sculptures.

Luckily, all their works haven't survived; they would have reached the moon! Can you imagine it? All those works by professional painters! And they kept right on painting them: beautiful girls and ugly women, gods and nongods! They were always easy to make out, unfortunately. If they hadn't been, maybe they would have been better. . . . But, no, really—hideous! Disgusting. And then, from time to time—but without fail—there came a Little Man. Sometimes a tramp. Sometimes a rich man. Respected. A friend of the king's: Velásquez, Rubens. After them, Rembrandt: people say he was called 'the Owl'; do you think so? Rich or poor, but always a little mad, right? There were no women."

The sound of his voice was as disconcerting as it had been during his previous monologue. It expressed wonderment, surprise. He wasn't putting on an act, for he was improvising. But he was playing. A game that was more especially perturbing in that while he talked volubly, he made no gestures. His words corresponded only to the narrowing or widening of his eyes, which were so black, and visible in the half-light.

"And the prehistoric sculptors! Not quite men? Yes, they were. No doubt about it. And very pleased with their sculptures. Not at all professionals! But all of them wanted to paint or sculpt as they saw fit. Goya put his Black Paintings in his dining room so that they could be seen only by his friends. Do you know what I sometimes think? It amuses me: I'm superstitious. I think that each one is always the same Little Man. Ever since the cave paintings. He keeps returning, like the Wandering Jew. Your guys in India, do they believe that painters are reincarnated as painters?"

"It depends on their worth. For the most part, no."

"They don't know a thing about it. Painters are necessarily reincarnated as painters. They're a race in themselves. Like cats. More than cats. On the one hand, there are all the images that people concoct. Piles of them! Huge piles of them! Even huger piles of them! Mountains of them! Museums, private collections, Grand Rapids furniture, kitchen calendars, stamps! On the other hand, there is the Little Man. All alone. He watches the professional painters. He waits until they've finished. But they never finish. So he makes a comeback. He returns. He returns again. Maybe it's me—how do we know? He loves bullfights, naturally. . . ."

In spite of the fact that he was improvising with words, I believe he was talking about a character to whom he had given some thought. (And whom I discovered in the transformations of another inspired individual, the one in *The Painter and His Model*, affectionately described by him as "that poor guy.") His touches of humor in no way obliterated the sarcastic grandeur of the little ghost laden down with the power to create— like Santa Claus with that pack on his back—and who for centuries has been making his way through the eddy of useless images whirling about in the wind of death, with the relentlessness of motherly love.

"And what if several Little Men happen to exist during the same period?"

"It would be by mistake! There are always mistakes, right? In the opposite sense as well. Sometimes he just goes away. He believed that Derain was a great painter; he saw how the wind was blowing; he left. Each and every time he changed his manner of painting. Occasionally even during one lifetime. Never as much as I have. But he's well aware of the fact that, basically, one

always deals with the same things: painting, death, life." His irony grew fainter. He stopped talking.

I remarked: "You once spoke to me about the theme of death in regard to Goya's *Shootings of May* 3. When . . . when did you last portray a pregnant woman? Was it in 1905 that you did *The Embrace*?"

"1903."

"Birth and creation are perhaps as profound and disquieting as death—and for the very same reasons . . ."

"I'll come down with you; I'm going to Saint-Germain-des-Prés."

As I walked down the extremely dark stairway he was there behind me, again talking in his joking tone of voice: "I forgot to show you my plates. Did they tell you I made plates? They're really fine." Then, quite seriously, "You can eat on them."

We parted company on the sidewalk. It was a beautiful night—just as beautiful as the time Max Jacob had first shown me the Bateau-Lavoir berthed in a summer night: the trees; the street lamp in front of Juan Gris's window; not a soul in the small square, which was as intimate as a dream. My car took off. And neither Picasso nor I knew that twenty years later I would organize the largest exhibition of his works ever. Nor that three months after his death the Fondation Maeght, situated quite near Notre-Dame-de-Vie, would make the very first attempt at an embodiment of the Museum Without Walls—within which he would have found almost everything that had made up his own.

# V

A T  S A I N T - P A U L - D E - V E N C E  T H E  P A G O D A
rooftops of the Fondation Maeght*—the only French
foundation that can compare to the great American
foundations—rise over the Renoir trees. One night in
1964 I had inaugurated the Fondation, but it had been
too dark outside to see it. On a level with the ground,
Giacometti's vaporish statues quivered in the shadows;
Miró had planted the horns of his devils, and the pitch-
fork straight out of his ingenuous hell, into the firma-
ment of Provence. There they were. The little girls who
had once brought me the keys to the Fondation on a
fine crimson cushion were now married.

The exhibition: "André Malraux and the Museum
Without Walls." Lots of documents concerning me—
books, photographs, and so on. I knew I wouldn't have
the time to look them over. But no matter. I was of the
same mind as Picasso when it came to his exhibitions:
all that's about a guy who has the same name as mine.

I was handed the catalogue. A profusion of famous
paintings: all the greatest French painters were repre-
sented, and in the rooms devoted to paintings of the

---

* Conceived by Marguerite Maeght and her husband Aimé, the re-
nowned Paris art dealer who made a gift of the Fondation to the
state. The building and gardens, designed by the architect José Luis
Sert, were under construction from 1961 to 1964. Malraux's "Mu-
seum Without Walls" exhibition opened on July 13, 1973. (Tr.)

past were one of the last Titians, an El Greco next to a Tintoretto, as well as Poussin and Velásquez. Sculptures from India, China, Cambodia, and Sumer. Very beautiful fetishes, masks from Africa, initiation helmets from Oceania. The five regions of the world. The great museums, the Empress of Iran, the Japanese government, private collectors—all had sent their major works. The *Head of a Prince*—either Darius or some other—in lapis lazuli. On the third floor, alone in a room and watched over by its curator, was the Far East's *Mona Lisa*: Takanobu's *Portrait of Taira no Shigemori*.

It was not the Museum Without Walls, for the Museum Without Walls can exist only in an artist's mind. It was not its treasure-house, because its treasure-house consists of the most important works of mankind. The real treasure-house was the film shown by the Fondation Maeght during the exhibition, in which statues from Buddhist grottoes alternated with those from our cathedrals. There were, however, a few masterpieces of Asian statuary. And, above all, something that no film could ever boast: a secret confabulation among the works, and also a sense of their materials, their textures, their true voices. The *Penelope* looted from the Acropolis and held captive in Persepolis, and the *Serpent-King* from the Musée Guimet,* were whispering together, as were one of Delacroix's most beautiful sketches and the *Kacyapa* from Lung-Men; Manet's *Berthe Morisot* and the Beauvais *King*; Rouault's *Worker's Apprentice*, one of the major portraits of this century, and Chagall's *In Front of the Painting*; Cézanne and Van Gogh; Braque and Picasso.

* The French national museum (since 1945) of Asiatic arts, founded in Lyons in 1879, and then moved, in 1885, to the Place d'Iéna in Paris. (Tr.)

That particular Museum Without Walls was the reflection of merely one life: I mentioned the above works, or works akin to them, because I happened to come across them during my lifetime; another traveler would have mentioned other works. Moreover, it was only one man's Museum Without Walls. Yet four-fifths of it corresponded to that of any artist today—similar to Gallimard's Bibliothèque de la Pléiade, even though every writer and, indeed, every reader adds to it in his own way. Picasso was quite right when he said, "it could actually exist . . . a small one." And the fact that it did actually exist at the Fondation was just as disconcerting to the viewer as a performance of *Macbeth* or *Le Bourgeois gentilhomme* would have been to someone who had read all the famous plays but had never gone to the theatre.

As I walked about I discovered a few projects I myself had organized: André Masson's designs for the ceiling of the Théâtre de l'Odéon; Chagall's, for the ceiling of the Paris Opéra.

Dialogue between Khrushchev and General de Gaulle in the presidential box. Khrushchev, nice and plump, pointed at the ceiling: "Do you like that?" "Did they tell you that the man who painted it is a Russian?" "That makes it even worse! A White Russian, obviously!"

The first watercolors Braque had painted for his mosaics that decorate the Faculté des Sciences; Picasso's *Reaper*, which had been intended to commemorate Baudelaire's *Fleurs du mal*. In the days of General de Gaulle . . .

I still hadn't come across any examples of Impressionism or Realism. They are also missing from Picasso's personal collection. (It wasn't the Realism that appealed to Picasso in his rustic Le Nain, ponderous as a caryatid.)

Yet I was sorry that Courbet's *Portrait of Baudelaire* was missing. In the room I had entered—and, indeed, throughout the exhibition—Realism was exemplified only by Velásquez. But here were some Fauves. Monet had thought he was seeking to capture the moment, whereas he had in fact been seeking to give a new power to color—a power that was to influence our entire century. But there were no Monets here. Nor are there any in Picasso's collection. The saints acting as intercessors were, as in Mougins, Cézanne, Van Gogh, and the Douanier Rousseau.

In the room devoted to modern painting: a court consisting of France's greatest masters and presided over by a huge canvas by the Douanier Rousseau—a haunted forest, a tiger, a screech owl, a sunset. I thought of his paintings in Mougins and at the Grands-Augustins studio, and of Picasso's "Old Rousseau wasn't a better primitive painter than the others, but he was a colorist of genius who happened to be a primitive. The fact that Goya was a genius doesn't mean that Spanish painting in his time was any good, right?"

I remembered the first Biennale in Paris. I had just become Minister of Culture. Only painters thirty-five or under were accepted, and were chosen by the juries from their own countries, not by the French. The Soviet Union and its satellites, India, Formosa, Japan, a few regions in Africa, Latin America. A large contribution from the English-speaking countries. For whatever all that was worth. But the paintings on exhibition came from all over the world. Hordes of young painters, multi-colored and long-haired, carefully looked over the other painters' canvases or the earliest "defaced and shredded posters," the most insidious of readymades. All the trends

of the day were represented: geometrical abstracts, either expressionistic or lyrical; free-form *tachisme;* Neorealism and Neosurrealism; Socialist Realism; even action painting. In front of the entrance to the Musée d'Art Moderne a machine by Tinguely was wandering about threatening the visitors with its jerky movements and printing strips of paper which it threw in their faces. The major trend: free-form aggression. The art of the future was showing its teeth.

"I saw a lot of the latest things take off, from the Nabis* to the *tachistes,*" said Picasso, flipping through the catalogue photographs. "They never made it. There used to be professional painters who painted to please the eye—pretty stuff; now there are professional painters who only paint to displease the eye—hideous stuff. Pleasing the eye or displeasing the eye—there's not much difference, right? Another thing: we used to have a taste for cast-off objects. I still do. Now they have a taste for rubbish. Are they putting us on? Easily said. It needs thinking about. They'll end by wanting to burn paintings. Painters have felt like doing that for a long time. . . . Freedom! It weighs more heavily than one would think."

The visitors were collecting around some few paintings scattered throughout the room which had come from throughout the world—Morocco, Yugoslavia, India, Mexico—to look, not at the works of the abrasive painters, but at those by the Sunday painters. Primitive painting from every continent had finally become legitimate, side by side with painting that was not meant to gain recognition until the future. It had replaced figura-

* A group of young painters around 1890, the most important of whom were Maurice Denis, Bonnard, Vuillard, and Sérusier, whose aim was to regenerate painting. Their first leader was Gauguin. (Tr.)

tive painting, which was dying out because research in that realm had come to an end. I had once said, "Whatever the fate of the new schools, painting has now gained its freedom, and it will be a good long while before painting loses it again! . . ." That was over fourteen years ago.

I admired the fact that this Fondation Maeght Museum Without Walls began with the Douanier Rousseau, and with a fight between a wild beast and its prey. Rousseau had discovered it in the Paris Museum of Natural History. Stuffed. Yet in Crete I had been shown pieces of silver struck with that same fighting motif. It also appears on the capitals of Romanesque columns—and, according to Focillon,* goes back, through Mesopotamia, all the way to prehistory.

There were also modern paintings in other rooms; most importantly, Picasso's painting dedicated *To the Spaniards Who Died for France*, as well as a crucial drawing for his *Weeping Woman*, and *The Charnel House*. We saw them as we walked through the rooms devoted to the ancient East and to Africa. What other European foundation could have assembled works by Manet, Daumier, Cézanne, Van Gogh, Braque, Kandinsky, Chagall, Masson, Fautrier, Balthus, and Picasso, together with the Sumerian *Great Singer* and the Romanesque Beauvais *King*?

How was it possible to see everything at one's leisure? I would have to return. To the right of the exit door,

* The distinguished French art historian and aesthetician Henri Focillon (1881–1943), professor at the Sorbonne and at the Collège de France, came to the United States in 1939 as a professor at Yale University. (Tr.)

Braque's *Chair*. Had he thought of Van Gogh's *Chair*? That had once seemed to me an ideogram of the name Van Gogh. And also the ideogram of a chair. Which Braque's canvas still is; but Van Gogh had looked at a chair as a painful appendage, whereas Braque saw it as an arabesque on a palette that was yet unknown. Color triumphed over the object and seemed to triumph even over the individual; painting had successfully carried out its coup d'état. Braque undertook one of his major canvases, *Landscape with a Dark Sky*, confronting Van Gogh's *Crows*, which had been painted a few days before he died, and which had rung the knell of his passing. Braque took over the birds and the long yellow wheat sign, but substituted a black sky for the intense sky. He also took over the abrasive sunflowers— seemingly wanting to pacify them. It was as if, at the time, he had expected painting to bring a form of peace more powerful than death.

On the other side of the door, Chagall's *In Front of the Painting*: an intensely black crucifixion surrounded by light-colored figures, in front of which stands the painter—a fanciful sort of animal—holding his palette and giving the impression of being the enchanter of the exhibition.

And there, in person, was Chagall.

He had started with the last room of the exhibition and was working his way back to the first, having already seen the Asiatic art.

"To think that men managed to invent all those forms!" he said with dreamy astonishment.

Picasso's astonishment was very like his devil's; Chagall's, very like his angels'.

"Our Spaniard always criticizes me for painting angels; it's only because he himself hasn't any!"

They were no longer on speaking terms. Picasso had indeed criticized him for his "folklore"; but with Matisse dead, he had considered Braque and Chagall as the two greatest living colorists.

"Painting is color, the chemistry of color. . . . But what is it exactly? I don't know. . . . You're the one who knows, not me."

Almost the very words of Picasso, who used to say, "It's impossible to know . . ." That type of innocence was clearly a game. Picasso had carried his to the extreme of irony; Chagall's was of an affectionate nature.

"It's merely a question of knowing how to use it," I said. "You're rather good at that."

"All these forms! But note that when it comes to color, nothing much has been invented . . . Really very little, until the Venetians."

"Don't you believe that color changed when Europe invented shadow?"

"If Delacroix came back to life, he'd be more surprised by us than by anything the scholars ever discovered in the past! Except for color. In Asia they have no ringing tones."

What he said was true, and would have seemed even truer had there been a greater selection of Asiatic paintings. Clearly, in painting, as in music, the concept of a large orchestra is purely Western. Ever since we conquered the world, there has been no chromatic invention—either in harmony, dissonance, or stridency— outside the West. I quoted him Picasso's bitter words: "Color weakens a painting."

"Of course: his best paintings are monochromes."

"So were Leonardo's. Even the *Mona Lisa*. And Goya's Black Paintings."

"Ah," said he humorously, "what a pity that so great a genius as our Spaniard has never really painted!"

"You know," he went on, "I'm sorry that the Fondation didn't manage to procure one of the late Monets."

"I'm sorry about that too. First of all, because I rather like them, but also because even Monet's earlier paintings would have shown quite brutally that Van Gogh and Cézanne, without altogether realizing it, expected painting to have another kind of power—in fact, your own. But I wonder what you'll think of the stridency of the art from the New Hebrides. Theirs is the only tribal color that truly is strident. When I hung a Matisse above my tricolored fetishes, it looked like a Persian fresco."

Chagall and I parted and went our separate ways. From the next room on, it became obvious that Western painting had given new life, not to other painting but to sculpture. Yet I was still thinking of our conversation. Among the paintings I had just seen, Picasso played as large a part as he had in the art of this century. However, although unequaled as an inventor of forms, he had never been a great inventor of colors, whereas the school of Paris had held its own with the schools of Venice and Flanders through its use of color, the least rational factor in painting. So how different this century would have been without Picasso! Chronologically: Rouault, Matisse, Braque, Chagall . . . But the Fondation Maeght—which had become the embodiment of a small Museum Without Walls, where chance played some part—kept doggedly repeating the word "sculp-

ture." Beyond the room devoted to modern art, it was clear that sculpture constituted the past of mankind, and painting only one period—which seemed all the more recent in that I saw no frescoes. One doesn't find many of them in the real museums. But if here I had found images of Tutankhamen, his feet nibbled away by rats, and images from Tun-Huang, Ajanta, and Nara, I would have found a world of all the great religions that was more akin to the world of Sumer or Thebes than to that of all the admirable European paintings most carefully assembled. So many years as against so few centuries! For the prehistoric bisons are also consistent with the sculpture of the early ages, and not with Velásquez. . . . The Museum Without Walls abounds in everything that is farthest from us, both in time and in space, from Lascaux to the New Hebrides—from magic to magic. Overrun by sculpture, its art rises from the invisible.

I then came upon an entire wall of Goya's *Caprichos*. Obviously I could hardly have had a request put in to General Franco for Goya's *Saturn*—which in any case he would never have lent us.

Because of the Spanish Civil War, Picasso spoke more to me of Goya than of any other painter. Goya had surely known that he had used colors and engraving in ways that no one else had ever done before him, and that what he had extracted from them, above all, was his very own version of the supernatural. Had he known that he would gain recognition as the prophet of the irremediable? And how could he have sensed that, beyond the irremediable itself, his tortured creatures would bring us a nocturnal world to which he gave expression without knowing what stars it dragged along

with it? I had no clear understanding of the profound paroxysm of mankind, only one aspect of which is revolution; dramatic individualism had contributed a haunting theme—one that was perhaps a harbinger of the death that was to rise up over Napoleonic Europe—the theme of prison. Used by Goya, Piranesi, Sade, the Gothic novel . . . Picasso had replied: "Have you noticed that painters never go to jail? Because they know they'd be kept from painting. Still, when Goya came to Paris he didn't go to Delacroix's; he went to Horace Vernet's.* Funny isn't it?" This conversation had taken place after the war, at a time when we were faced with the shadow of the Hiroshima mushroom, the corpses Alain Resnais had seen in extermination camps, and what artists called the invasion of fetishes. It was a time that called for Goya. It got Picasso. In relation to *The Shootings of May 3*, even *Guernica* became a part of the heraldic spirit. Picasso, who had invented so many things, would not have invented horror. At the Fondation Maeght, looking at that challenge to the world, *Los Disparates*, I was dumbfounded by the fact that Goya had not foreseen the world of Romantic art, having so greatly contributed to its creation. "Ugliness is beautiful." Why had those who formulated that rather witless declaration (which, as it turned out, pertained

* The most famous member of a family of painters, Horace Vernet (1789–1863) himself painted over 800 battle scenes, landscapes, historical subjects, and portraits, including those of Napoleon I and II, Louis Philippe, and Charles X. Also a lithographer and engraver, he was appointed director of the French Academy at Rome in 1829. A successful Classicist, Vernet was obviously the antithesis of his contemporary Delacroix, who, as leader of the Romantic school, radically departed from Classicism, and throughout his career was attacked by academicians and critics. (Tr.)

more especially to the art of literature) put the blame on Goya? His art had derived not from ugliness but from Rembrandt. And horror is something quite other than ugliness; no one ever made caricatures of torture. If he had decided to attack beauty at that depth, it was because young artists were to brandish his art, along with that of his master, Rembrandt, and that of Michelangelo, in the face of the triad Poussin-Raphael-Classical antiquity. Classical antiquity, not austerity of style or archaic art: Europe still believed in Rome.

Romanticism substituted the sublime for beauty. Now beauty resembled beauty, and Poussin resembled antiquity, but Rembrandt resembled neither Michelangelo nor Goya. The masters became the prophets of an unknown god; down with delight! Artists delved into the past and discovered an art as free of beauty as it was of painting's limitations—a power our painters don't willingly talk about, but which they all know and which imbues all the great works with the violence and contagion typified by the Prophets.

That scattered god, rather dimly reflected in painting but radiant in poetry—and because of which Victor Hugo considered Beethoven, and not Goethe, as characteristic of the German spirit—has no special room devoted to it in any museum, although it held sway in the memories of all artists. It is a mixture of the sublime, the superhuman, and the limbos which link Goya to Bosch to Piranesi. The Museum Without Walls, too, welcomes its works and doesn't assemble them. There at the Fondation Maeght I saw hardly any. Yet just a few hills away from those horned roofs was the presence of Michelangelo in his exiled *Slave* at Notre-Dame-de-Vie, and that of Rembrandt as well, in his *Musketeers*. And

right in front of me Goya's engravings were contributing their magical aquatint backgrounds.

The aquatint, like the background of *Olympia*, repudiates illusion. And which of Delacroix's works were on display? His finest sketch. In the masterpieces scurrying round me the substitute for beauty was no Mount Olympus of the superhuman but, rather, art, which is far more enigmatic. In the next room, although Michelangelo was not encountering Rembrandt, El Greco was encountering Chardin, just as shortly before, Cézanne had encountered Van Gogh . . .

Stained-glass windows. I don't understand why the stained-glass window, which awoke and fell asleep in accordance with the passing of day, was ever forsaken. . . . Art preferred its own light. But the stained-glass window—quickened to life by the morning and obliterated by the night—had brought Creation into a church to make it one with the faithful. The stained-glass window finally yielded to painting when it welcomed the innovation of shadow—and died from it. It took Chagall to invent a gradation in the intensity of colors—six hundred and fifty years later. And it took over five hundred years for painters to rediscover the arbitrary element in mosaics and stained-glass windows, which by their very nature seemed protected from illusionism. Will Schöffer's plans for luminous towers recapture the same life given by the southern sky to those two small stained-glass windows from the north, in the same way as our painting has recaptured the arbitrary? The electricity that lights up the towers at night, necessarily—would bring to an end the metamorphosis of God's light. When stained-glass windows vanished, clocks began to reign over the churches.

*The Tempter* from the Strasbourg cathedral, where Delacroix, at the end of his life, discovered Gothic sculpture. The head of the Beauvais *King,* his eyes closed, one of the peaks of the early Gothic art we used to call Romanesque.

Attributed to the twelfth century. In that century there were no comparable effigies. Boxwood figures with savage but smooth planes, their eyes closed, not lowered like those of the Khmer Buddhas, but suggested by horizontal lines corresponding to that of the mouth. Reminiscent of the Royal Portal of Chartres, whose heads are almost like those of the common people. One of the most ample styles, which served the ends of one of the highest forms of spirituality. And which violently drew attention to what was seriously missing from the exhibition: Romanesque sculpture.

No other Christian sculpture moves us so deeply. It is what mediates between us and the sculpture we have brought back to life (all but the Egyptian), for it is the sacred art of the West. The artists of the time discovered it when they discovered that the arbitrary nature of certain forms, later believed to be folk art, was in fact an expression of the supernatural. Like Negro art. And it is the only sculpture in the West that derives from the unutterable, from "the evidence of things not seen," according to Saint Paul.

What, in my imagination, did I substitute for its missing delegates? Figures from the cathedral in Autun? Most especially, the Moissac tympanum, with its Christ in Majesty and its Apocalypse, with the Elders in their barbaric breastplates playing small musical instruments. I thought back to the fierce birth of Romanesque art,

to the years during which "no one dared plough any longer," they were so gripped by the profusion of all that was eternal. To the path it took, from lonely seclusion to "the prayer for lighting fires." To its premonition of the world of God. Its will to unleash the sacred through symbols of the inexpressible; the spirit of incarnation which transformed the Byzantine mystery into communion and made Romanesque sculpture into an art that was foreseen during the years when the Christian peoples, who were to invent the Crusades, suddenly converted to their own religion. No art has ever so powerfully conveyed both the unknowable and love, which was precisely what Saint Bernard thought when he angrily shouted at Abelard, "Was it in vain that the Wisdom of God hid what we are unable to see!" Indeed, Romanesque sculpture owes the forms it gave the visible to the forms it found in the invisible. The Autun cathedral's vineyard workers are by no means an interpretation of living men. They are signs that correspond to the Christ of the tympanum; as far back as the ninth century, Scotus Erigena spoke of "perceptible signs." But it was sculpture alone that gave this Christ perceptible form.

A powerful expression of that phenomenon is the Beauvais *King*, who—like his fellow creatures—symbolizes one of the books of the Bible. He bears within himself the reflection of Christ. I was sorry that no group of Romanesque works was represented; but when the Museum Without Walls becomes an assemblage of actual art works, it encounters the same obstacles as any real museum. The Autun and Moissac tympana, or the Royal Portal of Chartres, could no more be brought into the Fondation Maeght than into the Louvre. The sacred

37. The Beauvais *King*.
End of twelfth century.
Beauvais Museum.

arts introduced scenes and characters into the sacred, but its style seemed to emanate from the buildings or holy places. Museums—even those without walls—can merely procure photographs of cathedrals, caves, grottoes, and hypogea. Yet what excitement there is in Romanesque sculpture, which invented not only the chitinous eyelids of the Black Virgins but the wonder-struck eyes of the Autun angels! When had sculpture ever before portrayed innocence? Moreover, the Beauvais *King* acted as a mediator for the Sacred in Majesty—for that of Byzantium, India, and the early periods of Buddhism. I should like one of the barbaric capitals of Saint-Benoît or Payerne to do the same for the sacred element in the tribal arts. Shepherds, along with the kings . . .

The great Parthian King of Hatra, sent by the Baghdad Museum. An exhibition of the Parthian works found in Iraq would be more revealing than almost any exhibition of this century. After Iraq was conquered by Macedonia, and during the struggle against Rome, it was the Parthians who, although in Iranian dress, fought

to the striking of gongs, and upheld the East. Did the women of the Persian court, veiled like those in Constantinople, know Hatra's barbaric Semiramis, not only their ancestor but the ancestor of the Eastern forms of the sacred that were to fill the Byzantine Empire?

I had told Picasso that the true place of the Museum Without Walls was in the mind. Yet just as the numerous works in private collections are forever thought of by their owners in connection with the places where they had been bought, so the works I was looking at evoked the places in which I had first seen them. The lapis-lazuli *Prince* evoked the bas-relief of Darius, which brands the Zagros Mountains in the same way as we brand bulls; the wind of the Steppes had drawn its moiré patterns over the high grass, so very like that which had once witnessed the Great King as he passed through, and an Iranian child had brought me fairy roses at the foot of the bas-relief bombarded by caterwauling eagles. It was in Baghdad that I had seen the colossus of Hatra. In honor of the royal wedding everything in the cellars of the Moussoul Museum had been brought out: an accumulation of effigies unknown until then, which had been found in the Parthian military capital—mothers of the Sassanians' effigies and those of the Queens of Palmyra, which had continued the hieratic style of the Achaemenides: sovereigns of decayed polychrome, trinities bristling with scorpions. The catalepsy of the eternal East filled a huge shed, under Iraq's Surrealist paintings: burning giraffes and melting watches, ex-votos strangely offered up to the gods that had held back Caesar and defeated the legions. Right in the middle were life-size photographs of the Queen and the King, who has since been assassinated.

The first time I went to Persepolis, the captive *Penelope*, stolen from the Acropolis, had not yet been found. All along the gigantic stairway, lizards playing lizards' games were leaping over the spears held by the Guard of the Immortals.

A few pre-Columbian deities. The *Plumed Serpent* from the Musée de l'Homme. We were still awaiting the obsidian skull from Mexico. I was sorry not to see any Toltecan axes, or terra cottas from Nayarit, or examples of Aztec astrology. Like Negro and cave art, the pre-Columbian arts were still waiting at the door of the Louvre. After all, Aztec sculpture belongs as much to history as Sumerian sculpture; but we think we know Sumer because of the Bible. And pre-Columbian art, like African art, owes more to the spirits than it does to the sacred. (Buddhism and Hinduism have been welcomed by our cathedral statues.) It introduces us to the domain of the night and of blood—a domain more of the night than of the blood in which the monsters and skulls had foundered ever since we had become more acquainted with them. Despite all the hearts rooted out that the sun might rise again, the inexhaustible discoveries in Mexico have tended to draw that type of art in the direction of mystery, not of atrocity. What do they mean, those gods of death that are not merely protecting gods? And what of Coatlicue, the beheaded goddess bristling with serpents, mother of the gods— mother of the river of deaths and births, like Siva? Still, despite the majestic Pyramid of the Moon, and despite the Sacred Way worthy of Erebus, certain Mexican forms have entered the Museum Without Walls, just as Goya entered the Louvre. Forms of inimical depths . . .

Funerary deities for women who died in childbirth, a nocturnal serpent with a crown of stars, altars of skulls abandoned in wild amaranth . . . I recalled the words of some Spaniard who once said, "After having taken the capital city, we arrived in great Teotihuacán, which has long been in ruins . . ." While it was being restored I had seen djinns of dust wandering down the Way of the Temples with the swishing sound of whirlwinds, like those in Sheba. A pity there were no idols from Sheba at the Fondation! But they would have been put together with the works from the East. What separates the pre-Columbian arts from the other historical arts, and explains why their admirers often also admire African sculpture, is the fact that the phenomenon of rebellion in art exists almost nowhere except in the West.

Here was a kachina, on loan from the Musée de l'Homme. Kachinas are the dolls of the Hopi Indians: they enable Indian children to identify the spirits invoked during the magic rites. I have a whole collection of them in some warehouse or other. I had discovered that art form in a dark showcase in the old Trocadéro with the help of a lighter. Deities of some kooky world, vaguely akin to the Managers in *Parade*, who had houses on their heads (the Hopi dolls have clouds) and wore costumes similar to geometrical butterflies. I had had one of the kachinas reproduced in *Les Voix du silence*; the American edition was shown to some Hopi sculptors who were working for a museum. When I accompanied the *Mona Lisa* to the United States I found that my publisher had boxes full of kachinas, sculpted in the traditional manner, given him as "thanks from the gods." My own were much older. I had bought

38. Dogon art. Mali. Antelope mask. Nineteenth century.
Musée de l'Homme, Paris.

them at a shop that belonged to the Indian reservation, in Hollywood, where I had gone to speak out for Republican Spain . . . I once asked André Breton, who was looking them over, "Do you know where the religious center of the Hopi Indians was?" "In Nevada, I think." "No, in Los Alamos." And since it was in Los Alamos that the Americans were then working on the atomic bomb, they had chased out the Indians. "That doesn't surprise me." he replied, with his look of a discouraged medicine man. "I don't believe in coincidences: magic takes over from magic."

What has become of my kachinas?

The next room was filled with Negro art: the large mask from the Zurich Museum; a few of its ancestors; the Dogon mask from the Musée de l'Homme, which I had had reproduced as one of the extreme forms of the African spirit; and the elongated fetish—also a Dogon image—that resembled a branch, like the angels on the tympanum of the Autun cathedral. The day before I had stood beside President Senghor and inaugurated the magnificent Dakar Museum, which houses the mask of Vlaminck, the ambassador of African sculpture, I had seen the Queen of Casamance, followed by her sacred cat under a luminous snow of kapok flakes and in front of the sacrificial tree streaked with the blood of young goats. It was at the time France was proclaiming the independence of her colonies in Central Africa. The "heart of darkness" was turning into a feast. Masks were hopping over the ritual fires; lion-men, their nails extended by Gillette razor blades, and wrapped in skins complete with manes, were fighting in front of the fascinated crowds from Chad.

One of the directors of the Fondation Maeght told me, "Of all our rooms this is the one that most impresses our visitors"; and he was clearly astonished, for he lived among modern paintings, and that type of art was as familiar to him as it was to me.

Yet right there was the crucial dividing line. Negro art will enter the Louvre along with Cubism. Perhaps for the Cubists it will merely be a matter of adding a few rooms to the museum; but the rooms for Negro art will call into question those devoted to the ancient arts, which are organized in accordance with the evolution of our history. African art has no history. And no architecture. And almost no paintings. Phantom empires, like the nomadic empires of Asia. True, Benin, a veritable kingdom, had melted bronze and woven velvet. But its art can hardly be called African, and surely not Negro. The art of the savannas and forests is foreign to cities, and as foreign to sacred grottoes as it is to cathedrals. All the other rooms of the Fondation already are or will be part of the Louvre, of which the Musée Guimet is gradually becoming an annex, like the Jeu de Paume. "Ladies and gentlemen, just a few steps more and you'll see Manet and Khmer art." The tribal arts will be a good deal more than a few steps away, and so will prehistoric art—those arts sans history. . . .

Numerous collectors of the greatest sculpture known to man still consider African sculpture as folklore. It was thanks to Cézanne that the austerely stark figures of all the great religions made their way into the Museum Without Walls: the early ages of China and India, and the resurrection of the biblical East, Thebes, and Babylonia. He also interceded for the monumental Chaldeans, the *Gudeas*, in which there was no longer any trace of ant-eyed idols. The power that gave impetus to all of

modern art did more than revive a specific realm of forms. What is there in common between a fiber mask, a Sardinian idol, a Mexican death's-head, a Dogon ancestor, and the Lespugue *Venus*? Hasn't modern painting revived a power similar to its own—one that drifted about for thousands of years, but not necessarily throughout history—the power possessed by that Little Man from the Cyclades so dear to Picasso, that minute sorcerer of our museums to come, just as Cézanne was the sorcerer of the "austere style" of the West?

In his *Meninas* Picasso showed respect for Cézanne, but there is no trace of Cézanne in his *Little Girl Skipping Rope* or in his tarots. Those arbitrary and persuasive creations restored life to the Oceanian masks and the prehistoric Venuses, just as Cézanne restored life to Romanesque sculpture, to the sculpture of the Chinese grottoes, and—along with Seurat—to the frescoes of Piero della Francesca. Cézanne's genius had manipulated the past in accordance with his own unity, whereas Picasso ransacked it in accordance with the manifold possibilities of his own power. He was escorted by all our great masters, whose works escorted African sculpture to the art dealers: the early Derain, as well as Vlaminck, Matisse, Soutine, Chagall, Rouault, and Modigliani. There, at the Fondation Maeght, Negro art was exhibited for the first time amid the art of our Middle Ages and that of China (not far, either, from Corot and El Greco), and no longer exiled between the Eskimos and the Oceanians.

I had thought that the Museum Without Walls had assimilated the tribal arts as a more barbaric form of the other historical arts: from the Gothic to the Romanesque, from the Romanesque to Sumer, from Sumer to Africa . . . Yet the resurrection of the early ages corre-

sponded to our Western sensibility, whereas the discovery of Negro art, for which our artists had been responsible, affected them alone over a long period of time, in a way that no other art had done before. But they didn't discover it all at once. First came the stocky fetishes, which were somewhat jolly and vaguely akin to folk art, like Apollinaire's fetish: primitive art, funny little men brought back by humorous colonists. Then masks that were so dissimilar they might have belonged to several different civilizations. Then the old Trocadéro, the Dogons in the Galerie Paul-Guillaume, the population studied by the Croisière Noire expedition,* the albums, and the profusion of works from the Dakar Museum on exhibition at the Grand Palais. As early as the collection shown at the old Trocadéro, the plurality of African forms endowed that art with a virulent force, because those forms seemed not at all bound up with any common significance in the sense that historical forms are. Although people talked about Romanesque fetishes, our artists found that all the Black Virgins spoke the same Christian language; but when the Dogon antelope mask, which is more structured than any head by Zadkine,† was exhibited along with the nail fetishes,

* The name given to the first crossing of Africa by automobiles, organized by André Citroën and directed by G. M. Haardt and L. Audouin-Dubreuil. The expedition, made up of eight Caterpillar tractors, took off from the Algerian Sahara on October 28, 1924, broke up into several groups that went their separate ways, and came together again in August of that year in Madagascar. (Tr.)
† A French sculptor of Russian origin, Ossip Zadkine (1890–1967) studied in England, then settled in France in 1909. His works, largely carved out of wood or stone, are made up of convex and concave forms, with great emphasis on hollows, which accounts for the fact that some of his sculptures are often described as "transparent," despite their massive structure. (Tr.)

39. Photograph of Apollinaire's study.

painters were dumbfounded by their discovery of an inexhaustible inventiveness which they called the language of freedom. When one painter said, "Negro art is good because *il y a de tout* [there's a little bit of everything in it]," the freedom implied was expressed by painters in a play on words: they called it "Yadtou" art—the art of a tribe they had invented in order to name Negro art.

But that expression itself, as well as the discovery, was clear only to painters, who wanted to speak of unpredictable and persuasive forms on the same level as they spoke of the forms of Bosch's demons or those that Baudelaire called "viable monsters"—but viable only in the world of sculpture, and unimaginable as creatures in a world of fantasy. Like Picasso's tarots.

Their "viability"—which painters, although aware of their connection with witchcraft, considered aesthetic in nature—was determined by a power that differed greatly from the power responsible for the style of the early ages, and its expression took the form not only of round masks but of square masks, not only of massive ancestral figures but of pin-headed ancestral figures. The arts of the early ages, which were all religious in nature, had revived systems of forms. Gothic, Romanesque, Wei, and Gupta are the names of styles. The forms of the funny little men called fetishes were thought to be akin to those of folk dolls and folk sculpture. In contrast to the forms of all the great religions, they did not express the type of transcendency that art revealed in a way similar to music.

Everything changed when the plurality of African forms came to light: for the first time the discovery of an art was not the discovery of a style. African *art* was

discovered, not *an* African style. The art of the funny little men had been heedlessly called Negro art; but the antelope mask was spoken of as sculpture. (In the room of the Fondation Maeght where I then happened to be, and which was presided over by an antelope mask, the style of the funny little men was not even on display.) Europe was aware of a link between the masks and a supernatural with which painters were little concerned, more especially as it hadn't the prestige of the sacred; but Picasso alone *felt* it, and that is why he alone considered that Negro art was not restricted to forms: "Fetishes sense that things are not what people take them to be. . . . They're weapons." At the time, the ethnology of Africa was uniquely the province of specialists; the unconscious had not yet become the monster of the depths. Even if the tradition of those forms complied with the laws of medicine men, fifty art works from altogether different tribes—a mixture of masks with holes for eyes, and other masks with cylinders for eyes, and an ephemeral naïveté such as that of Picasso's fauns—reminded painters that men had invented the wheelbarrow before the articulated arm, and that the influence of certain figures on all the artists was not predictable, nor could it be considered legitimate. Negro sculpture compelled recognition when its multiplicity of forms made it impossible for us to see it as either a folk art, an inferior mode of Romanesque art, or a mode of Expressionism. Thus it promulgated the law that Picasso had understood: the right to what is arbitrary. Before our painting ever existed, and with altogether different purposes in view, Africa had discovered that creation is contagious. And painters were little concerned with witchcraft when they discovered the magic of creation.

But in this case witchcraft was creation. At the inaugura-
tion of Dakar's magnificent African museum a Senega-
lese sculptor had told me rather anxiously, "Our art is
terrific, but we are as far removed from it as your sculp-
tors are from Romanesque statues."

Next I saw a statuette from Easter Island, some masks,
and the initiation helmets I had loaned to the Fondation:
facing Negro art was Oceanic art. The vain attempts
made to contrast the two are understandable. At first
they had been lumped together; artists saw Oceanic art
as just another form of Negro art. The massive fetishes
from New Guinea were thought to be related to the
kings of the Congo; the axe-hewn masks found in
Astrolabe Bay—the whole stocky population of them—
were thought to be akin to African fetishes. A less tra-
ditional Africa is reflected in certain elongated figures—
like Giacometti's or Picasso's *Cretan Women*—and even
in the figures made up of hook forms. Hooks, not often
found in Africa, were basic to certain styles in Oceania,
where skulls were hung on them (the prolific art of
New Ireland would seem to have transformed Bantu
beams into praying mantises). The ritual headdresses
from New Britain, like the parasols of the Negro kings,
are attached to the sorcerers' shoulders by ropes and
large eye signs, which are also hooked and intended to
stand out against the sky. Headdresses, helmets, faces?
Let's say: the heads of spirits. The secret geometry that
so often gives shape to African forms vanishes when
fiber, tapa, or basketwork is substituted for wood. On
display from the Vitu Islands in New Britain was a
truncated cone of cream-colored fiber, with vertical
stripes of red and blue as decoration, set-in eyes, and
two spindle tips thrust through the nostrils; below, the

40. Art of New Britain. Vitu Islands. Tapa fiber mask. Nineteenth century. Museum of Ethnography, Budapest.

41. Art of New Britain.
Baining. Tapa fiber mask.
Nineteenth century. Museum of
Ethnography, Hamburg.

mouth, made of a match-stick fence, a gateway closing in the spirit. At least that magic candlesnuffer had a shape. But the mask from Hamburg was merely shaped like a gigantic moth, beneath which was a yawning, faceless mouth, with something like a tongue or a chin hanging from it. On display also was the art of small luminous feathers, dyed orange, like flowers from a coral tree, which went to make up royal helmets, war gods, and shields—an art that disregards structure altogether. Nothing remained of that which, in African art, recalls Cézanne's comment on cones, cylinders, and cubes. Color had already begun to come into its own. A great many Oceanic figures are colored, most especially those from New Britain; but I was right to have pointed out to Chagall that the New Hebrides showed a true knowledge of colors in their mummies, their recast skulls, their puppets, their tree-fern ancestral figures, and their initiation helmets adorned with spider webs. Chardin blue; vermilion and white; black, yellow, and orange; a tricolored palette with, here and there, a salmon pink

triangle—primary, flaglike colors, which would be no improvement on mere childish daubings were it not for the depths of their ultramarines, which are as rich as those of Chartres' stained-glass windows, and were it not for the tom-tom quality of their colors in general, compared to which our most violent canvases come to look like Caravaggios. The fan of freedom opened out and encompassed even crab claws and the proboscises of butterflies.

The initiation helmets dwarf the masks from Gabon, which have been so highly praised for their Japanese purity. . . . Today the Museum Without Walls welcomes all the tribal arts, even the Brancusis from the Caroline Islands, their heads shaped like tops—even the Eskimo-healer's masks, which are more contorted than the animals of the Steppes. But there is no equivalence for the discovery of freedom.

Thus what was astonishing at the Fondation exhibition was not the fact that one was viewing the tribal arts themselves but the fact that, thanks to contemporary painting, one was viewing them together with Poussin and Velásquez. We react just as strongly to works created by artists who never knew that art existed as we do to the most striking works undertaken with a view to being works of art. The Fondation Maeght's Museum Without Walls affirmed what had been suggested by the dialogue between reproductions: that our own civilization is acquainted with a world of art no other civilization had ever been acquainted with before.

A painting that could not be transformed into a *tableau vivant* used not to be considered a work of art. We have forgotten that at the time Taine was writing

his *Philosophie de l'art* he deemed the Byzantine mosaics in Italy childish and barbaric. "Imagine Theodora coming to greet Justinian on one of the platforms of the Barcelona station with a head like that!" As soon as the Tuscans discovered nature—not so they might go out into the fields, but in order to contrast it with the sacred quality of Byzantine art—everyone thought it obvious that the essence of artistic creation and that of Creation itself were one and the same. This was due to a persistent illusion as to what was the truth, an illusion similar to that which had been expressed for so long in phrases like: "When I see a clock, I tell myself: there was once a clockmaker," or "Man was born good." Truths of that sort are actually no more than feelings— and, to a certain extent, civilizations are defined by such "truths." When imitation—whether faithful, idealized, or transfigured—was maintained as a precept, the world of art was an annex of this world, and history of art was the history of its means for creating illusion.

Now, faced with the admirable Titian in the next room and the festivities of the doges and Harlequins that were recalled to our minds by Venice, the Sumerian sculptures of four thousand years ago, on loan from Aleppo and Damascus, affirmed that there was a world in which the *Great Singer* and Titian's *Saint Jerome* are fellow creatures. Probably a hundred years ago the *Great Singer* and the singer Ur-Nina were not thought to be identical, nor were *Saint Jerome* and Saint Jerome; however, a masterpiece was thought to be far closer to its model than it was to another masterpiece. Greece, which had allowed—and, indeed, proclaimed—that a statue of Aphrodite was in no way a copy of Phryne's body, would not have allowed that it be considered the

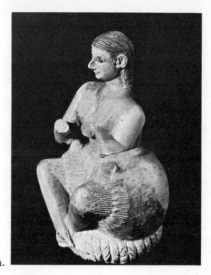

42. Mesopotamian art. Mari. The *Great Singer*. First half of the third millennium. Damascus Museum.

fellow creature of a statue of Darius or of Queen Nefertiti. What many civilizations loved in their art was the fact that it was a means of expressing their dreams; the Renaissance believed that its art and its dreams were brothers to those of Alexandria (which it confused with Athens), but not to those of Thebes or Persepolis.

Painters know that so-called artistic production (that of professional painters—according to Picasso, "Quantities of it! Mountains of it! Enough to reach the moon!") conveys to us all the clamor of the society from which it derives, and which it rather vaguely resembles, whereas the *Great Singer*, which is clearly Sumerian, resembles Sumer to the degree that plums resemble plum trees. Such quantities of useless images are the images of human beings who have become one in death—peoples who, at the Fondation exhibition, were replaced by their gods and their dreams, burdened down by the transitory, within which the Babylonian spider

of nightmares, so faithful throughout the centuries, weaves its web. But if every madman is an inherent part of his civilization, he is also an inherent part of madness itself; and if every nightmare is an inherent part of the person who sleeps, it is also an inherent part of sleep itself and of dreams. But in spite of recurrent Realism, which was rare at the Fondation exhibition, how is it possible not to see mankind just as inhabited by the procession of its creations as it is by the permanence of its dreams? From behind the masks of darkness, as well as from behind free-form paintings, by way of the imaginary—which was called the mythological when it brought Venus back to life—how is it possible not to glimpse the metamorphosis which, like some deity from India, plays with the reflections of what men have seen mirrored in the river of what they have never been able to see?

In the context of the Fondation's Museum Without Walls, with its colliding centuries, its horned-roofed buildings, and its pepper plants and bougainvillea, our painting of the past, from the great Venetians to Delacroix, was in fact that of Baudelaire's *Phares*, with a few additions: El Greco, Velásquez, Georges de la Tour, and Chardin; to them, one's imagination should also have added those painters who, in the days of Baudelaire, were called Primitives, and those still related to them, such as Grünewald, a contemporary of Raphael, as well as Breughel and one or two others. But we think less in terms of schools than in terms of the dialogue between our painting as a whole, on the one hand, and, on the other, all the sculpture created during the early ages of history or that outside history altogether; and noting what distinguishes one form from another, we think of

what inspired them. From the cave art to Picasso, via Titian and the kooky bronze Hittite—which, enlarged on the poster for the exhibition, came across as an idol— most of those forms had one thing in common, as did *all* the works on display: they were in no way similar to the forms that reflected outward appearances, and were in no way similar to outward appearances as such. Those artists who specialized in the sacred and who, rather than ignore "nature," subordinated it or scorned it, seemed to be dealing with a superworld—a truer, more lasting, and, particularly, a more significant world than that of outward appearances—a world depicted by their scenes but revealed by their style. The subject matter of the Autun cathedral's *Last Judgment* is Christian in nature; its style is sacred in nature. The divine element in Greek art and the faith embodied in Christian art play the same role, although somewhat less clearly: Athens discovered beauty as a style in the same way as our cathedral figures were to discover spirituality. And we become well aware of the fact that it wasn't Realism that followed upon idealization; it was spiritualization. The superworld of the unreal was almost as much a part of the Fondation exhibition as the superworld of Olympus or of the sacred. Our own superworld began in the room that began with Manet, but men are aware only of their predecessors' superworlds. If one wants to see an aquarium properly, it's preferable not to be a fish.

The gallery, which was the museum's ancestor, cared nothing for the shapeless past, but, like Poussin, did care for the "golden past," whereas the Christian spirit, from Moissac to our cathedrals, sprang forth without in any way emulating the past, just as, it would seem, Sumer, Egypt, the Buddhist or Brahminic grottoes, and

the tribal arts did. It was during the Renaissance that the past appeared on the scene; in the eighteenth century its art was called great art, and Chardin considered his painting an unworthy rival of antiquity. (Voltaire judged his tragedies superior to his *Candide*.) Delacroix, who was not quite so modest, was almost as blind. It was well after his death that Gothic sculpture replaced that of antiquity, but did not exert the same influence; and the art of the conquerors—Courbet and Manet—did not include sculpture.

In choosing one type of sculpture over another, we choose another past. At the Fondation exhibition there was no trace of Classical antiquity; at the Louvre the rooms devoted to Classical antiquity—and those rooms alone—are now devoid of visitors. Classical antiquity, not Greek archaic sculpture, not the "austere style": "We have chosen one Greece over another." The only empty rooms belong to the one civilization that was severed from infinity: the Roman Empire, which had been completely unaware that Byzantium would follow. . . . When, in the past, had a place ever existed in which we could admire Titian, Poussin, and Rembrandt together with the Sumerian sculptures and the fetishes?

On the evening after the opening of the exhibition, in order to illustrate a conversation between André Parrot* and myself—"Sumer and This Foundation"—it had been decided to compare that embodied Museum Without Walls to the Museum Without Walls of sculpture, which

* An archaeologist born in Paris in 1901, who was a member of the French School of Archaeology at Jerusalem in 1926, directed the excavations in Telloh and Larsa from 1931 to 1933, and in Mari from 1933 to 1957. Parrot became the French Secretary General of Excavations in 1958 and has written several major works, including books on Sumer and Assur. (Tr.)

had been given permanence on film: sixty famous images filmed on the walls of their caves or against those of their cathedrals. Within ten years that film and many others will be shown by all the important television networks and on videotapes; and our world of art will become as different from that of the nineteenth century as the Museum Without Walls is from the galleries of Classical antiquities. Perhaps the bulldozer has provided us with no more than an extremely large shovel, but the electronic microscope has surely provided us with more than an extremely large magnifying glass, because it forces us to discover things we were not looking for. Those very modern rooms in Saint-Paul suddenly resembled the old Western locomotive that had once lorded over Grand Central Station, for they signified not an end but a beginning. The Museum Without Walls does not multiply the questions posed by museums; it imposes its own. What had got its start in Saint-Paul—almost secretively, and despite all the festivities—was this: that one of the greatest of human adventures was being introduced into the minds of men.

"What exactly is a painting?" asked Picasso. "After all, an object and a piece of sculpture can be the same kind of thing. Well, almost. Sometimes. My glasses melted by the lava from Mount Pelée, my skeleton of a bat . . . But an objet d'art and a painting—never." I was imagining Queen Subad's ornaments as replacements for the Sumerian *Great Singer* (although it is now assimilated into Babylonian art), or medieval jewels as replacements for the Beauvais *King* and the secret presence of the Avignon *Pietà*; or . . . *what* as a replacement for the Persepolis *Penelope* (Greece left us so few ob-

jects)? Why not substitute gold pendants for Negro masks and Aztec gods, or furniture for all the paintings from Giorgione to Delacroix (actually, yes, there in Saint-Paul, painting began with the sixteenth century, like *Les Phares*)? They'd create the right atmosphere. Or substitute the most lavish costumes from every period for all the works of art? And what about the Roc-de-Sers *Ibexes*? For want of prehistoric crinolines, we could substitute a well-cut piece of flint. An instructive exercise, since for us art is precisely that which distinguishes the *Supper at Emmaus* and *The Three Crosses* from the Dutch goldsmiths' craft, and all the cave art from all the flint pieces—that which makes prehistoric and Sumerian sculptures the fellow creatures of Picasso's *Reaper*. Objets d'art belong only to the period during which they were made; works of art belong to our own period as well. Mostly, for the very good reason that they are immortal. In order to understand our relationship to art today, one must understand that it is because of art, and art alone, that the presence of the *Ibexes*, which is like the presence of living beings, is in no way related to the presence of a flint artifact (or of skeletons), even if that particular piece of flint changes the course of prehistory. The recent exhibition of the latest Chinese discoveries called upon us to understand by displaying them all in one place: on the one hand, bones, flint scrapers, and a photograph of the skull of the last Peking man; and on the other, the head reconstructed from the skull, photographs of prehistoric engravings, and the bronze horses from the tombs. One may be set to dreaming in the face of that *homo, sapiens* or not, who ironically appeared with no wisdom teeth six hundred thousand years ago to show us that the hominid wasted a hundred

182

thousand years before ever inventing the trap. . . . But the skull was used to reconstruct the head; and no one ever used the Lascaux paintings to reconstruct bisons, or other paintings to reconstruct *tableaux vivants*—with the exception of those people who don't even know what painting is about. The skull is a witness to one stage of sculpture: it teaches us; the bronzes speak to us. And to each other. For works of art are the only "objects" that metamorphosis acts upon. Not furniture, not jewels— not flint artifacts. That is perhaps one definition of them. "The presence, in life, of what should belong to death . . ." When did I write that? Twenty years ago? Today it is applied to me. . . .

Built for works of art, the Fondation Maeght gave shelter to the Museum Without Walls, which ensures an afterlife, just as cathedrals harbor the supernatural. Was it chosen from time immemorial to trap—within its fine buildings surrounded by geraniums, Miró's devils, and olive trees quivering in the profuse heat— the "world of art" envisioned at the end of this century, which brings to us a form of the supernatural and surely a form of timelessness? It was there that we were finally to hear the historical arts and the arts sans history speak out in the same voice—the voice of metamorphosis, our fleeting immortality—in order to ask the tormenting question: "How does art now appear to the first civiliza- tion that ever laid claim to all the arts of the world?" Clouds were floating over the pagoda rooftops—and so was metamorphosis.

# VI

TO SEE THE REST OF THE EXHIBITION ONE
had to cross the cubical courtyard, which opens onto
hills sloping down to the Mediterranean. There, amid
the smell of resin and the rasping chirp of the cicadas,
the Giacometti statues were in their place. Would Miró's
devils, who were already at home among the olive trees
and the holm oaks, live there one day like satyrs? I should
like to see them joined by a few of Picasso's fauns, which,
judging from their little horns, belong to the same race.
Farther down, under the pine trees, the low walls, cov-
ered with mosaic designs by some of our great painters,
were shining like the blue fragments of the Babylon
ramparts. I decided to look first at the rooms devoted to
Asiatic art, where I would be deaf to the chirping heat.

I entered the world of historical civilizations.

We think we know all about the trade and crafts of
Egypt, but the only knowledge we have of Sumer comes
from the reconstructions in the style of Madame Tus-
saud's Wax Museum. Yet ever since we discovered its
gods, we are under the illusion that we understand it
because we know its secret, just as we are under the
illusion that we understand Africa through its fetishes.
By depicting its gods, historical mankind revealed itself
to us; but prehistorical mankind depicted its bisons and
so revealed nothing. Owing to its lavish possessions, as
well as to what it will never possess, the Museum With-

out Walls reveals what the world of art has come to mean to us: we would never dream of looking to it for small paintings from the streets of Samarkand, but we would, for a colossus of Moses and a statue of Solomon. To get a true sense of the nature of art, how ideal it would be to have an imageless past! An Alexander minus his statues and a Napoleon minus his portraits would lapse not into obscurity but into the star-studded night of the Bible. . . . Everything displayed in those rooms evoked everything that will never be displayed in them. Effigies of the Prophets (an allegory of Israel), bronze heads of Jeremiah and Isaiah, as ravaged as the head of King Sargon of Akkad; a figure of Christ by one of the Apostles; images of Genghis Khan and Karakorum; sparrows from the Hanging Gardens of Babylon; Timour on horseback in the thistles, in front of his golden cages filled with birds; Timouride frescoes ranging from the Balkans to the Gobi Desert . . . I dreamed of all that no one would ever see, disturbed yet again by the thought that an imageless world would be more a world of poetry than a world without forms, that a portraitless Napoleon would be Victor Hugo's Napoleon, just as the statueless Cleopatra was Shakespeare's Cleopatra.

Pieces of sculpture. And in inexhaustible dialogue. I was sorry there were no Indian caves, which are not so much a part of me as our cathedrals. And also the clay-colored Chinese rivers that once slumbered within the great sleep of Asia . . . There was the Musée Guimet's head of *Kacyapa*, which Fautrier* considered to be the

---

* Jean Fautrier (1898–1964), described at first as a prophetic painter and an alchemist of color, was rediscovered after World War II, when he had turned from terrifying visions of reality to abstracts verging on the figurative. (Tr.)

best Chinese bas-relief; the nose and an ear in profile within a full-view face, dating back to around the fifth century. It came from Lung-Men. On my last visit to China, while I was awaiting Mao's return, the river had overflowed and reached the grotto; children had placed their little shoes at the feet of the protecting colossi like offerings, and from afar radios were winding the streaming strains of their patriotic songs around the giant Buddha, the mountain's coat of arms.

The red statues of India; Mathura's *Serpent King*. Why, for me, does India bring to mind the beautiful leper who held flowers out to me beside the fish-eyed goddess, and the two little black cats that a Tibetan child wanted to give me in Nepal, and the brass nails that had been polished by bare feet in the dust of sacred thresholds, shining like lamps in a mist?

Khmer Buddhas. I was not yet fifteen when I read in Pierre Loti: "I saw the evening star rise over Angkor . . ." These days there is fighting around Angkor, and the dew at the break of dawn is still pearling the giant spider webs that cover the dead guerrilla fighters. I myself once saw the evening star rise over Lascaux, where our weapons had been hidden, and I hadn't known that it was Lascaux. . . . In the heart of the brush another Angkor exists: Banteay-Chmar (the Fortress of the Cat), which at one time I had wanted to study. But there at the exhibition I saw a small relief next to which, around 1924, a stone god had been meditating, with the frogs of the ruins asleep on its shoulder; the frogs that inhabit ruins are almost transparent. Will I ever again see the forest of Asia?

When I was a child I was occasionally taken to the Musée Guimet: friends of my parents lived on the Place

d'Iéna. The Japanese porcelains seemed to me the height of refinement. Hindu gods with arms spread out like tentacles reminded me of the Thugs—the stranglers—in my comic books. At that time the museum was still an old curiosity shop, filled with Buddhas, gilded magots, and canary-yellow silks embroidered with characters like large butterflies; when I asked the guard what they meant, he made up an answer. Years later I witnessed the presentation of Khmer art in the first of the Musée Guimet's modern rooms, designed by Hackin.

At the old Trocadéro, Picasso necessarily got to know Khmer art. Part of the Musée Guimet's collection had run aground there after the 1900 exhibition, with its endless casts of the Angkor Wat bas-reliefs. Had he forgotten it? The resurrection of the early periods of Buddhism and Brahminism had provoked no more than a kind of absentminded admiration in our artists, who had no admiration at all for the newly discovered, quasi-profane art of the Scythians. Our painters were then discovering Oceanic sculpture, including the ear-shaped masks from New Britain.

The Western sensibility had first come to know Chinese curios and then progressed to the angular austerity of the Weis, during the same period that it was discovering the molten grounds and occasional preciosity of Khmer art. The miles of bas-reliefs belonged, in fact, to the realm of archaeology; indeed, the only ones to enter the Museum Without Walls, even its treasure-house, were the heads that are an expression of supreme meditation—an art form that was apt to have a disturbing influence on a West that had just barely given expression to the meditation of Christ, and even less to that of the saints. Western art discovered simultaneously the closed

187

43. Khmer art. *Queen
    Jayaraja Devi* (?).
    Twelfth–thirteenth centuries.
    Musée Guimet, Paris.

eyes of the Buddha and the hypnotic eyes of the Panto-
crator. And its orientation was changed more by By-
zantium's hieratism than by Asia's, for the corrosive
metamorphosis of that period did not grasp the Khmer
spirituality, which was quite the contrary of Western art
and of the Christian figures it was restoring to life.

Many Christs could well be taken for men, but what
Christian figure of a man could be taken for Christ?
Atop the towers of the Temple of Bayon in Angkor,
King Yayavarman turns his four giant and divine faces
toward the cardinal points. At the Fondation Maeght the
head of Queen Jayaraja Devi—in those photographs
where it appears out of context—looks like the head of a
Buddha. The closed eyes of those statues express the
same spirituality—and the same function of art—as cer-
tain figures from Ellora and the *Mahesamurti* of Ele-
phanta. The sculptor's idea had been to lose his own self
completely and to impose the same psychic action on

188

44. Hindu art.
The *Mahesamurti*
of Elephanta.
Seventh century.
*In situ.*

the viewer. Genius frees a sacred face from all human
characteristics and from its iconography (however re-
spected), just as poetry frees the epic from the tale. The
increate Brahma conveys his beatitude within supreme
peace to the ascetic: deliverance is a reflection. The
greatest art, in turn, captures that same reflection of the
sacred by ensuring that the sculptor and the viewer are
free of themselves; the emotion it conveys corresponds
to that of prayer. It transfigures the universe; its essence
is its power of spiritual transfiguration—a power that
doesn't shrink from even the most frightful acts in order
that it provoke the loftiest emotions; the Indian sculptors
of animals were unequaled, and the Khmer queen exudes
Buddhistic spirituality to a greater degree than any of
our queens exude Christian spirituality. (Brahminic In-
dia has no statues of kings.) All great religious art illu-
mines our own spirituality. The queen's eyes are closed;
so are those of the Beauvais *King*. But the sculpted

throngs of the Buddhic grotto are altogether absorbed by the Buddha, and those of Elephanta absorbed by the *Mahesamurti* of Elephanta; however, the Buddha is also called "the Compassionate One," and what has the *Mahesamurti* of Elephanta to do with compassion? Yet the spiritual workings of their sculptors help us to understand those of the Romanesque sculptors. The *Mahesamurti* sets the Truth of India against universal illusion; the little people on the Autun capitals depict the earthly life according to Christian Truth. The Hindu creative act was a form of dispossession; the Romanesque creative act was an incarnation. Do those creations still act upon us in the same way? I thought of the sculpted throngs in the grottoes of Asia, and of Picasso's tarots covering the walls of the Palais des Papes. Directly behind me were Homer's Mediterranean, Virgil's olive trees, the cemetery, and men who were living at the start of the atomic age and of the real Museum Without Walls, that which doesn't exist—just as, not so long ago, I had seen the haunted caves of Elephanta, in which the Absolute was meditating among figures that had been freed from impermanence and illusion. In Hinduism, as in Buddhism, Christianity, and Greek tragedy, the word "deliverance" is applied to one of the high powers of art. Not to express, but to attain . . . However, the Western notion of the sacred is akin to India's only when the Eternal predominates, as in the Pantocrator and even the Moissac Apocalypse. For Christ, who is also God, imposes his mediation upon the unattainable.

It seemed to me that I could hear one of Miró's little devils—a geometrical one this time—saying: "I am the soul of Europe. My name is 'Frame.' Everybody thinks I'm absolutely natural? I'm a small window. Man's field

of vision is not rectangular; space is not cubical. You have seen the grottoes of India and China: their entrances seem like seals placed at random on each mountain; their figures are scattered about like the Lascaux bisons. Chinese scrolls can be hung, but they can also be unrolled, scene by scene. Those of the Han dynasty have no backgrounds; do you know of any serious European paintings without backgrounds? You Europeans were the only ones to invent geometry; and you repeated that same offense with perspective. You will find freedom in Mexico and in Africa, as you do here. It is not freedom that's debatable; it's you Europeans, who are quite alone historically and geographically. You began with Greece. You had just about invented Romanesque sculpture—which, come to think of it, has no relation to pediments—when you started all over again. I was the tympanum, just as I had been the metope; I was the Flemish window; then I became the painting itself. The stretcher makes the painting; the painting doesn't make the stretcher. You'll find symmetry very often in these rooms; but you will find me, the frame, only in the rooms of Western art. If I were one of the guests here, I should think it over . . ."

The Museum Without Walls reveals to us a basic feeling about life which our civilization will soon begin to look into seriously. It contrasts the arts of transmigration with the arts of men who believe in only one life, a magic life, an eternal life, and perhaps with a feeling that is more difficult to understand—the feeling of being a part of the future, which sprang up when we deified the future—thanks to the archangel Progress and the archangel Revolution, or to them both. Why has no American ever made a statue of Progress that differed

from Bartholdi's Statue of Liberty? Why has no Soviet Russian ever made a sculpture of Revolution that differed from François Rude's?* Will it be necessary to go to a museum in order to analyze the religion of those who have no religion? At least we shall not have left this exhibition without having realized that if we were threatened with the possibility of being reborn as birds, or even as women, we would look at birds, women, and ourselves with new eyes. How is it possible not to link the composition of the Buddhist frescoes in India—as well as their many vanishing points of perspective and their scenes that appear to be scattered but that are in fact connected by smaller scenes, as in the *toiles de Jouy*†—to those indifferent waters by which metempsychosis suggests universal life? Why have a window in a world in which nothing frames anything? Western composition is structured around its center; Indian composition is structured in accordance with the whole, which predominates. India is inseparable from the All-Embracing, from "psychic states" (illumination, ecstasy), from transmigration. The Sheol and the Elysian fields of our godfather, Israel, and our godmother, Greece, were never altogether sure of what happened to man after death, or of what didn't happen to him—and, as for us, are we really that sure?

* Rude was a French sculptor (1784–1855) whose haut-relief on the Arc de Triomphe in Paris, *Départ des Volontaires en 1792*, better known as *La Marseillaise*, is one of his most famous works. (Tr.)
† In 1760 Christophe Oberkampf built a factory in Jouy-en-Josas, near Versailles, which produced machine-printed copies of the delicate hand-printed cottons from India that had been extremely fashionable toward the end of the reign of Louis XIV. As of 1783, almost all the patterns, based on specific themes, were created by one J.-B. Huet, whose drawings have been preserved at the Paris Musée des Arts Décoratifs. (Tr.)

The unknown value that has given rise to the Museum Without Walls does not structure it; and although Western art plays a great part in it, that role is not a kingship.

The works of art that make it up have in no way become unique and personal: the rooms devoted to this exhibition remind us relentlessly that our relationship with a work of art is ambiguous. "How many of those sculptures that you admire—whether they be Hindu, Negro, Chinese, Khmer, Mexican, or Egyptian—are merely some craftsman's reproduction of prototypes!" And the addition of Romanesque sculpture to all that would suggest that it's anything but simple.

Would we admire copies of the brooding *Kore* or of the *Nike of Samothrace* were they lost? Metamorphosis plays many other tricks on us as well. It is very likely that we are more moved by most of the derivative works, which nevertheless convey a specific style, than were the people who saw them when they originated; change of context is also a part of metamorphosis. But when we call those who create forms "artists," and those who copy them "artisans," it remains to be seen whether or not the sculptures in these rooms and in the room of African art are copies.

In the recent past the Dogons' antelope mask was sculpted in accordance with tradition—in other words, in accordance with a type, for the sculptor didn't take an ancient mask as his model. Tourists are going to change all that, as they did the Hopi Indian country. But wouldn't we be as justifiably sensitive to traditional masks as we are to excellent reproductions of a Cézanne?

All the same, such traditions often welcome freedom. Romanesque sculpture and the great sculpture of India and China present us with trends, not models. Beaulieu

is not an imitation of Moissac. The Virgins in places of pilgrimage are not identical. An artist follows in the steps of his predecessor, but at the same time he discovers what was lacking in him. It is not a question either of skill or of illusion. The sculptor of Beaulieu very likely considered Beaulieu more Christian than Moissac; and every Dogon thought his mask more supernatural than the others. But no matter; for what is important is that they altered the previous work intentionally. But, then, what becomes of the notion of copying? It is not the individual but the style—the fictitious artist (trial and error, maturity, death)—that provokes our admiration.

The evolution of anonymous works follows the life of styles. Christian sculpture proceeded from the Romanesque to the Gothic, not to the pre-Romanesque. It is indeed somewhat disturbing to think that sculpture evolves even among the Oceanic tribes, every one of whose members sculpts when the great ceremonies are to take place.

In certain works we admire the results of a power that appears to be scarcely connected with the actual person of their creator. Yet that power is connected with his will, not with the stroke of luck that forms the various "structures" of agates, and not to his mere skill as an artisan once he stopped slavishly copying, once he overcame his will to imitate. The Little Man from the Cyclades was sometimes the servant of the collective and successive power of creation—that which was responsible for the development of myths and tales. But he was also often its rival: the evolution of forms consists of mutation as well as continuity. The Sumerian who sculpted the *Gudeas*, and about whom we know absolutely nothing,

broke with his predecessors as patently as did Giotto. The Moissac tympanum is not a copy. We like Khmer heads sculpted by men who perhaps believed they were imitating their predecessors, who themselves had believed they were depicting the Buddhas; we like the thirty or so forerunners of the antelope masks made by anonymous sculptors who, during one century, had been inspired by the Dogon style, a product of the spirit. But somewhere in the Cyclades or in Oceania, Picasso's Little Man, all by himself, found the brother of that mask, which had been developed after so much trial and error. Think of the skeins of dreams and the successive lucky finds that went into creating just one Puss in Boots! I admire Puss in Boots; I like the night spinners who see only the back of what they spin, and whom Puss in Boots forsakes so that his image may be woven somewhere further on. I also admire Shakespeare. (And even Perrault.) And the sculptor from the Cyclades.

Asia sets no great store by the idea of self-expression, which we consider so very important. Van Gogh expresses Vincent, but we know nothing about the Vincent who sculpted the *Mahesamurti* of Elephanta (or, indeed, about the Vincent who sculpted the Royal Portal of Chartres); we get no sense of him from his work, in which he would have considered himself an intruder. Like the Mexican religions, the religion of Christ can be accommodated to a form of emotional Expressionism that is not especially compatible with the gods of India and is incompatible with Buddha. Creation is often a mixture of the will to express and the will to attain, but the will to attain is no more concerned with the individual than are the historical civilizations of Asia or the tribal savagery in the room devoted to African art.

Half the Museum Without Walls obliges us to substitute the words "reach out" for the word "express," and to sense that up until Phidias, beauty itself was also the object of an artist's reaching out. Thus the artist didn't take his start from a model he knew in order that he might copy it or transform it; he took his start from the invisible, which he would try to attain by way of the visible. That particular species of the invisible was bound up with the highest value of the civilization into which the artist was born. Even if we knew nothing about the sacred texts, we would realize that the species of invisible that gave rise to Vézelay is not that which gave rise to the sacred grottoes. But when the deities of Asia, which were then surrounding me, entered into a dialogue with the Beauvais *King*, when all those figures revealed that the process of their creation was the same, they were reunited with the modern paintings in the next room—and, more especially, with those by Picasso. I had just seen *The Reaper*, the *Monument to the Spaniards*, and the *Women on the Beach*. And they had no relation either to women or to a reaper or to expressiveness. They did relate to an artist's reaching out—no longer to the sacred, or to beauty, or to the divine, but to the world that Picasso called "painting" (so as not to use the word "art"). A world that, in his eyes, was filled with one of the highest values. Enigmatic, yes—but any more enigmatic than the world of the gods? Less justifiable, perhaps—but any less justifiable than the world of music? In music one of the roads that reaches out to the unknown winds through what Menuhin called "praise." In painting it winds through rebellion. And, looking at a figure of Siva, is it really going too far to associate those well-known words of Picasso, "I don't seek; I find," with the

45. Takanobu. *Portrait of Taira no Shigemori.*
Twelfth–thirteenth centuries. Jingaji Temple, Kyoto.

words Pascal noted down for the centuries to come: "You would not be looking for me had you not already found me"?

A small staircase; pre-Buddhistic Japanese figurines, recent acquisitions of the Museum Without Walls. In the last room, isolated from the others, with the Japanese curator beside it, was a famous masterpiece: Takanobu's *Portrait of Shigemori*. And there began the most imperative cross-examination of Western art.

Even to painters who have been to Japan, the form of Japanese art most familiar to them is still that of the color prints. But a Japanese color print is an arabesque, a light background, paper, and an anecdote, whereas *The Portrait of Shigemori* is austere and black architecture against a flat background, silk that is almost at the point of rotting, and the greatest of serene styles.

In the West, flat painting means frescoes. But frescoes have shadows. And a fresco is never mannered. The only substance I ever came across which was comparable to the scroll's was that of Cézanne's *Château noir* in Picasso's collection: Vollard had been loyal to Cézanne and had never varnished it. Western paintings shine. . . .

During my visit to Japan I had seen the *Shigemori*, not in its temple but in the office of the curator of the Kyoto Museum, because the museum exhibited it only one month each year. The poetry in the art of Kyoto holds its own with that of Venice or Isfahan. There, among the sinuous deities of the hieratic school, Takanobu's monumental geometry had seemed as curious as it did at the Fondation Maeght. Still, in Kyoto the *Shigemori* dwelled among its fellows; at the Fondation it was

alone. In the art of great figures it has no predecessors and no followers. It is a meteor, like the *Gudeas* in Mesopotamian sculpture or the Avignon *Pietà* in medieval painting.

Taira no Shigemori was a great minister around 1200. His life-size portrait—with legs crossed under an angular kimono that allows us a glimpse of the tiny and irreplaceable ornaments on the pale-blue, garnet, and salmon-pink accessories—is a form of absolute geometry, as eternal as a triangle, as sovereign as a *Guernica* attuned to the cosmos: an ideogram of the word "hero." The flat face alone, in which features, eyes, and moustache are almost obliterated lines, forms a hieroglyphic structured by the large trapezoid mantle. Is the light in Venice better than the light in Kyoto? The materials of the portrait seemed as fragile as butterfly wings, just on the point of crumbling into dust, and held together solely by the architecture of the work. As rigorous as a Braque collage, black gashes against a dead background. The character himself has as little importance as the real women Italy transformed into Venuses. Had it not been for a kind of intoning from the beyond, one would have tended to think in terms of Cubist construction or of the folded papers children make—birds, arrows, little boats. Actually, that ancestral portrait is a ship of death, topped by the face of the dead man being borne away. It was difficult not to think of the way other civilizations have signified man—of what Picasso called "the Mask." In this case, the Mask was the painting itself. I also thought about what Christianity calls Glorified Bodies, bodies released from all that is human. But it was painting itself that released Shigemori's body from the human—a style of painting altogether unlike our own.

Chairs had been placed in front of the vertical scroll. Although a European leavening agent had restored it to life along with a number of other masterpieces, it entered the Museum Without Walls but did not thereby lose its state of recollection, just as the tribal sculptures entered it without losing their tribal savagery. Nevertheless, that insidious masterpiece called into question not only Western art's conquest of the world but the entire Museum Without Walls as well, even though it had taken it in as one of its own.

To begin with, we found that it had a few lesser surprises in store for us.

Dexterity, which always played a major role in Western art, played none in the art of the Far East or Egypt, perhaps because of their ideography. The *Shigemori* is not a primitive: in the European sense of the word, there are no Japanese primitives.

Our play of shadows, to which an entire room on the ground floor was devoted, does not exist in the Far East. Doubtless it doesn't exist in our modern art either; yet Japan does not dismiss it in the same way. At Notre-Dame-de-Vie, Velásquez's, Delacroix's, and Courbet's use of shadow embraced an entire period. But when confronted with one of the major works of Asia, their use of shadow no longer seems that limited to one period; it is an expression of the Western world. Portraiture, which originated at the same time as shadow, born in the fifteenth century (and about which we knew absolutely nothing when Takanobu was painting), will not outlive shadow for long.

Shall I describe the third surprise also as "lesser"? The art of Takanobu transforms ours into an art of antagonism. With the exception of a subtle and private inclination restricted to Vermeer, Chardin, and Braque, some-

thing in our works of art is always fighting something else. Compared to the great art of Asia, our painting—since the Baroque, and including Rubens, Venice, and the Romantic triad that linked Goya and Rembrandt to Michelangelo; the whole spirit of our cathedrals; and the creative wonder of the Romanesque, despite its rigidity (Romanesque catalepsy is haunted)—indeed, all of Western art, from the first Christian figures to Van Gogh, seems clearly to be an art of devastation. Even Classical antiquity ended with the struggle between the Titans and the gods in Pergamum. True, the tireless wrangle is not as evident in the austere styles of Greece and Tuscany, or, afterward, in Raphael and Poussin; however, the very beautiful Poussin in the first room of the exhibition seemed like an *external* Takanobu. Among our various worlds of art it is the world of beauty that is most akin to that of the Far East, because each of those worlds took a specific direction—a direction that imposed unity on its works. The great architecture of Cézanne, which he reinvented and mastered, restored El Greco to life; Poussin, who claimed that he took his inspiration from Classical antiquity, could do no more than uphold the resurrection of that style, which Europe had forsaken and which America deemed negligible—whereas we are restoring life to all the claws, all the hooks, all the arts of the night. It was not only Asiatic art but Asia itself that discovered the murderous secret of the universe in the modern Western world: to Darwin, Nietzsche, Marx, and even Freud, the *Tao* of nature, history, and man was combat. To Picasso the soul of painting was "tension"—to use a mild term. Even to Raphael's "reconciled man," the pacified smile with which Buddhism had blessed the Great Abyss would have been inconceivable.

Except for Takanobu's dazzling masterpiece, Far East-

ern painting—at least that which does not derive from the fresco—was missing from the Fondation exhibition. Its absence didn't bother anyone: it was absent from our minds and from our artists' Museum Without Walls, for Japanese color prints differ even more from Takanobu's style of painting than from our own. Crowds rush off to the Grand Palais to see pre-Columbian sculpture, but centuries of Chinese, Korean, and Japanese painting are the concern of specialists alone.

What exactly constitutes that taboo? How is it that we, who so avidly restore life to the merest Nestorian illuminated manuscript, scorn the profusion of the only paintings that are in rivalry with our own?

Just as I had been overwhelmed by those "monsters" that were heralding Picasso's tarots, and previously, by the Villeneuve-lès-Avignon *Pietà*, Arezzo, Grünewald's altarpiece, and the brooding *Kore*, so I was again that day, and, as I said, even more than I had been in Kyoto— probably because the *Shigemori*, isolated from paintings of the same period, sprang forth like a meteorite. It had been painted to be seen alone, and very rarely. And it was indeed alone in that room. Its pictorial scope came as a surprise, because it was only gradually that the viewer sensed its perfection, whereas he was struck straightaway by the discovery of unknown resources, just as, in certain Rembrandts, the viewer discovers that Rembrandt invented a light all his own, or that the Avignon *Pietà* is akin to no other painting. In the *Shigemori*, Takanobu countered the subtlety of large areas of dead, flat tints by attuning them to the powerful thrust of black geometry, just as in a room nearby, Manet's well-known black tones were attuned to Berthe Morisot's face. But Manet's painting displays a masterly brushstroke;

Takanobu's is invisible. The moment one thinks of Manet, Takanobu's admirable painting ceases to be a painting; it would seem like a chunk of black quartz were it not flat—a leveling off as arbitrary as our depth, an absence of the third dimension that has nothing at all to do with nature, since it expresses a relationship between shadowless volumes that can exist only in art. The salmon-pink triangles and the pale-blue cord are heedless of space and imbedded in the jagged black of the garment, just as a Chinese flute is imbedded in the low-pitched sound of bronze kettledrums. Those angles, so un-Chinese but absolutely inconceivable in the West, remind us that Japan and China do not share the same scales, chivalry, love, or feeling about death. Ideograms and Inner Reality are enough. And the materials of the timeless work of Takanobu suggest not only a fragility unknown in our solid painting but a patina that bears the weight of centuries, like Chinese patinas, so very similar to the dust of crushed green almonds.

The most austere work produced in a world of sumptuous art; the centuries that have passed; the solemnity; a vague sense of Cubism; the incisive modernism of what we have not yet discovered . . . That scroll is a work of genius, and therefore strange. Metamorphosis changed it into a painting in the same way that it changed an African ancestral figure into a piece of sculpture: the Museum Without Walls assimilated it by virtue of that process. It would be pointless to admire it as perhaps Shigemori himself had, or as a painter contemporaneous with Takanobu. We do not admire the Royal Portal of Chartres as did a twelfth-century Christian who worshiped it, even if he were a sculptor. The medicine men didn't admire their masks. To banish metamorphosis

from the Museum Without Walls in order to get a better understanding of the works it contains would be equivalent to banishing the supernatural from a cathedral in order to get a better understanding of the service. Our relationship to the art of the past is as bound up with metamorphosis as a believer's relationship to Chirst is with Christianity.

We do not quite consider the *Shigemori* as the work of a Far-Eastern Braque—even in the sense that we can consider Chardin's *A Smoker's Articles* an eighteenth-century Braque. Yet if it were impossible to limit the Japanese scroll to the pictorial domain, we wouldn't *see* the scroll; we would see only what it depicts. That is why the Museum Without Walls is almost impervious to any attack from Chinese painting.

I had hoped to see Rogier Van der Weyden's *Portrait of a Young Girl* at the exhibition. What a pity that the Fondation was unable to obtain it from Washington! The Christian painter, by way of a process that was still somewhat magical (since the model, in her portrait, has eluded both old age and death), incorporated a woman into a new form of Christian painting; Takanobu, by way of an almost similar process, transformed Shigemori into a sovereign ideogram. Compared to the portrait's invulnerable gentleness, all the other works in the Museum Without Walls seemed to be thrashing about.

Neither light, nor space, nor volumes. Signs. In contrast to the Flemish girl's thick belt are the graphics on the hilt of Shigemori's sword and its ash-blue cord; and in contrast to the transparency of the girl's veil is the arbitrary placement of the salmon-pink triangle next to the largest section of the kimono. The imperceptibly precise lines that form the minister's eyes, lips, and delicate

moustache reply to the faithfully reproduced planes of the girl's face with the words Michelangelo had written to Francis of Holland: "The painting in your country is meant only to fool the eye!" Inner Reality does not counter illusion any less effectively than the creation of heroic figures.

The West knows little about that concept, because our individualism considers all inner reality as subjective, and confuses it with the specific quality expressed by works of art; what Van Gogh's paintings express is his inner reality. The traditional Far East is interested not in Takanobu's personal feelings but in his powers, which are similar to those of a diviner. Inner Reality existed as much as outer reality. The latter was confirmed by the evidence of our senses; the former by the evidence of a higher sense shared by all cultivated men, just as the religious sense is shared by all believers. The common reality was that of the common man. Art alone attained the Inner Reality; one didn't know it, one recognized it. Romanesque Christianity would not have been in the least disturbed by the idea of an objective Inner Reality: it depicted it lavishly on its tympana and called it Truth. But it wanted all things to reveal the testimony of Christ; all that the Far East expected of its emotive signs was the Inner Reality they expressed. The West wanted some higher value to be inseparable from the highest truth. Was that always the case? In China, almost inadvertently. Not that Inner Reality was a chimera; the truth was merely one of its attributes. The important thing was that it contribute its quality to life, just as all the highest values do, and that it lead man not to solitude but to a form of communion. The non-Buddhist Far East wants to escape from life, just as Buddhism wants to

escape from the Wheel, but by communing with life's essence. There was a Chinese aesthetics; indeed, there were several. Yet the Far East's relationship to art is not merely aesthetic. Although its art is indifferent to knowledge in the Western sense of the term, it is a means of revelation. Far-Eastern artists discover and express the essence concealed in the things they choose to depict, and believe that all such essences reflect the supreme Essence. Inner Reality governs what they create in the same way as Siva governs the creation of Hindu sculpture—perhaps—as "painting" governed Picasso's creations. A European still life expresses the painter himself; a Far-Eastern still life reveals life. That is why the artists of the Far East are forbidden to depict manufactured objects, and why Japanese painters in particular were staggered by Van Gogh's *Chair*. According to Cézanne, "There is a pictorial truth of things." "Or quite simply Truth," a Far Easterner would have replied. As Chihtao wrote during the time of Poussin: "The brush serves to bring things out of chaos." I recalled a cell in an almost abandoned convent near Nara: hung on the vertical matting was just one vase, a shapeless wonder, and in it was just one flower—a garnet-red hibiscus—that quivered to the beating of a distant gong: spaced sounds in eternity.

Takanobu links Shigemori to the supreme Essence. Just as the Franciscan painting of the trecento countered transitory living beings with a world of Jesus, so traditional Far-Eastern painting has for over a thousand years united its figures, its animals, its landscapes, and its flowers—everything that was not created by man—within a world free of fighting and free of sin. Let us not be misled by Buddhism: Asia considered art a power that could penetrate the world, well before it knew anything

about the Sermon at Benares. Asia found it, here and there, in Taoism, Confucianism, and Shintoism, whose successive or simultaneous outcroppings merely disclose that power's subterranean current. The great Chinese painters copied the masters of previous dynasties more faithfully than the art of late antiquity copied Greek art. For the language of Inner Reality, which existed before art, but which art reveals, is intentionally heedless of time. When Takanobu undertook the painting of his *Portrait of Shigemori*, he was preparing to paint in communion—and also, probably, in rivalry—with the scrolls that had represented Inner Reality, having only a vague idea of what they were like as a whole. (Poussin too painted with only a vague idea of those works which had represented beauty, just as Manet painted with only a vague idea of those which had expressed pictorial power.) The works that survived provided Far-Eastern painters with a past released from time—in other words, with the same world in which the *Portrait of Shigemori* was to be born: Asia's Museum Without Walls.

Asians are struck far more strongly by the continuous state of combat that fires our art than we are by the harmony that once inspired theirs; they are violently struck by what they call our rage for possession—in Van Eyck as in Picasso, and in the terrifying Expressionism of the Rhenish crucifixes as in the theatrical Expressionism of the baroque. For the sculptor of Elephanta, of Angkor, of Brobudur, and of Nara, and for all the masters of wash drawings, a protective zone, similar to that of the sacred, emanates from the great works of art—whether those masters were familiar with the idea of art or almost unaware of it, like the sculptors of India's great statuary. All that type of art keeps man at a distance: Do

not touch, but draw near. . . . The very way Tantalus was healed, through delectation.

None of our languages has words to express that age-old attitude. One of my Japanese friends told me in Kyoto: "You want to *be* in the painting, whereas we want to be outside it. European painting has always wanted to catch the butterflies, eat the flowers, and sleep with the dancers." Asiatic art lovers are mesmerized by a painting, but remain separate from it because of an aura that protects it as would an invisible glass. Our word for that phenomenon would be "recede," in the sense that it may be used to describe a seascape skyline that draws back from us. For it has to do with distance being protected by its very essence. No one hugs the *Mahesamurti;* no one draws near to the *Shigemori,* which is separated but not removed from us. The landscapes of Far-Eastern wash drawings have no foregrounds; Chinese perspectives keep the viewer at a distance; and never has Asia understood our indifference to the mist in their landscapes, which plays the same role as light does in ours.

The wonders of the ungraspable were not unknown to Titian or to Rembrandt. Nevertheless, a traditional Japanese painter always notices the stress we put on possession, which is in fact always bound up with light, and which is apparent to us the moment we compare the glowing mud in the *Man with a Helmet* to the *Shigemori.* No doubt Christian art has, for centuries, been groping toward Christ, but in the eyes of Asians, it always seems to have captured him. And even in our own eyes, when, among all the Christian masterpieces, we look at only one Christ . . . Moreover, to the West's dogged notion of "self-expression" Asia has long responded with: "Express what no one possesses." We speak of Asiatic art as if it nonetheless wished to possess

the mystery it represents, but it possesses merely an approximation of it.

It is pointless to try to imagine how our Museum Without Walls would assimilate Far-Eastern painting, for no one can predict the ways of metamorphosis. Pointless, but fascinating. We would first collect those works that are most dissimilar to those based on outward appearances, either because of their hieratism, their style, or their tantalizing insistence on not imitating what they depict: all the great painting of Buddhism; Takanobu and the scrolls of the Kamakura period: the wash drawings, with their splattered-ink or conventionally drawn patches (from Ying Yû-chēn's to the well-known fruit of Mu-ch'i); the Eccentrics, whose violent freedom of style has begun to interest Western art lovers; then, the imaginary rocks and the beloved Zen wash drawings. In other words, we would be extracting art from Asia according to non-Asiatic criteria. As we do for . . . And for the sake of what? That is one of the most important questions posed by the Museum Without Walls.

In 1935, when Paul Valéry was writing his "Preamble" for the great Italian exhibition catalogue, he told me: "What I call great art is that which involves the whole of man, in accordance with the very hierarchy of the mind." I had thought of that a short while before as I looked at the portrait of his aunt, Berthe Morisot. And what a strange ring that statement had in the room where the *Shigemori* evoked its relationship to the works of Valéry's choice—a declaration (refuting those works we had restored to life) to the effect that the greatest art was that which expressed the highest degree of civilization!

The art "which involves the whole of man" was, to

begin with, in conflict with the art Valéry had always lived with. Indeed, Valéry would have approved of the letter Baudelaire had sent to Manet after having seen his *Olympia*: "Don't forget that you are merely the first to participate in the decadence of your art."

A position that was more disconcerting than Valéry's, for had Baudelaire discovered El Greco, Georges de la Tour, and Vermeer, he would have admired them; and it would not have taken him long to understand the language of the masks, the fetishes, and Miró's devils. He, like Valéry, spoke of beauty—but beauty of another sort. The painting he contrasted with Manet's was Delacroix's.

Delacroix had used what Cézanne called "the most beautiful palette of the century" for purposes of transfiguration. He had respected a hierarchy for lack of a cosmos. He had considered the preeminence of "great art" as indisputable. He had judged transfiguration to be the most powerful means at his disposal. He had felt guilty about preferring certain of his sketches to his paintings: transfiguration encompassed the imaginary; sketches merely encompassed painting. Baudelaire liked Delacroix's sketches. But at the time that Valéry discovered painting, the last and most powerful expression of "the whole of man" was the imaginary. When Van Gogh "copied" Delacroix, and when Manet and Cézanne copied the Venetian masters, they began by destroying all that was poetic in them, for the benefit of a new deity: painting, and painting alone.

In point of fact, it was painting that Valéry considered the usurper. But a short while back, in the exhibition's largest room, it wasn't the Impressionists or even Manet who had reigned supreme: it was Cézanne and Van Gogh. Claude Monet and the Promeneurs responded to what Valéry called "the highest faculties of

210

man" like opticians and gardeners; Van Gogh responded like a martyr. When confronted with his paintings and with his frightful letters, who among us would say that his painting, in which every inch of himself was manifestly involved, does not involve the whole of the viewer?

Would Valéry have liked Takanobu? He would surely not have dismissed him as a mere sculptor of fetishes. The art of Inner Reality is also bound up with a hierarchy (a rather more secret one) and is thus inseparable from some degree of civilization. Looking at the *Shigemori*, we do not find ourselves confronted by a pictorial statement alone, even one linked to the imaginary.

It suggests and enriches a realm of sensibility that the Court of Nara deemed one of its highest values—in poetry, the dance, and life, but also in the martial arts. Its highest form of expression was not the relationship of superb black planes and the sign of a face; it was ritual death—hara-kiri. Which Takanobu suggests extremely well. The adjective "civilized" does not adequately express the quality of his art, but that quality is altogether contrary to the word "barbaric." A word that originated in Greece, where beauty dominated art, just as Inner Reality dominated Far-Eastern art; the art of one cosmos is never completely foreign to the art of another. In Hangchow and Nara, as in Olympia, art was intended to be the reflection and the agent of an ordered harmony of the world, whether we call it the cosmos or the yin and the yang. The phosphorescence of the firmament.

The "whole of man" means the whole of Classical man. The art Valéry judged to be most lofty—that of Leonardo or Racine—expressed and enriched a higher state of *culture*. It was an art which promised to be immortal, and kept that promise. And that is how the West understood it for many long years. But what about

the art created during the great periods of faith? So that he might restore modesty to the art of his time, Valéry contrasted it with "the very hierarchy of the mind." Manet's works were a weak response to that principle— even his admirable *Berthe Morisot*, exhibited at the Fondation; but what of the Beauvais *King* and Moissac and all of Romanesque sculpture? He most probably thought that it didn't involve the mind. Valéry, that adversary of Pascal's, who was so desperately intelligent, rarely used the word "soul." When Picasso drew his portrait, why didn't they talk about masks? Because the spirited mind doesn't like spirits any more than it does souls. But I know what Valéry would have replied: Even if those arts engage the whole of man, man does not control them.

Then the sound of rain that was beginning to fall on the olive trees called me back to the Mediterranean lesson I was being given, and to which the Museum Without Walls had a reply: The mind is not enough to explain intelligibly the creative process that was responsible, in turn, for the Parthenon frieze, the *Shigemori*, and the Dogon mask—for the arts that man perhaps controls and for those he does not control. And it is surely not enough to explain the process which is responsible for the fact that all three of those works speak to us. For this art, which had not assimilated the art of beauty, much as it resembled it, has been assimilated by the civilization that conquered the earth's Museum Without Walls—the Museum that has given new life to the most devastated arts, as well as to Takanobu. By way of a Draconian process of metamorphosis, the *Shigemori* will become one of its masterpieces. Although it leaves its temple for the Kyoto Museum for a period of barely

one month a year, it was there at the Fondation exhibition. Japanese painters, who are delving ever more deeply into Western art, are doing nothing any longer to revive the traditional art of Japan. Her art world is disappearing, just as our own world of Romanesque art, which was contemporaneous with Takanobu's, has disappeared. Japan, now converted to combat, is, like Africa, entering into our art world, and for the simple reason that no other universe of worldwide art exists. During the period of colonization, Asia scorned Western art; and the Museum Without Walls did not invade the world brought to it by the conquerors; rather, it itself conquered that world because of its emancipation not only from beauty but even from culture, so that it showed promise of becoming a universal language. For the time being, the Museum Without Walls is the West.

The Sumerian statues were soon to be returned to Syria, the *Shigemori* to its temple, and all the modern paintings to their owners. Manet's *Berthe Morisot* would no longer be seen beside the Douanier Rousseau's *Virgin Forest*; nor would Titian, Velásquez, El Greco, Poussin, Chardin, and Corot ever again be together in the next room, nor would all those sculptures of the early ages then surrounding me, as night fell over the Mediterranean . . . Beyond the hills, a few miles away, Picasso's canvases were keeping watch over the cluttered rooms of Notre-Dame-de-Vie. "An objet d'art and a painting are not at all the same thing—ever . . ."

I thought of Le Corbusier's funeral service in the Cour Carrée of the Louvre—a nocturnal well surrounded by lighted walls. The Indian and Greek ambassadors were waiting to present their offerings.

213

"Farewell, my old master, my old friend. . . . Good night. . . . Here is some holy water from the Ganges, and some earth from the Acropolis. . . ."

Those masterpieces I was leaving behind: Weren't they offerings brought to the funeral service for the last great period of painting?

From Chardin to Picasso, all the great painters came to Paris, just as they had formerly gone to Rome. In my speech for the inauguration of the first Biennale I had said: "Beside a river flanked with *bouquinistes'* stalls and bird-sellers, in this city where painting grows between the paving stones . . ." Braque and Picasso were still alive. Painters were moving out in all directions— in other words, going nowhere. Years before, I had read about Renoir's death in *Le Journal*; I had seen the "Degas sale"; so I didn't find it surprising to have lived for fifty years among the greatest paintings of my time . . . Up there, in the Fondation Maeght, Prince Shigemori, whose Japanese eyes, accustomed to nothingness, had never seen anyone paint shadow, was watching the art of the West—which gave new life to all the painting on earth—reuniting the great poets of Western shadow, the haunted darkness of Goya, Titian, and Rembrandt. I had to go off to prepare the speech I was to make at dinner, and add my impressions of that day to my notes. . . . The light setting behind the pine trees was attuned by the solemn cypresses to the mosaics, as it is to all the Mediterranean ruins, from Sagunto to the sacred wood of Epidaurus. In the courtyard, Giacometti's figures, absorbing shadow, were turning into veritable ghosts. Night was gradually rising up from the hills of Provence to Miró's pitchfork and devil, outlined against a sky growing gradually paler.

214

# VII

THE FONDATION MAEGHT DINNER TOOK place at the restaurant in Mougins. No lights were on at Notre-Dame-de-Vie, directly above us. A friendly hum of conversation. Painters, curators, critics, art lovers. The Japanese curator who had accompanied the *Shigemori* to France. Baron Thyssen, who for the first time had agreed to lend one of the last Titians, El Greco's *Annunciation*, and two other masterpieces. The Spanish secretary who, in 1938, had helped me when I was directing the film production of my *L'Espoir*, and who owns one of the largest art galleries in Barcelona. She took me back to the days when the Rambla of Flowers was filled with hawthorn and shot through with shadows, to the clandestine nights in Madrid when only blind men wandered about, singing "The International," and to the French civil servant completely absorbed in his canaries while black lines of refugees were crossing the border. André Parrot, whose excavations in Mari had unearthed the three Sumerian statues. Dina Vierny, Maillol's mistress and model, whose body reigns over the Carrousel Gardens. Roger Caillois, who had written a perceptive and apprehensive preface for the exhibition catalogue. Ludmilla Tcherina. Louis Guilloux.* Chagall.

* A French novelist, born in 1899, whose works, in the populist tradition, realistically but dramatically portray the misery of everyday life. (Tr.)

The bay windows opened out to the rustling sound of night rain. I thought of the snow that had fallen on Verdun, on Teruel, on northern China, on the *maquis,* on Alsace; and I listened to that tepid rain falling on the olive trees.

For my reply to the friendly speech Aimé Maeght's guests expected him to give, I had taken notes with a view to summing up the propositions I had begun to develop thirty-five years ago, and the response to which was this exhibition called "Malraux and the Museum Without Walls." I had often felt that the experience of literary creation shed light on the pictorial creations of the masters I had known. Ever since I had defined art as "the revolt against man's fate," I had been away from Europe too often not to sense the exceptional and unique nature of our art and our museums, despite the fact that they had conquered the earth. It doesn't much matter whether my impressions win approval, so long as my questions cannot be ignored. *La Condition humaine (Man's Fate), Antimémoires (Anti-Memoirs),* and *La Métamorphose des dieux (The Metamorphosis of the Gods)* are all chapters in the story of one life; I was twenty-two when I met Braque, and sixty-two when I transformed the colonnade of the Louvre into two wings for the vigil at his funeral service. And the Museum Without Walls of 1973 was not the Louvre of 1925. . . .

The following was my speech.

We have just witnessed the first embodiment of the Museum Without Walls. It was not sponsored by any state, but by one of the first galleries of modern art of our times. For the Museum is inseparable from our art, and our art—from Manet to Picasso—is inseparable from its dialogue

with the Museum Without Walls, which it restored to life.

In spite of its masterpieces, what a wretched Museum it is, compared to all our dreams! But its embodiment brutally poses the problems that it itself, as a conception, posed in a whispering voice.

What did the Louvre assert? What was Giotto's response to Cimabue and to the Byzantine mosaics of the baptistry in Florence, which he passed each day? Art is an interpretation of nature—of what men can see.

What do the four thousand years of the Museum Without Walls suggest? That art is a manifestation of what men are unable to see: the sacred, the supernatural, the unreal—of that which they can see only through art.

In many respects the Renaissance was a resurrection of the visible.

In many respects the Museum Without Walls is a resurrection of the invisible.

It seemed that inscribed on its pediment there ought to have been the following Declaration of the Rights of Modern Art: "A painting—before being a war-horse, a nude woman, or the depiction of some anecdote or other— is essentially a flat surface covered with colors arranged in a certain order."

And now we find that the Museum is amazed at itself for having called that very declaration into question. For it has become transformed and now reads: "A piece of sculpture—before being a Sumerian goddess, the *Mahesamurti* of India, Aphrodite, the Virgin, or Michelangelo's *Slave*—is a system of forms arranged in a certain order."

Which would have greatly astonished not only the men who sculpted the *Gudeas*, the Greek archaic works, the grottoes of Elephanta, and the Romanesque figures, but Michelangelo as well. They would obviously have replied:

"Arranged to what purpose if not to make them into a deity, a Virgin, or even *The Heroic Slave*?" Thus today the goddess and the Virgin, in order to escape from "the real," have become assemblages of volumes.

Yet just at a time when painting ought not concern anyone but painters, our art-filled cities are becoming places of pilgrimage. I once wrote: "Works of art as private property are a phenomenon that has not only become less prevalent but is limited to a man's lifetime. Masterpieces are loaned to retrospective shows, and almost all the great art collections are being given to museums: three such collections constitute America's finest museum. Millions of Americans and Japanese have filed by looking at paintings by Braque and Picasso, while ceremonies commemorating Rembrandt's death were presided over by the last of European kings, while an exhibition of our stained-glass windows was inaugurated by the last emperor of Asia, and while Soviet citizens rushed off to the Hermitage."

Since then the Grand Palais has exhibited all the works from the Dakar Museum; Braque's state funeral took place under the colonnade of the Louvre; and all the newspapers in the world heaped funereal flowers on top of Picasso's tomb. And the Fondation Maeght, which is not located in Paris—not even in a large town—is expecting a hundred thousand visitors.

Our art—the art of the past and of the present—is understood as art. From the time of Sumer to the period of Romanesque sculpture (probably with the exception of Romano-Hellenistic art) that had rarely been the case. But the word "art" is not really applicable to the emotion *we* feel when we look at a work of art; it is not even applicable to the community of artists. What does "art lover" mean? Are Christians called Christianity lovers?

At least we do know that those men and women we call "artists" are people to whom art is necessary, whether or not they are creators. Loving someone does not mean we consider him marvelous; it means we consider him necessary.

Nevertheless, while we know—and are indifferent to the fact—that art formerly referred to beauty, each one of us uncomfortably realizes that we have no notion of what the art we cannot live without refers to.

The Europe of the great monarchies was unable to *see* a Romanesque Virgin without comparing her to a Virgin by Raphael.

Now that the Western world has discovered the arts of the early ages, it looks at a Virgin and relates her to the figures in the Hindu and Chinese grottoes, to the Khmer queens, to the Hindu deities, and to the great Japanese Kwannons in Nara.

It is also discovering evolutions of forms that are very like each other: Chinese sculpture ranges from the Wei dynasty to the Tang, just as our sculpture ranges from the Romanesque to the Gothic.

But the comparison stops with Classicism! Whereas all the arts of Asia range from the Gothic to the Baroque, Europe alone experienced the adventure we call "the Renaissance," and without which Europe would doubtless never have become mistress of the world.

And it is that specific adventure that once imposed its frame of reference on European art: beauty, nature, dexterity, illusionism, etc.—in other words, its history.

When Europe discovered the Asiatic arts of the early ages, she was flabbergasted and underwent a Copernican revolution: She found that no longer did all the art in the world revolve around those references.

The Museum Without Walls destroyed their pre-

eminence not because it repudiated them but because it encompassed them.

Europe then tried to invent a universal Middle Ages.

Yet there was no end to the discoveries being made; the tribal arts and Sumerian art are not medieval, and modern art is going to force Europe to hear what those arts have to say.

This time, no new concept of beauty replaced the old; it has been replaced by interrogation.

And whether they know it or not, Western artists have a new frame of reference which no longer includes either nature or self-expression; it is each one's own Museum Without Walls.

Now the All-Encompassing, which has taken the place of nature or of God, originated largely in works that had been created to represent the unknown.

Our ventriloquous civilization readily uses the vocabulary of previous civilizations to give voice to everything it contributes to the world. It has thus managed to remain unaware of the fact that it has already called into question or destroyed not only the four concepts on which nineteenth-century theories of art were based but even the general feeling that art produced.

It has not relinquished the word "beauty," with the result that our relationship to art is unintelligible.

Nor has it relinquished the old theories of *vision*—which, after all, played no more than a minor role in Cubism or in the sacred arts. Impressionism merely strengthened that prejudice. But Cézanne, Van Gogh, and the Fauves—in other words, chromatism, not photography—put an end to it. An artist uses vision for the purpose of creation, and not the other way round—"creative vision," as Rouault put

it. The Chinese vision is nothing other than the language of traditional Chinese painting (even though a few years ago the painters from Peking didn't see in Chinese; they saw in Russian). Braque did not see his guitar as bits and pieces; and the men who sculpted Chartres did not see their women in the form of statue-columns.

Nor has our civilization relinquished the theory of *nature*. Owing to the preeminence of nature, the questions posed by artistic creation become blurred and pointless; indeed, the very essence of artistic creation has become vague in our minds. Art has been waging an extremely uneasy battle against time; Islam didn't put the eyes out in paintings for nothing. But nature and vision have got on very happily together.

Nor has our civilization relinquished *expression*. That an artist wants to express something—even himself, especially at a time when individualism reigns supreme—goes without saying. But when an idiotic painter gives total expression to whatever it may be, it is not enough to make his work into a masterpiece. Attributing what was formerly called distortion to Expressionism is a good way of not understanding that the quest for such distortion has almost invariably been the same throughout the history of art. The man who sculpted the Autun tympanum very likely had little interest in expressing his own person; he wanted to reveal his Christ to Christians, because in Him they would discover their own. For four or five thousand years works of art—whether expressions of the artist or of the sacred—were, like contemplation, anonymous. And there is no doubt that expressing the invisible, the soul of things, of other people, or of oneself, calls for different forms of art.

Nor has our civilization relinquished something far

more dangerous—the *lack of distinction* between artistic production and creation. Now that Taine is out of fashion and Hegel is being pulled in every possible direction, Marx has followed in their wake. Well before the craze for superstructures, the whole muddle resulted in the subordination of art being accepted as fact. Certain ideas are judged on the grounds of their success, and glass trinkets are judged by their sparkle.

To begin with, art is subordinated to history, which holds sway over museums just as beauty held sway over the galleries that displayed works of Classical antiquity. What a temptation it is to make the adventure of mankind intelligible! It remains to be seen whether the adventure of art coincides with the adventure of mankind. Up until this century, European history of art comprised the history of European art; but the Museum Without Walls has no history; it has histories. A painter's dialogue with our historians and psychiatrists is a dialogue between ludicrous hunters, because the latter are out hunting for that which "conditions" art, whereas the painter has poached the power by which art eludes them. While the historians and psychiatrists are building houses of cards that testify to art's bondage, the painters are watching the Musée Guimet and the Jeu de Paume quietly creep into the Louvre . . . and nonchalantly waiting for the Louvre to set up its room of tribal arts—the very one you have just visited, and which will be the first room, in any museum, that defies history.

The Museum Without Walls at first seems rather Spenglerian. But not for long, because Spengler believed that all culture was destined to die, whereas the Museum Without Walls is based on the assumption that the destiny of all great styles is metamorphosis. The Museum is gathering together works of successive or various civilizations at a

time when styles are no longer considered interpretations of nature, but rather meanings of the world.

Hence the radical interrogation to which it submits both itself and art. In the forms that have been accumulated from civilization to civilization—in the neo-Sumerian *Gudea* or in the Moissac tympanum—do we find merely volumes in equilibrium? Was the order that makes for one color being set next to another in the greatest paintings of our century meant to please the eye? Meant to be harmonious? Meant for delectation? You can't be serious. Who considers our painters—from Manet to Braque—as merely men who created pleasant combinations of color tones, like the dress designers, from Doucet to Christian Dior? Who considers Marie Laurencin the equal of Chardin? The realm of correlations within a work of art is not the realm of correlations within life; it is its rival.

The will to escape from being a slave to "the real," which is obvious in all the major works of religious art, is not quite so obvious in Braque, Picasso, Klee, or Kandinsky; but that's because their paintings are free of the real, because their colors, "arranged in a certain order," form something quite different from a harmonious whole. Braque's painting is a world in itself, to the same degree that music is, and Fra Angelico's painting. A world from which Christ is missing? The God of the Museum Without Walls is the unknowable, and—above all—the struggle against death.

Death, not passing away. What I'm speaking of is the basic emotion man feels in the face of life (beginning with his own) in civilizations that have no belief in eternity. And also of the emotion, in other civilizations, that he feels in the face of eternity. "Why is it that something exists rather than nothing?" gives rise to the question:

"Why has life taken this particular form?" Anyone who has glimpsed the banks of death has, upon his return, experienced the depth of that feeling. Most of us have felt it, undramatically, when confronted with other civilizations: it makes the most commonplace of them seem exotic. No doubt it is inseparable from the passing of time—an awareness not only of the strange but of dependency and of the ephemeral. It is what Christianity expresses in the words "here below"; what Hinduism expresses in the word "impermanence." The most elementary awareness of impermanence and illusion is the invincible awareness of death.

From the very birth of historical civilizations, art has given form to the invisible. When faced with the Sumerian statues we have just looked at, the idea that sculptors made copies of gods, kings, or dead men seemed as questionable to us as it had in the room of African art. A statue is created not in order to copy the character it portrays but to release him from the world of men, to give him access to another world. Most often the world of the gods. What we call style—the hieratic, the expressionistic, etc.— is the means to that assimilation. Byzantine art is a clear example of it. The scenes here below become sacred when the style employed to depict them is sacred. No one conceives of the Virgin as a mortal woman dressed in clothes draped like the folds of an icon. And you—have you ever transposed an icon into a *tableau-vivant*? The iconostasis— indeed, the whole Byzantine world of art—is in no way similar to the world here below, just as its hieratic forms are in no way similar to living forms. They are inseparable from the supernatural. One moves not from the golden background to twilight but from the golden background to the world of God.

The style of Asia's sacred grottoes or of Europe's cathedrals, like the style of the iconostasis, gives the divine figures access to the invisible. But out of earthly figures those styles extract no more than their gods' little people.

Until the Renaissance, at least in the case of sculpture and frescoes.

At that point an unprecedented event occurred: the gods of a dead religion were restored to life as statues. Beauty had been the style of the Greek divine, and therefore of the supernatural, just as hieraticism had been the style of the sacred: all the famous nudes represented goddesses before they represented women. Once beauty became separated from the divine, it inspired Italy to develop a technique, idealization, which made it possible to beautify mortal women—indeed, to beautify everything, including landscapes. Aphrodite existed, in her own way, for Phidias, but Venus did not exist for Botticelli; she did not exist for Titian either, even though he was to make the dreams of Christianity conform to her. From the Classical mythology of the Florentines to the historical fiction chosen by Delacroix, Olympus and Paradise were replaced by the imaginary. Artists had represented the characters of Classical mythology in accordance with faith, but they then came to represent the characters of the Christian faith in accordance with Classical mythology. And for the sake of the imaginary, art was to practice the sorcery it had practiced for the sake of Christ, Olympus, and the sacred.

Between Dante's death and Shakespeare's birth, who, in your opinion, was the greatest poet? Ronsard, who sang of Hélène to his own accompaniment on the viola? Or Michelangelo, who invented the hero? Or Titian, who brought Aphrodite back to life? Let us not be taken in by

the great Venetians: Venice may have been the first to orchestrate color, but she was in service to the poem, the successor of Paradise, the divine element of the gods in whom people no longer believed.

And she was to remain so until the end of Romanticism.

Romanticism did not play nearly so great a role in painting as it did in poetry. The passionate dialogue that Delacroix engaged in with Venice via Rubens had no more future than Ingres's serene dialogue with Raphael. But Romanticism revealed a world of art that was as unknown to Venice as it was to Raphael. And not only the world of the poem, which was reigned over by Titian, but a world in which Goya became a brother to Rembrandt and to Michelangelo. A world with mystery at its core, like the world of faith, and in which geniuses are intercessors of the superhuman. Around 1850 Delacroix tremblingly prophesied that the day would perhaps come when we would at the same time admire not Rembrandt and Michelangelo (we already did) but Rembrandt and Raphael. With great serenity, you admire Rembrandt and Piero della Francesca. We shall soon admire them along with Takanobu and the sculpture from Sumer and Africa. Only five hundred yards from us, in Picasso's studio, a cast of Michelangelo's *Slave* is holding sway over the underbrush of clawing sculptures. The West believed that it based its admiration for works of art on its aesthetics, whereas for two hundred years its irresolute aesthetics has derived from the works it admires. Love is not an honors list; neither is the Museum Without Walls.

But with Romanticism the whole world of art was to change: the medieval saint was chosen for sculpture, just as Venus once had been; the range of art included all the

great religions and was to give new life to forms of spirituality all the way to the Gobi desert.

The glory of the word "beauty" came to an end with Delacroix. Courbet and even Corot no longer said, "It's beautiful." They said, "It's good." At the same time as Europe was discovering a multiplicity of the sublime—the first discovery not to be restricted to a quarrel among various schools—it was also discovering yet another form of Realism. All the dull-witted preaching about it seems curiously limited today, now that we know that Courbet's genius is not considered realistic either by the Japanese or by photographers; that the painters of prehistory did not imitate their shadows cast upon rocks; and that images of gods had been created far before portraits of men.

The great forms of Realism can in no way be defined in terms of *trompe l'œil*. Compared to Corneille, Molière was certainly a Realist, but not a photographer. Every form of Realism should, like Socialist Realism, be modified by a specific adjective. For it derives from the idealism, spiritualism, or Romanticism that preceded it, and against which it fights. Romanesque, Gothic, Flemish, and Spanish Realism are related more to the styles of their time than to other forms of Realism. The Realism of the *Shigemori* had made it necessary to close the room in which the scroll was on display; the Realism of *Olympia* had made it necessary to call the police. It was not to Sancho Panza that Don Quixote owed his life; it was to Don Quixote that Sancho Panza owes his prominence.

"Painting what one sees" applies only to fairly recent schools of painting, even if, in certain Primitives, one can pick out a bit of a landscape or a few portraits of donors. On the other hand, the canvas around which the first Museum Without Walls, devoted to painting, will develop

227

is that which Courbet called "a playing card"—Manet's *Olympia*.

I have shown how that particular painting, in which Manet did away with the illusionism and the poem in the *Venus of Urbino* in order to vie with it, had isolated the pictorial statement—that is, the relationship of colors that, within the painting, is separate from the poetry, the religion, or the sacred it had been intended to serve. Manet's discovery has inexhaustible possibilities, because *Olympia* is obviously not just a *Venus of Urbino* that has been severed from Titian's poem. A painter can take any painting and abstract from it the pictorial statement it conceals; however, he cannot give it permanence unless he invents a correlation of forms and colors that can actually *replace* that of the original. Which is precisely what Manet did: the consistency of *Olympia* within the world of painting equals that of the *Venus of Urbino* (a goddess recalled from the imaginary) within the world of poetry. The pictorial statement, very like souls that are reborn through metempsychosis, is again made visible through the process of incarnation.

In museums we find an assemblage of pictorial statements, but we get only a very hazy notion of them, for a painter embodies the pictorial statement by translating it into his own language: the pictorial statement that Manet discovered in Titian is perhaps similar to that which Cézanne discovered in Sebastiano del Piombo, but Manet could only make a Manet of that pictorial statement, just as Cézanne could only make a Cézanne of it. The major importance of the Museum Without Walls—the reason it is replacing the temple and the palace—is the fact of its being the place for that pictorial world, and in it painting

actually becomes its own highest value. Painting, not beauty or genius.

Painters discover the pictorial statement in every painting in the world. Which means, first of all, in European painting throughout the centuries. For European painting is color's favorite realm, and the pictorial statement transcends history: every painter detects it in Van Eyck as well as in Titian. It is the recognition of the pictorial statement that spawned the inner museum, in which paintings elude the gods and the saints they depict—and, to a certain degree, time, for although in itself a work of art belongs only to its own period, the deciphering of it—its changing face—belongs to that same period or to no period at all. Throughout the ages the pictorial statement took on a transcendency which is ironically akin to that of beauty. It is thanks to the first Museum Without Walls, and to it alone, that Western painting has ceased being considered a value of civilization, because it no longer refers to anything but itself. It knows not why. And the day it no longer seemed to be anything more than an arbitrary play of forms and colors, cursed painting made its appearance.

Contemporaries have hardly noticed it, because they consider Rembrandt to be the first cursed painter. The first? He was the only one. He was also the only one who had tried to change the function of painting; he never expected to find in it the same unknown dimension as did his Dutch rivals, who were laden with honors, and he knew their painting was doomed to nothingness. He was born with the bambocciades just as Romanticism was born with Joseph Prudhomme.

When modern art appeared on the scene, museums were in all their glory. The survival of masterpieces seemed far

more assured than it is today: before the discovery of metamorphosis, immortality lasted longer. What caused the Independents to be fanatically—hence religiously—opposed to the Officials were their conflicting views, not on representation but on survival: the Officials believed that a painter carried on the tradition of the dead masters by resembling them; the Independents knew that the only way they could carry on that tradition was by not resembling them.

To the Officials, paintings were spectacles and would survive because of their beauty. However, when the word "beauty" lost its precise meaning, beauty itself lost its immortality. For immortality had coexisted with beauty, just as eternity had coexisted with hieraticism. Théophile Gautier's proclamation:

> All things pass. Sturdy art
> Alone is eternal.
> The bust
> Outlives the State.

no longer had much meaning for painters who one day began to admire works of art that had been scorned 150 years earlier, such as the Romanesque Virgins, which had not been sculpted for the purpose of being statues; nor did it have much meaning for those who remembered that the Roman busts and Greek nudes had been forgotten during their thousand years underground.

To the Independents, painting consisted in the use of a creative power—a power they would possess only by not imitating that which had been created by it. In their civilization, devoid of immortality, that power was the power

of survival. They encountered it daily at the Louvre. They sacrificed everything to it. Art had obviously not become a religion, but it had become faith. The sacred nature of painting was not the same as the sacred nature of the gods; it was the sacred nature of the dead. Cézanne and Van Gogh, both of whom were believers, valued the possibility of their paintings being hung in the Louvre more than they did the entombment of their bodies in Christian earth. To Cézanne, as well as to Van Gogh, Degas, Matisse, or Braque, the sacred place was the Louvre, because every painter believed that the works chosen by the Louvre were guaranteed *survival*. Those images, which were released from time, were often created for places that were released from time: churches or temples. In its own way a museum is also released from time. If God had declared to Cézanne that one of his paintings was bad, Cézanne would have been grieved, for he had never really been satisfied with his paintings; but if God had told him that his *painting* was bad, Catholic Cézanne would have taken Him by the hand and led Him to the Louvre. So would we.

The Museum Without Walls, even more than the Louvre, gives us a sense of art's own time, which is disconcerting, since it is no longer identified with immortality. For many of the Museum's works never merely belonged to that closed, restraining time which the nineteenth century had called "real time" and which art has almost always suggested that men call "the time of death."

I once tried to suggest art's own time by comparing it to the time of saints when one prays to them. The faithful believe that a saint belongs to the present, which his eternal life bestows upon him, and during which prayer takes place. He also belongs to historical time, since he

has a biography: Saint Francis didn't live either in the nineteenth century or at the time of the Apostles. Finally, he belongs to chronological time, to the duration of the living. Admiration "actualizes" a work of art just as prayer actualizes a saint.

A work of art obviously belongs to its own period, but not only to that period. Its time, which is that of metamorphosis, has made the life of a work of art intelligible to us by releasing it not only from the present but from eternity and immortality. Outside of religion, the Museum houses the only world that eludes death.

The artist's power was to become increasingly enigmatic —that is, less and less limited to a pictorial statement. The nineteenth century had revived schools of painting; ours, by reviving the art of the early ages, has revived styles of sculpture. A few thousand years as against a few centuries.

And the effect Cézanne had on painting was not limited to the pictorial statement. From the Romanesque statues to El Greco, via Piero della Francesca, Cézanne revealed to us the "austere style" of the West, as well as a hidden architecture. And Picasso revealed the nameless power that will be defined by our successors, just as we define that of Cézanne and Manet, and which you have just seen lying in wait, ready to capture for the Louvre the prehistoric Venuses and all those figures from the New Hebrides.

Although artists have never defined that power, they have time and again recognized its existence. During a conversation with Picasso, I had once quoted Van Gogh's remark: "When it comes to life and to painting, I can perfectly well do without the Good Lord. But as a suffering creature, I cannot do without something that is greater

than I, something that is my life, the . . . ," and Picasso had completed the quotation: ". . . the power to create."

We still don't understand its language; we only hear its voice. That power sweeps through civilizations with biological vigor. The death of the artist who exerts it does not destroy its effect, and at times unleashes it. It sets the correlation of the forms it discovers against the correlation of living forms. It can originate from the most disquieting unpredictability, from a madman's inspiration, from the naïveté of the naïve, or from the patience of a shepherd: we have discovered, among other things, those arts which are based on chance. But more often that power takes on permanence in a profound domain: art has not given shape to the forms of life according to its own sweet will, but according to given styles—according to a civilization's highest values, when it knows what they are. I remember a remark I once made: "Formerly, in Chartres, there was a population more Christian than that which prayed in the nave: the population of statues . . ."

Art harmonizes its own elements in a way that life never does. What face possesses the unity of Vermeer's *Portrait of a Young Girl*? Vermeer made that unity perceptible, just as other artists—the sculptors of Olympia, for example, or the neo-Sumerians who sculpted the *Gudeas* —made other elements of the essence of the world perceptible. Braque's dialogue with Picasso, Cézanne's with Van Gogh, Raphael's with Rembrandt, and that of the Acropolis with Chartres is a very old dialogue, although it grows more profound now that the scattered pieces of sculpture here amid the olive groves and the geraniums tell us that it is the same as the *Shigemori*'s and Poussin's dialogue with the blood fetishes. Aztec sculpture and the tribal arts made a breakthrough into our Museum With-

out Walls, just as Goya did into Manet's, and Masaccio into Cézanne's. It assimilates its new styles just as we welcome young painters. Colors yet to be born will be confronted with the power expressed jointly by the apparently irreconcilable colors we have not forgotten. Every one of our masters created his works in relation to all the works he specifically chose from the past, even when he created his own to refute them. The ultimate place of the Museum Without Walls is to be found in the minds of artists, and the jury that hands down a verdict of survival is the collection of works that each of those artists chooses out of death's debris.

This Museum is not a tradition; it is an adventure. It doesn't derive from any hierarchy—especially not that of the mind—for it encompasses them all. It pays no heed to the Manichaean dialogue that Europe carried on for so long: Are you concerned about whether to choose the Dakar Museum as against the Acropolis Museum, or would you rather try to discover what unites them and thus causes the pervasive effect that both have upon you, and that you know is more complex than mere admiration? Beauty implied an aesthetics; the Museum Without Walls calls for problematics.

Since we have been invaded by the art of other continents, as Christianity was by Classical antiquity, we are not aware of the first cycle of global history drawing to an end any more than we were of its coming into existence: it began with the first colonies and ended with their independence. Whether or not Western art expresses our conquest of the world, from the great discoveries to the downfall of the British Empire, the Museum Without Walls was born along with the independence of the Third World, and the screen processes of photography—without which

it would have been born far later—are curiously contemporaneous with the liberation of India. The arts too were emancipated, and the first treasure-house of the Museum Without Walls will be a worldwide collection within less than a century.

For although the Museum is wider-ranging than any of the others, barely a hundred masterpieces in it obsess our memories and our hearts; and the same may be said in the case of traditional museums. We are all inhabited by a treasure-house from, for example, the small Acropolis Museum, and we are all inhabited by our own Salon Carré of the Louvre or its equivalent. The Musée de l'Homme and the Museum Without Walls will soon have their own treasure-houses, which will resemble them only to the slight extent that the *Nymph and Shepherd* resembles Titian's works as a whole, or that *The Three Crosses* resembles Rembrandt's.

The paintings we call masterpieces are sometimes accomplished works and often haunted works. "If I were a believer," Braque once told me, "I should think that certain paintings had been touched by Grace." I have never known one great painter—not one!—who hasn't told me in some way or other that the most important element in his best works, as in the masterpieces of other painters, was inexplicable—no matter whether that implied mystery or clarity. That same sense of the inexplicable holds sway over the treasure-house of the Museum Without Walls— over what makes a major work the privileged fellow creature of its brothers, but also makes them brothers to works that have absolutely nothing in common with them —except the fact that they belong to a world that is still unknown. *The Woman Governors of the Almshouse* is not the most accomplished work of Hals, that tedious

painter! The *Nymph and Shepherd* is not as accomplished a work as the dazzling and multicolored Titians of 1555. But the treasure-house unites that *Nymph* with the last Rembrandt through a process of inexplicable and obvious fraternity. It constitutes itself. We believe that we choose the members of the jury that decrees survival, but each one of them is also chosen by the others. At times the jury as a whole calls for the presence of related works, and at times, for foreign works, precisely because they are foreign. There are not many Dogons who could stand up to Phidias, but neither are there many Phidiases who could stand up to the Dogons. Van Gogh calls for Picasso, who calls for the sculptor from the Cyclades—like the artist who wants to carry on the tradition of his masters and also to destroy it. Even if the nature of art is impossible to express, this treasure-house may well convey it to the civilization that has begun with us, for art conceals something more profound than art. Our artists' world-of-art, as suggested by each one's Museum Without Walls, follows in the wake of the superworlds of the great religions and the unreal, at least by reason of the timelessness to which it belongs—by reason of what separates it from the time of men. In our civilization sans superworld, it is, in any case, their successor.

And when enigmatic timelessness takes the place of the opera of the unreal, in the same manner as the unreal had taken the place of the gods, our treasure-house will be the most recent conqueror of fate; for the sacred, as well as beauty, the superhuman, and the imaginary—all of which gave the impression of serving the artist—have become dead servants of his surviving presence.

And the treasure-house of the Museum Without Walls is a constellation of forms we believe we have chosen

because it corresponds to the questioning that is basic to our civilization—a civilization that cannot manage either to drive out the unknowable or to welcome it—just as beauty was the one and only star in the constellation of forms that corresponded to the Hellenic unknowable.

The sound of the summer rain was being drowned out by falling beams, and very soon after, by the din of construction work. Whatever could they have been building at that hour of the night?

Almost all historical civilizations—as well as the others—have carried on a dialogue with the unknowable. Not in mysterious ways: when it comes to reflecting upon art, complacently accepting the mysterious is nearly as pointless as complacently accepting the rational. It is a question not of choosing the unknowable but of defining its scope. Which is what we ask of some few lookout peaks of knowledge. For while no one has experienced death, everyone has a knowledge of death; and the Hindu sculptor who has lost himself in the Absolute remembers the road that leads to it. The unknowable encompasses death, sacrifice, cruelty, and the meaning and origin of life; it is a mixture of what man hopes to know and what he will never know. The study of religious feelings, the unconscious, and magic feelings, has accustomed us to their limbos; and the most powerful language used by mankind to give answers to answerless questions has almost always been drawn from art: the Greek unknowable had called upon the style of beauty, and the Christian unknowable upon the style of Christian spirituality.

Our civilization, which now sees that of the nineteenth century as a hesitant and optimistic preface to it, is not

devaluing its awareness of the unknowable; nor is it deifying it. It is the first civilization that has severed it from religion and superstition. In order to question it.

And were it not for that process of questioning, the Museum Without Walls would have never been born.

Greece and Romanesque Christianity had responded with forms created by their own artists, because each had responded with a religion. But art never expresses more than the unknowable of its own religion. The unknowable, like the sacred, takes its shape from whatever suggests it. The sacred dominated the arts of Sumer, Egypt, and Byzantium, but the art works of those civilizations expressed the Sumerian, Egyptian, and Byzantine sacred, not just the sacred itself; because the arts derive from feelings, not concepts. Our art cannot express the sacred element in our religion, since no religion holds sway over our times; and what type of art could express the unknowable in itself? Now that we have discovered its plurality, our approach to it is through the plurality of its forms.

At a time when individualism made us the heirs of the pluralism of freedom, Manet, Renoir, Cézanne, Van Gogh, and Seurat could have lunched together; but what do Matisse and Kandinsky, Rouault and Mondrian, Picasso and Modigliani, Soutine and Klee, or Braque and Chagall —all guests at this multicolored banquet—have in common? The realm of forms that resist those of outward appearances. Monet still believed that the landscapes he captured were better likenesses than Corot's; but there are no more landscapes.

The forms of our art have become as arbitrary as the forms of the sacred—those forms you heard them conversing with the whole afternoon. Like them, they are in no way similar to outward appearances. And like them, they

are forms of what we are unable to see. But what is "the sacred" today?

Art's own time does not coincide with the time of the living.

Great artists cannot ever quite be considered as among the dead, nor can their images. All those painters who conversed with those now gone will also converse with those who have yet to be born; together, Rembrandt and Baudelaire clearly contributed to creating a future population in their names.

Painting's own space is not life's space.

The correlations of artistic creation are not the correlations of Creation.

Works of art are objects of metamorphosis—like the gods.

Human life is governed by the most profound awareness of the dependency that subjects us to the god of Greece to whom no temples were ever erected, to the god all historical civilizations have called "fate"—and who, to the individual, to mankind, and to the world, is the contrary of freedom.

Through the creative act the artist invents another basic correlation, which is why, twenty-five years ago, I wrote that we experience art as "a revolt against man's fate." And whether it be the art of our contemporaries or *our* art of the dead, it will remain so, as long as this civilization lasts. Like the iron dice in the laps of the Japanese gods, the past is in the lap of the future, waiting.

And then . . . Well, the Museum Without Walls is not eternal either.

The machines were making such a racket, I was obliged to raise my voice.

I am reminded of the night when Michelangelo lit candle after candle so that he might contemplate, tirelessly, the resurrection of the Vatican *Torso*, amid a crashing of the hammers that were building Saint Peter's and which filled the night. . . . Did he know then that some three hundred years later—at a time when the West was no longer even Christian, when all that remained of his times was that eternal uproar—men would remember the Roman night when, upon what was then called beauty, candles had cast the shadow of Michelangelo? . . .

The din ceased as suddenly as it had begun.

It would seem as if the shadow on the *Torso* is reaching out toward the pacified hills. Listen to the little song of the frogs. . . . This afternoon we have truly heard the ageless river throb: perhaps one day, when the Museum Without Walls is thrown into the charnel house of great dreams, someone will remember these hours during which we heard the creations of mankind singing back through the centuries, just as we hear those frogs singing far back into the night. . . . I recall a small forest in the Vosges that we had just recaptured. In the trees, above my dead comrades, birds were starting to sing again in that same small voice, and the silence was saying in its haunting voice: "They sang over the bodies of soldiers in the year II . . ."

The hum of conversation was starting up again. To-morrow, Vauvenargues; Jacqueline was coming to fetch me. All through my speech, especially while I was talking about the creative power, I kept thinking: "There once was a Little Man from the Cyclades . . ."

# VIII

To the right and left of me, the mountains of Provence, like vertical panels. Low clouds hid Cézanne's Mont Sainte-Victoire. In the valley below was the cubical Château de Vauvenargues, with its four flat turrets topped with truncated cones. Vertical, separated from all the rest by its rocky pedestal, it was a tomb.

Had that château been Picasso's idea? No, Jacqueline's. When Kahnweiler told him, "It's enormous," Picasso had replied prophetically, "I plan to fill it up!" He meant: with paintings. And, indeed, merely the paintings in Mougins would fill it up.

It is somewhat like the Cid's mausoleum, but to really resemble the Cid's it would have to be haughtier, and have towers more like those of the Palais des Papes. It is also somewhat like Don Quixote's. The French consider that ancestor of Lear's Fool—an equal of the King and of his brother Hamlet—as too much of a fool! During the Spanish Civil War my friends in Spain quoted him as they quoted Karl Marx. It was in front of Barcelona's Sagrada Familia (the only diabolical church in the world), contorted by flames, that a nurse told me shyly, "Don Quixote's tomb . . ."

I too find Don Quixote a character of magic spells and sorcery; and I once saw a sunset spread the shadow of his windmills over the cracked clay of the plateaus of Castille, just as it had cast the shadows of Bucephalus'

46. Picasso. *Figure with a Vase*.
Bronze. 1933. Vauvenargues.

funeral pyre over the Persian desert and its huge crickets, in the presence of Alexander the Great's army.

I saw Cervantes' tomb in the church at Alcalá during the winter of 1936. Our planes were being repaired and I wandered about in the main square, while the frosty petals of the Spanish dust swept across it. I entered the burned-out church. The crucifix, still intact, was bound to the tombstone by a large charcoal arrow, which the anarchists had decorated with an inscription addressed to Christ: "You were lucky. He saved you."

The road Jacqueline and I were taking led straight to the Château de Vauvenargues. To enter, one climbed a steep flight of steps, above which the building rose slowly and solemnly. At the top of the steps was ironwork similar to that of the Escorial and which led to the terrace where Picasso is buried. On the lawn the black-bronze

*Figure with a Vase*, a guardian spirit, had one arm stretched out—parallel to the ground and against the noonday clouds—to present its offering. Volutes of Spanish or Mexican stone, a medieval entrance hall, a puzzling stairwell, a guardroom in which one could only make out narrow cobblestones closely set into a paved floor; at the very back, a monumental and very low fireplace. In the extension to the entrance hall, a huge copper cauldron filled with flaming gladioli: a blazing mass alive at the center of flat white walls rising toward shadow. Farther on, a few real flames in the fireplace above red logs—gladioli on fire. On either side, lead greyhounds that had been found in some antique shop, seated and life-sized.

"Does all this seem right to you?" asked Jacqueline.

"Extraordinary . . ."

Love had indeed devised that tomb, but the gods of shadow had helped. In all of Picasso's studios, even in Mougins, there had been the kooky little devil that caused Rafael Alberti* and his poet friends to say, when they saw the tarots, that Picasso had just conquered the Palais des Papes at the head of his musketeers, his Masks, and his toreros. There at Vauvenargues everything picturesque was relegated to the background by the constant questioning that had consumed his life in a glittering burst of flames. (I thought of the funeral chamber in the Great Pyramid, and of the glow that rose

---

* An important twentieth-century Spanish poet (b. 1902) who, along with Lorca, is classified with a group called the "Generation of 1927." Alberti's poems take many forms, from the classical to free form, and from the logical to incoherence and free association. In his collection *A La Pintura* (A Homage to Painting), only two modern artists are considered, Solano and Picasso. (Tr.)

from Hitler's underground office, along with the disconsolate singing of the black truck drivers, when we had taken Nuremberg.) Once given over to paintings, Vauvenargues will probably be the noblest mausoleum any painter ever had. But nothing will keep those flowers burning like a funereal flame, there in front of the open door through which I saw the *Figure with a Vase* hold out its offering to a sky with low, passing clouds. The symmetrical greyhounds alone will keep watch.

In the dining room, also near the fireplace, was one of Picasso's gilded bronze cats, its tail in the air—a brother to the cat in Mougins. The sideboard of Picasso's famous *Buffet de Vauvenargues*; and a surprising life-size photograph of Picasso himself: his eyes played so great a part in his face that when they were lowered, almost closed, he no longer looked like himself. High-backed chairs decorated with outline paintings of satyrs.

"They were meant to be upholstered in velvet," said Jacqueline, "but since they were still only covered with canvas, Pablo painted them."

On the mantelpiece, near the photographs, was a sort of small paper napkin, cut up but folded. Jacqueline pinched it with two fingers of each hand and, smiling—but this time with a twinge of past happiness dispelling her misty sadness—opened it out into a festoon of small dancing figures, hand in hand, very like the satyrs.

At the right, the painting of Barcelona rooftops I had seen in Mougins. The bathroom wall was painted in fresco: a forest interior and another clownish satyr.

"So he made you a present of a forest?" I remarked.

"Oh no! I never asked him for anything. When he saw the fresh new cement, he felt like painting on it and did a faun in the woods. So, naturally, I bought some garden furniture . . ."

And, indeed, there was a bench with the trademark always found on park benches: "Allez Frères." Life . . .

An empty room.

"We lived here," she said, 'but we never quite settled down."

"Did you ever really settle down anywhere? Judging from Mougins, I should say that it was the flocks of paintings that had settled down there. And spent their time reproducing at top speed. What you two did was tend the sheep . . ."

We soon returned to death's side. Out on the lawn, framed by the door, was the *Figure with a Vase*.

In contrast to the statue, whose gesture married the grave to the bitter landscape, I should have liked to see *Guernica*'s apocalyptic horse's head, which strains upward over the charnel house, like horses' heads in dreams.

"Unfortunately," she replied, "it can't be done. But when Spain is once again a democracy, we'll go together and take it to Madrid, as he promised. With Miguel. Would you like to come with us?"

Again, as in Mougins, I saw that wonderful smile; yet she didn't seem to me to be suffering quite so much, because Picasso's tomb filled her life.

If he had hung *Guernica*—that weapon and coat of arms—over the hearth in the guardroom, it would have resembled those black swords that the Spaniards—black as well, and with amputated limbs—hung, after the Battle of Lepanto, on the limestone walls of their empty castles peopled by fireplaces. Soon Jacqueline would fill Vauvenargues with Picasso's paintings. "They don't belong in people's drawing rooms anymore," he used to say.

No great artists are watched over by their works. The houses of Rembrandt and El Greco, as well as one of

Michelangelo's, were turned into museums. Death is missing from them. Even if the statue of Colleoni stood over his tomb, that tomb would be nothing in comparison to Rembrandt's if it were watched over by *Bathsheba*, or to Titian's were it watched over by his last *Pietà*! One dreams of having Pierro della Francesca in the church at Arezzo, and Giotto in the church at Assisi; their spirits would still be there in the service of God. The most striking tomb in the world was never built. When Shah Jahan saw the white Taj in which the queen was to be put to rest, he decided to have one erected for himself in black marble, with the largest white and black arches in the world, to link it to the queen's, overlooking the Jumna. But Shah Jahan died in the citadel at Agra, a prisoner of his son Aurangzeb. Through its marble window one can still see the Taj, the vast river, and the desert, with its ghost of a mausoleum.

Picasso used to say that his paintings no longer belonged in drawing rooms. But what about museums? He had tolerated them, and had no intention of being dismissed by them. Did they perhaps belong in his studio? After all, every one of his studios had overflowed with paintings and sculptures. Did they belong in Avignon's papal palace, which might be occupied by his canvases while awaiting the Devil? He had been seeking a chosen place, destined for his paintings, but death is patient: the chosen place was that tomb at Vauvenargues. Of course what transformed Jacqueline's idea into a true discovery was the nature of Picasso's genius. If Corot's tomb were in a small château somewhere in the Ile-de-France region, where Gérard de Nerval could have watched over his *Rose in a Glass* and *Woman with a Pearl*, it would be in keeping with his art. And we regret that Fra An-

gelico was not buried in the San Marco convent in Florence, and that Michelangelo's coffin was not placed under the recumbent figure of *Night*, which would have turned back into a block of stone were it in one of his vineyards that today grow wild. But imagine what Goya's tomb might have been! The haunted hustle and bustle of his Black Paintings, watched over by the ghost *Saturn*, forsaken in an unfurnished castle deep in the grassless Aragon sierra . . . For an art such as his, nothing is so fitting as a tomb. Monument, solitude, coffin, rebellion. Death does artists more honor than a museum.

With death thus confronting genius at Vauvenargues, Jacqueline's paintings will set the tomb in contrast with another haunted place. What, with the exception of *Guernica*, can we expect to find there? On those immense funereal walls the canvases that had rushed to death's door seemed more real than those that would one day arrive. But may those too never come to know the chronological order of life, and may they rediscover the enchantment of Mougins—from the sketches for *Les Demoiselles d'Avignon* to the most agonized of the tarots, from the *Woman with Leaves*, who casts a spell on her branches and boxes, to the diabolical totem at Notre-Dame-de-Vie . . .

"You never know how paintings live or how they die . . ."

But one can at least foresee how at Vauvenargues they will live the inexplicable life of works of art in time. They will take no part in becoming "immortal." They will not generate Picasso's presence, as did Clouzot's film that was devoted to him (and, yet, that voice of his . . .). They will, above all, generate the life of painting—that life that alters canvases one hasn't seen for a long time

and which return, as Picasso said, in golden robes. "The oranges used to change all the time," Jacqueline had pointed out to me regarding Matisse's large still life. A well-known change when works of art are linked to the supernatural—as if sculptures, for example, were spirits. The lowered eyes of the Khmer queen, the half-closed eyes of the Beauvais *King*, the hypnotic eyes of the Sumerian *Singer* shaped like a prehistoric Venus, and the spellbound geometry of the Dogon mask all vary according to the hour and the month, as if that within them which is inexpressible sheds a light on them that is as changeable as the light of day. The least haunted of paintings vary just as much as the others. Chagall had spoken of the "chemistry of color" as one speaks of an animal's changing coat. When she had been gathering the tarots together in Mougins, Jacqueline murmured, "Sometimes Pablo and I made walls for ourselves . . ." Actually, each painting in itself makes its own wall. I once saw Braque shrug his shoulders, saying: "No one can explain the one really essential thing in a painting— not even the painter. Maybe it's somehow connected with the whole. . . . Note how good painting takes on a sort of poetic quality, just as bronzes take on a patina. . . . People claim that we discovered the poetry of guitars and packets of tobacco—a stupid thing to say when it comes to Picasso, Gris, or myself. Packets of tobacco take on a sort of poetic quality all by themselves. Vermeer painted guitars before we ever did. Vermeer's and Chardin's objects are not poetic, and neither is the atmosphere of their paintings! It's their paintings that become poetic." And as Picasso and all the other painters have said: "There are certain paintings you stop work on, planning to go back to them later—paintings that finally complete themselves."

Any language of colors that is unrelated to "the real" always ends by being called poetry. For centuries people have had a vague awareness of the magical nature of art (an awareness that has caused madmen to shoot at the *Mona Lisa*, put out the eyes in frescoes, draw pictures of the dead, and so forth), and have generally applied the word "life" to figurative spectacles. The public used to speak of painting in terms of *trompe l'œil*, and add, when looking at a portrait, "I'll bet he can talk." Today everyone knows that the life of a masterpiece is not the life of the characters it portrays, but I have always heard painters speak about paintings as bewitched objects. "We think we're making an idol, but we're making a sculpture," Picasso used to mutter. "No matter how, a true image is an image that is capable of going out in search of adventure, right? When the ship sails off, it means the painter himself dies."

That is what he considered the first step in metamorphosis—and the most ambiguous, for we move imperceptibly from the works of the living to those of the dead. The day before, at the Fondation Maeght, the Douanier Rousseau, Braque, Picasso, and Balthus had seemed almost to belong to the same world of art. Paintings make up only one empire, but many kingdoms, and life joins forces with survival, yet remains separate from it. In Saint-Paul, Picasso's recent death had added to that perplexity; yet *The Reaper* and the drawing for the *Weeping Woman* were, like the Sumerian statues, as plainly alive as a plant. But their sort of life is more difficult to define, because it does not conform to the same biological evolution; its course does not run from birth to death: the plant will die, whereas the painting we look at is one that has survived, precisely because it *has* survived. Only dead works of art never change. Indeed, we begin to

wonder whether a true work of art can be separated from whatever it was that caused it to change: pulsation or the chemistry of color, the transformation of a packet of tobacco into poetry, the metamorphosis of gods into statues. The works that die don't lose their leaves; they lose their phosphorescence.

We link the living to the dead by creating little purgatories called museums of modern art. But artists speak of art only in terms of life, and the life of a work of art is what has become the great enigma. One day, at the Grands-Augustins studio, Brassaï said: "Today we know that the Portuguese navigators—Pinzón, for example—had reached America, probably Brazil. Before Columbus. Let's not forget that he died declaring that that continent didn't exist, and that his ship had reached India by the western route. Why, despite the name Amerigo Vespucci, is Columbus still the Ancestor?" I reminded him that after the discovery of the first savages, navigators had merely discovered other savages, whereas after Columbus' discovery of the savages, Cortez had discovered the empire—and the gold. Picasso grabbed me by the arm—a thing he never did. "Like in painting!" he said. "Instead of gold, they might have discovered the plague, right? Or might never have returned? A painter, he paints a picture. He's rather pleased with it. Or he isn't. But the same picture is painted again! It's painted again and again! After all, you can't kill off your successors."

He had no fear of posterity, but he dreamed of the Cortezes to come. Because of that genius he had as a "diviner," he knew that certain pulsations of history, and the revolutions of man's sensibility, are no less responsible for the metamorphosis of a great artist than his successors are. If Picasso had shown that much interest

in the fact that Cortez transformed Columbus, it was because Roosevelt had transfigured Cortez.

The gladioli were glowing red in the shadows, very like the yellow gladioli that, in Asia, are placed before the gods in museums. During the period of Asia's great sleep, from Peking to Constantinople, admirable small fragments of faience and mosaic used to fall gently into the silence. I had heard chips of mandarin tiles from the Imperial City fall when foxes would climb into the violet asters at the foot of the high wall; and turquoise chips from the Koranic School at Isfahan, where roses grew wild again behind silver doors; and chips of porcelain from the Siamese temples that were still called pagodas. Their towers, higher than those of Notre-Dame, were sparkling with the glass beads and broken dishes the East India Company had once showered upon Siam. Small bells were set to gently humming by the morning wind, which blew chips of Chinese and Dutch pottery, painted blue, onto my book. . . . For the great ceremonies, thousands of kneeling women, who held in their long-fingered hands gladioli as yellow as the bonze's robes, would, all at once, lower their fields of flowers, which formed patterns that flowed like the wind's. It was at the Bangkok Museum that I first saw the bonzes offering necklaces of tuberoses to the Buddhas of the ancient kings. (Where did I see those necklaces again a few months ago? Around the necks of the seriously wounded in Bangladesh.) They had the guard's approval.

What if robed Dominican nuns would bring lilies to the Gothic Virgins in the Louvre? What if our museums would welcome offerings, if the gods and the tombs would still welcome their faithful? . . . Gods and tombs

from Egypt, Mesopotamia, Palmyra, Greece, a small corner of Rome—not too big; and from our own Middle Ages; also, all the Renaissance Venuses and the characters out of Classical mythology; and "the imaginary" that awaits its flowers, like the Giorgione painting in Boston, which is always honored with a magnolia. Offerings to metamorphosis . . . Everything we have resurrected would receive flowers as a substitute for their original surroundings—the temple, the cathedral, or the vanished palaces; all the anemones, canna, cineraria, and valerian of the Fondation Maeght's gardens would not have been enough. An amazing period, which asks for statues as such, unrelated to what they initially were meant to be: functions of the soul . . . No posterity—whether a lottery, fate, or metamorphosis—accounts for the posthumous life of works that will transform Picasso's tarots into paintings we yet know nothing about, and over which we have no control. "The idols we're not acquainted with can always be thought of as pieces of sculpture," Picasso once reminded me; "so can the ones we are acquainted with, but less so." Aphrodite has been a statue for a long time! But Venus had never been more than half an Aphrodite; it is uniquely because of our civilization, with its taste for mystery and its mania for the past, that the past of art is spewing forth secularized idols, which have so successfully emerged from the world of the gods or the dead to become a part of the world of art! The day before, at the Fondation, I pictured the pieces of sculpture surrounded by the network of cathedrals, Indian temples, and grottoes (as well as glades for the fetishes) for which they had been sculpted. I thought of the Narayan sect's Hindu temples, in which a profusion of sculpture had imperceptibly united the faith-

ful with gods as lush as the tuberoses around their necks; Narayan then substituted mirrors for those gods, and in the half-darkness of the endless vestibules, frames of heavy coral, which had been artfully set in to cover the walls, guided the faithful toward their own images, which they deified. The banished gods are in museums; why, then, won't mirrors be in them tomorrow? Why wouldn't Picasso have played with the fragments of one of the mirrors that have inserted men into a deathless world?

Those mirrors evoked another mirror, that at the National Museum of Mexico, which I once visited with the last ambassador of the Spanish Republic, and where I had found the pre-Columbian obsidian skull, which the Fondation was still awaiting. A celebrated object, it was displayed alone in a glass case, in front of a mirror that united it with the visitors, as the built-in mirrors that had replaced the gods united the faithful with the sacred. It also reflected the huge glass window through which trees entered the room—large trees, which are heirs to those which had lined the canals of the Aztec capital, where the Spaniards had found "so many magnificent flowers and sad dwarfs." In that cyclopean museum, one of the most modern in the world, the Indians bring their flowers to the idols, which have not yet quite become statues.

That obsidian skull represents Death, but do we ever understand the vanished idols? Yet the skull transcends civilizations more than do the Mexican idols surrounding it, just as hunger, which metamorphosis does not destroy, transcends fleeting emotions—not because the obsidian represents the skull, but because that black quartz represents it in accordance with a style. Despite the everlast-

ingness of archetypes, that style transforms it into a dialogue between man and the hereafter—and into a sign as well as a symbol (in the old sense of the word), a symbol expressing that which it alone can express: "The secret of things, which does not lie in their outward appearances," according to Aristotle.

The clouds that floated through the mirror stopped moving and formed a leaden ground against which the obsidian gleamed. From outside, one could hear the streaming rain, like the sound of paper being swept against the huge window. Driven in from the garden by the storm, Indians entered and formed a procession that was reflected in the mirror. The dying Indians passed in front of the sacred sign of the dead Indians, while the rain, indifferent to funereal symbols, poured down as it had once poured down upon the dinosaurs.

On the polished skull a reflection of the rain encountered the reflection of men. What the mirror said was that ever since the time of the fighters who wore helmets shaped like eagles' heads, the starry sky has cast its light "upon the dead warriors and upon the sleeping conquerors"; it also said that a fate, equally persevering, had caused the Spaniards to see the Aztec idol first as a demon, then as the imitation of a skull, and finally as a masterpiece. The obsidian skull was imposing its metamorphosis upon the royal mummies nearby and upon the clouds that had been swept along by the winds and were drifting about in the mirror. Metamorphosis plays more readily with the images of gods than with the image of death. All life created by the gods is doomed to nothingness; but the lives that have triumphed over it—forms, ideas, and gods—were created by men. The word "art" had a strange ring to it in that temple of metamorphosis,

which was born along with our civilization and is no doubt doomed to vanish with it.

Picasso had been more profoundly inhabited by metamorphosis than by death. He had seemed to be linked to it, just as medicine men are linked to people from beyond the grave. He had experienced, contagiously (I hadn't forgotten the Grands-Augustins studio), that process of metamorphosis that had brought him the violin-shaped idol and the Lespugue *Venus*, but also the *Bull's Head*, which he had hoped to see revert to a bicycle seat and handlebars. "All that I've done—the handlebars and seat—all that is not enough: the idea would be to find a branch and transform it into a bird." That same process of metamorphosis that had caused him to say that at exhibitions his forgotten canvases returned to him in luxurious robes, and that when a form was created, "it was there to live its own life." His own process of metamorphosis, which forsook his successive manners, and into the face of which he threw his creations as others entrust theirs to time—that same process that had foisted upon him his Confrontations and his population of tarots, hanging like butterflies along the four hundred yards of his two Last Judgments—there, in the Palais des Papes, where viewers could hear the Cretan outcries, like Pasiphae's shrieks at the death of the Minotaur. And that same process of metamorphosis that was awaiting him there at Vauvenargues.

"There once was a Little Man from the Cyclades . . ."

His Paris studio: one day with *Guernica*, then one night without *Guernica;* a cupboard cluttered with statuettes, on a shelf under the slender bones of bats; the round-headed character, his eyes radiant with blackness

under his pointed hat, and dressed in the same gabardine coat an American actor had worn that year to impersonate Death. Fingering a violin-shaped idol, he had talked about the Wandering Jew, about the creative power, about the Little Man born in the Cyclades three or four thousand years ago, who was reincarnated from century to century, until Van Gogh, like the invincible thread of motherly love—about the Little Man who knew that the images of the gods are always discovered by unknown sculptors. "I made my plans out of the dreams of my sleeping soldiers," said Napoleon. . . . Among the statuettes Picasso had carved with a penknife, the Lespugue *Venus*, and all the wildly mad paintings, the rue des Grands-Augustins had made its way into the studio in the form of a few short barks. And Picasso had asked, looking like a surprised kitten: "Maybe he's me, how do we know? He loves bullfights, naturally. . . . And people always remember him, naturally. . . ."

That had all taken place in Paris, among the living. There in Vauvenargues the Little Man had something more to say. Picasso has been reproached with trying merely to renew his art, whereas his predecessors, even Van Gogh, had wanted to probe ever more deeply into theirs. Like the black statue on the tomb, the Château de Vauvenargues, rearing up against death, replied that a painter may change his costumes, but that a dead man doesn't choose any specific disguise: he resembles his own skin. The tarots are a far cry from Picasso's first "Negro" canvases, but they move in the same direction, which distinguishes him from everyone else. "Style," he once told me, "comes after you're dead: note the recumbent figures on tombs!" What is there in common between the paintings of Picasso's greatest rivals (during

one of the major periods of painting, in a country that produced the best painters of the time) and those sculptures by a captive prophet, or the fettered rage of his tarots? Relentlessness. From his *Demoiselles d'Avignon* on, the constant factor in his vagabond art was a deep probing into his own spirit of rebellion.

Had Jacqueline done no more than make visiting painters aware of that fact, she would not have wasted her efforts. When Van Gogh rebelled, he was in search of communion; so was Rembrandt. Throughout the chaos of the centuries, I expect that Picasso found only one forerunner: his master, Goya. *Los Disparates* sinks more deeply into the irremediable than *Los Caprichos*; the last misty "Colossus" dreams among the stars like an atomic cloud above the panic-stricken little arms waving from out of the débacle. At the age of eighty, the painter's fingers had trembled as he drew his last torture scenes. Yet his art pays no more heed to old age than Picasso's. However, his last masterpieces are a continuation of those that came before. Even the Black Paintings, which were clandestine and shown only to his friends, give no impression of having broken with *The Shootings of May 3*, whereas the Avignon tarots show a clear break with *Guernica*. When I thought of Goya closed into his solitude and of Picasso imprisoned in glory, I remembered Menuhin, as I had remembered him at Notre-Dame-de-Vie, talking about "praise" as the distinctive characteristic of European art.

"I just won't stand for being taken for Bonnard—really! Either now or later!" To Picasso, Bonnard symbolized a guilty serenity he had never found either in Matisse or in Braque. Also, a harmony between himself and his paintings which, given Picasso's ambivalence, he both

envied and disapproved of. Never did a painter have that incurable feeling to the same degree; painting never ceased being both the realm of his slavery and the means to his freedom. He had intended that his rebellion be incurable; and it was—owing to that ambivalence, to his aggressiveness, and to his basic hostility to any cosmos. The anti-Takanobu. He had told me that he had no need of style, because his rage would become a prime factor in the style of our time. He declared that Negro sculpture had preserved its virus, and that Vauvenargues would necessarily remain a challenge. "Lautréamont ended up in deluxe editions, and the *Dances of Death* in a museum," he added—and with such bitterness that I did not reply: "So did Goya. But that's where Picasso found him."

He was too much aware of having staked his fate on deeply probing into his own rebellion not to have feared being "retrieved" by metamorphosis. He had been obsessed by it time and again, and it is not foreign to his tarots. The threat of it was the most subtle embodiment of everything he had been fighting against. It is clear only in Marxist terms, but in the context of those terms Picasso's anguish was pointless: Goya was hung in the Prado not for the Spanish aristocracy but for the young Picasso, and for the soldiers of the Spanish Republic who stood in great clumps around *The Shootings of May* 3. Yet any revolt that becomes obsessive turns into a feeling: a basic refusal of the universe—that is to say, of man's fate. And an enemy of power, but also—whether or not it is meant to be—of any power whatever. A revolt, not a revolution. In religious terms, it is the discovery of a usurping God; and in other terms, the "no" Antigone threw in the face of life itself, with all its

heroic resonance. Hence the usurper is, in fact, any attachment to this world—a usurper that wins a victory over an elusive rebellion, the highest value of every artist and of every suicide. But while Rimbaud, for example, was writing his *Saison en enfer* (*A Season in Hell*), and while Goya was painting *Saturn*, a world existed in which mockery was not merely laughable—a world that would have existed even if Rimbaud had burned his manuscript or Goya his painting. Universal mockery is equivalent to a feeling of servitude, and the most profound servitude is questioned by the act of creation itself. Neither the Aztec sculptor nor Picasso sculpted their skulls as a submission to death. What does "retrieving" *Saturn* mean? Making a painting out of it? It is one. Making only a painting out of it? No attempt at that has ever been very successful. A museum can probably retrieve Picasso's *Massacre in Korea*, but not his *Woman with Baby Carriage*, not his most agonized tarots, not even *Guernica*—the crying out of Spain over the centuries. And why would the Museum Without Walls try to retrieve them? If the Museum is our answer to the unknowable, it is because it welcomes those that Greece called "the gods one adores in the night."

Music pays no heed to the direct accusation as expressed in Goya's torture scenes—the stump of a prisoner on a branch, and the besotted victor smoking his pipe as he watched the hanged men of 1813, just as my customs official cared for his birds as he watched the throng of refugees in 1938—or as expressed in, among all other sculptures, the Perpignan *Christ in Prayer* or *Devout Christ*. Such works stole into museums which, ever more faintly, had beauty as their criterion. Neither the terrifying Christ crucified, nor Goya, nor the Siva of the

*Dances of Death* has been conquered by any of the serene figures—not even by the figures of communion. No Fra Angelico and no Giotto have driven them out of the Museum Without Walls. The most ruthless rebellion takes a distance from its rebellion, but only the most radiant harmony takes a distance from its harmony: not only Goya but Raphael, not only Picasso but Fra Angelico. And Goya did not take his distance so that he might yield to Raphael. Picasso wanted the future to remain the greatest adventure of them all; the next century's metamorphosis was no less unpredictable than his own genius had been. Nothing ever made Goya into a painter of *fêtes galantes*, in spite of his tapestry sketches, or even into a rival of Manet. The West is still agonized by the shrieks of the Atridae, having completely forgotten that *The Oresteia* ends on a reconciliation. And similarly, for us Prospero, in *The Tempest*, a master of men who "are such stuff as dreams are made on," is not the master of Lady Macbeth's somnambulism. Fetishes do not become angels, and the world of art is more irrational and more profound than the world of reconciliation.

Men no doubt believe they will discover precisely what that world is from the world to come. Yet we are aware of living in a time of significant change, very like that which replaced the world of the cathedral with a world of dreams; aware too of the intrusion of that population of canvases which, for the first time, a painter had made as arbitrary as the great stained-glass windows. But those stained-glass windows were inspired by Christ, whereas our painting is no longer inspired by anything but its own power. Still, that power had made Picasso an obscure and secret promise. In his Grands-Augustins studio the painter had heard words that the Little Man

from the Cyclades had never uttered, though he was pregnant with them; similarly, two or three thousand years from now artists will perhaps hear the Little Man from Vauvenargues—on the lawn, bearing witness to the earth—speak unforeseen words well beyond what we call retrieval and rebellion. . . . The future language of art is always an unknown language.

That tomb, which will be filled with dazzling or haunted canvases, that mausoleum of creation built at a time when cities were in flames and extermination camps existed, will also be a temple of ageless creation. As soon as we cease mistaking the creative power for the power to interpret spectacles or dreams, we shall discover its fraternity with the power of our art. It is not as enigmatic, for we know the Gothic style that inhabited Romanesque sculptors, but we do not know twenty-first-century art. A sequence of creations is not as obscure as a major creation: the significance of the style to which it belongs, or the style to which it will give rise, clarifies it. It stands out only from afar, because close to, its name is Truth. . . . It has been said that Shakespeare's genius was to have torn away a curtain to reveal what everyone knows, as if no one had ever perceived it before; in that sense Picasso's art revealed to him the creative power, as far back as his Lespugue *Venus*. And all our art suggests to us that the exercise of that power is akin to a mystical experience when the artist believes he is copying, and akin to a prophetic experience when he wishes to innovate. The anonymous sculptor, who believed he had lost himself in the divine when he faithfully imitated some prototype, sculpted the *Mahesamurti* of Elephanta or the Dogons' antelope mask; the sculptor of Moissac, who was also anonymous, revealed the divine

to throngs of Christians—a divine that they hailed, just as the faithful were to carry shoulder-high the Tuscan Madonna. Overflowing with canvases gleaming from the tomb, Vauvenargues will shout that out, because it is from there that Picasso calls upon us, more violently than any of his predecessors, to understand that creation is as mysterious as death.

That is doubtless why the Little Man who goes by the name of *Figure with a Vase*, and who seems to present his offering to the sun, stubbornly recalls to my mind the obsidian head. To whatever civilization its image belongs, a skull is the sign of death, but to religions that know the great funereal language it lacks weight. The necklace of heads from Dourga belongs in the category of the picturesque when compared to Siva; a skull and shinbones are negligible when compared to the crucifix.

All the same, that language is subordinated: for Siva, it is subordinated to the increate Brahma; for the dying Christ, to the Incarnation and the Resurrection. Only Aztec Death—about which we know so little—seems to reign supreme; its art seems to attain the All-Encompassing, which is not the case either with Yahweh, or the Father, or Allah, or Brahma. For the obsidian, quartz, and turquoise skulls are no more restricted to signs than the bronze skull sculpted by Picasso, which I had stumbled over in the hall of the Grands-Augustins studio. We know the sign; it is the Mexican hieroglyphic—that of the Holy War's monolith, which symbolizes the heart torn out of the prisoner—whereas the sculptor endowed the obsidian skull with the enigmatic life of art, just as Greek sculpture endowed the human body with transfiguration in order to make it the body of its gods. Were the direct rivalry of art and death known to us, we should

think it unimaginable. All we have found with which to speak of death are the bones of dead men before which our eremites meditated, our recumbent figures, and our effigies of nude, decaying corpses.

Death's dark glimmer sheds light on the sorcery of the creative process and likens style to the voodoo pin. In order to vie with nothingness, art reveals how it vies with fate. The symbol that provokes man's deepest feeling of dependency, the sign of death, teaches us how the stamp that can leave its mark on man also leaves its mark on the cosmos and the unknowable.

When it comes to Aztec Death, we haven't any idea of the role it played. Not the slightest. But the dark fraternity of death forces us to acknowledge it in those places where we know nothing about it. The idols from the Cyclades, found in the burying grounds, represented life in the same realm of limbo: the Great Goddess, the Earth Mother, who was to become the Virgin of Byzantium, an emblem in the shape of a violin, or a trapezium inscribed between signs of arms around allusive breasts, above a knife wound that cleaves the legs, starting from the genitals. I remember how Picasso, who had got used to his idol but hadn't thought about its meaning, looked stupefied when he saw the carnivorous corollas of my clay fertility figures, which were, to all appearances, as arbitrary as his own sculptures. In order to represent both the essential and the invisible, the Cyclades had found the most subtle and abstract sign of the Mother-Goddess, who tirelessly surrenders to the earth those humans she tirelessly calls forth. The soul of life and the soul of death, Vishnu's liana and Siva's liana, become intertwined in the inaccessible unknown of the increate Brahma; the archipelago's fertility figure and the

Mexican skull meet together in the mirror, where, above the obsidian head, floated forgetful clouds. . . . The All-Encompassing quality of what we continue to call "art" is metamorphosis. Its train of stars drags Vauvenargues along with the Mexican ruins, where whirlwinds of dust dance over the funereal gods; this tomb, which, in the morning, will raise up the most intransigent works history has even known, is attuned to the intense image of death daringly provided by a Little Aztec Man, and to the idols which, at night in the Cyclades, led shadows stumbling among the demons onto the road of their resurrection.

Why was Dostoevski obsessed by "the torture inflicted upon an innocent child by a brute"? I recently wrote that, against a background of nothingness, the most humble act of heroism or love was just as mysterious as torture. And against that same background of nothingness, the most humble creation is a miracle—more diffident, perhaps, but just as strange and just as fascinating. It converses only with metamorphosis, which draws it into its own enigma and thus farther afield than revolt and reconciliation—into the unpredictable Prado, where Spain is still awaiting the arrival of *Guernica*, and where the greatest of all Goyas was awaiting the young Picasso. Directly across from me Picasso's tiny festoon of dancing paper cutouts was quivering in the warm air from the hearth. Because of the obsidian head, that farandole reminded me of a scene I had observed many times in Mexico: around an invisible lamp, children would watch a turning lottery wheel and its small skeletons, their gesticulating shadows cast upon the gaunt little faces, which were gradually illuminated by wondrous smiles . . .

Everything that eludes time belongs to the mysterious,

264

and what will strike artists most especially at the Château de Vauvenargues, and in the straightforward dialogue between creation and death, is the same phenomenon that had struck them the day before at the Fondation Maeght: the elusive time in which works of art live. If Jacqueline were to one day exhibit *Guernica* at Vauvenargues, while it was en route to Madrid, it would be clear there that *Guernica* does not belong to the same past as the Spanish Civil War. For the Spanish Civil War *was*, whereas the painting *is*—which puzzles us, because masterpieces are no longer immortal. I had been surprised the day before by the fact that the survival of art could seem so fascinating compared to the thousands of years the human race has been in existence and the millions of years of the Milky Way. Would nothing prevail over Stalin's words, which de Gaulle had once quoted to me: "It is always death that wins out"? At Vauvenargues, where the dreams of Spain broke—and would continue to break—their batlike flight, I recalled the cave in which Siva had mingled men together with monkeys that closed the eyes of the men killed in the Vedic battles—and the jackdaws of Provence shrieked like the gulls over the Indian Ocean. All the works gathered together by the Fondation Maeght had put this rather commonplace question to me just the day before: What's the use of our surviving so short a time under the bright light of stars that have been dead for so long? Yet there at Vauvenargues, confronted with the death of a friend, I understood that victory over death retains its deep voice even in the face of eternity. For it derives from open defiance, not from victory. We know a more widespread form of defiance: that of courage. A courageous life doesn't postpone death for a few centuries as art does;

it doesn't even postpone it for an hour. Yet courage carries on from civilization to civilization even more invincibly than the Little Man from the Cyclades. The artist's relationship to art eludes us as much as art's relationship to death. That is why Picasso knew Van Gogh's remark by heart.

That morning the Little Man atop Picasso's coffin, by the name of *Figure with a Vase*, raised up its faceless body, which so unaccountably resembled Picasso's, while low clouds drifted toward the Mont Sainte-Victoire, like the clouds in the mirror in Mexico. Since the cavemen, had that sprite—shaken by death as a ball is by a spurt of water—had he sometimes guessed that he was struggling against fate? In the case of Van Gogh, had he been aware of the fact that what was at stake in *his* struggle was even more elusive than survival? Those words Picasso knew by heart had, as early as the Rose period, forced him to paint *Les Demoiselles d'Avignon*, had driven him to create his works. I remembered *The Embrace*, the man with a pregnant woman, which, at the Grands-Augustins studio, had given me the idea that birth made Picasso as uneasy as death did. To Van Gogh, life and death belonged to the same realm. He expected the pictorial realm to be different from the realm of nature. Interpretation, expression, accession, no matter: something other. He would have said, had he not been exasperated by that sort of vocabulary, that it had . . . another essence. But by countering nature's noises with a musical scale, he foresaw that art countered Creation, and indeed life itself, with artistic creation. Picasso had actually been more aware of that than Vincent, the Christian. When Picasso said, "We must not imitate life; we must work like life," sometimes adding, *"in order to* work

against life," he believed that Van Gogh had meant: I listen to my creation in the depths of my being—and it's as mysterious as God. The Little Man from the Cyclades had said the same thing over the centuries without knowing it. Set up on the coffin, where not so very long ago a cross would have stood, the statue by an incarnation of the nameless sculptor from the earliest days of Greece keeps watch over Vauvenargues.

What will have become of this tomb of rebellion in the next century? "When the ship sails off, it means the painter himself dies. . . . We never know how painting lives or how painting dies. . . . People making all those stupid judgments. . . . Luckily there's no Last Judgment anymore!" When I once asked him why it is that we admire both Poussin and Goya, he shrugged his shoulders as if to suggest that there are never any answers to true questions, and merely grumbled, stating what he considered the obvious: "Painting! . . ."

Then he replied: "Dialogues . . . Poussin and Goya, sure! But afterward, Cézanne and Van Gogh . . . Contemporaries! . . . You finally end up with the guys of your own period, right? At a certain age you become attached to people who have given you a pain in the ass all your life. What are friends, exactly? They're painters with whom you weren't on speaking terms. Funny! Eighty years! Doing that to me!

"Painters—anyway, paintings!—are like ducks that have swallowed the same string. You know, like elderly couples. Maybe it's just France: Corneille and Racine, Ingres and Delacroix, Corot and Daumier, Cézanne and Van Gogh, Nénette and Rintintin . . . No one ever says Velásquez and What's-His-Name. Yet we Spaniards have two names: Ruiz y Picasso. It's funny . . ."

"Aeschylus and Sophocles, the Orient and Greece . . ."

"It's lasted so long, it must mean something . . ."

He knew perfectly well that to those famous dialogues France would add Braque's dialogue with Picasso. When he had had his exhibition at the Grand and the Petit Palais, at the same time as Braque's *Studio* was hung in the Louvre, the two of them had by then become invincible adversaries . . . Had he watched Braque's state funeral on the newsreels?

The catafalque had been set up between the two illuminated wings of the Louvre colonnade. During the rainy night, floodlights shot through cloudburst after cloudburst. Braque's family and friends were waiting under the archway of the old entrance to the Louvre, giving onto an unlighted courtyard in the depths of the night. One could hear a vague sound of music, then the *Funeral March for the Death of a Hero*. The soldiers carrying the body came into the range of the floodlights. Once the ceremony was over, the crowd broke up between cloudbursts, and on the black catafalque the coffin remained alone in the shadowy hole between the two rows of columns that stood like statues sculpted for a king's tomb.

In Braque's studio *The Large Plough*, unfinished, was still standing on the easel. Beneath it, probably for the sake of comparison, was the *Studio with Skull* of 1938, which he had also called *Vanitas*. Surrounding them were twenty canvases that seemed to have set themselves in order: heirs of Vermeer's and Chardin's states of recollection, despite the large white birds flying through them—nuns of silence around the last two prioresses of serenity. I remembered the side aisle of the Varangeville church, where the painter's pale-blue

stained-glass window kept watch over his coffin, as, in the past, the turquoise domes of Isfahan had kept watch over the Persian night and the passing barouches. The forsaken *Plough*, depicting work that men once did, brought *Vanitas* into its pacified world as an occult delegate of the funeral service—a canvas in which the traditional funerary skull encounters the painter's brushes and palette, as if Braque had always known that, at the end, the purpose of his art would be to tame death.

The last time I happened to be there I had quoted to him Cézanne's remark, "If I were absolutely sure that my canvases would be destroyed, and that none of them would ever be hung in the Louvre, I would stop painting." Braque, already bowed with age, patiently considered those words, and then said in an undertone, as if he were fearful, "If *I* were certain that all my paintings would be burned, I think I'd go right on painting—yes, I'd go right on painting . . ."

He has now been dead for over ten years.

What would Picasso have answered? The same thing, I believe . . . Braque spoke like the sculptors who built Gothic towers, and he worked like them—but for the sake of an unknown God. "One never has done with choosing one's choice . . ." Picasso told his works' fortune, using his last tarots as cards: the last adventure for the most adventurous painting ever. At Vauvenargues there was no burial procession of columns, but there was the *Figure with a Vase*, a fetish, protecting the mountains, the incandescence of heaps of gladioli in Gothic obscurity, Jacqueline, and the secret presence of Don Quixote, because of whom the most stubborn of all rebellions was watched over by the greatest dream the world has ever known.

I was about to leave, and went back to the dining room to get my raincoat. In a corner of the fireplace, the gilded bronze *Cat*, the first version of which I had seen in the Grands-Augustins studio.

*Was* it the Mougins cat?

I thought of Notre-Dame-de-Vie. Such a short while ago . . .

Jacqueline and I were walking toward the sculpture room—talking about Picasso. In the hall I asked, "He had worked late into the night, hadn't he?"

"Yes. When the doctor came in the morning, I wanted to get up. Pablo held my hand and said, 'Doctor, are you a bachelor?' The doctor replied that he was. Pablito said, 'You're wrong. It's good to have a wife.' I threw on a dressing gown and left the room. Five minutes later I sensed that someone was behind me in the hall. I turned around, and I understood. I never even heard the doctor say, 'He's dead.' "

When we got to the sculpture room, the shadow of a cloud drifted over the tangled bronze of the sculptures. I remembered: "What will happen to all that? . . ." and "There is no Last Judgment!" There was still some light at the top of the room. On the upper half, a gilded *Cat*; on the other, on a level with it, the fetish, separated from the baby carriage it had been steering as Anubis leads the dead. The photographs of it never caught the quality of its eyes, like star-studded cabochons, which were related in my mind to the atomic pylons in Bombay—those Martian watchmen across from Elephanta— and to the huge empty sockets of the *Christ in Prayer*, an icon gone mad. Those eyes, that crosierlike headdress, those arms, as if bearing an offering, like the arm of the *Figure with a Vase*, and that tall post of a body were

ageless. On a table, the cast of the Lespugue *Venus*. All sculpted poles come from time immemorial; this one, the totem, also plunged into an abyss even more disquieting than that of mankind—into the past of the most ancient of beasts, the millennial spider that awaits us in the corner of a dream. As always, it united time immemorial with atomic reactors, barbaric forms with the creations of some century to come. That day it held sway, hypnotically, over the convulsive horde of bronzes, imperturbably awaiting the Judgment that had been rejected by Picasso.

A totem linked to its whole race of wood and bronze, just as totems made of the trunks of tree ferns are linked to the underbrush of the New Hebrides. It made me think of the lion goddess I had seen at Luxor in its hypogeum, where no ray of sun ever reached it except at noon: the Goddess of the Eternal Return. One day I should like to find the totem across from *Guernica* at Vauvenargues. We shall not take the totem to Spain with Miguel after the revolution. The Little Man would understand why he had sculpted it, and what the Saturn of Metamorphosis was doing there. . . .

Had Jacqueline guessed that? In the sculpture room, at the top of the steps, across from the *Cat*, the sun shed its light on a jumble of bits of wood, unrecognizable objects, and coil springs.

"All of you—you'll never become sculptures, never again," she told them sadly.

# ILLUSTRATION CREDITS

Brassaï (4, 26)
*Cahiers d'art*—Zervos (17, 18, 27, 29, 34, 36)
Chevojon (5)
Galerie Louise Leiris (3, 10, 11, 19, 20, 21, 24, 25, 28)
Galerie Maeght—Claude Gaspari (7, 42, 43, 45)
Galerie de la Pléiade (22)
Giraudon (1, 35)
Gouloubev—Musée Guimet (44)
John Hedgecoe (2)
Friedrich Hewicker (41)
Metropolitan Museum of Art, New York (23)
Museum of Ethnography, Budapest (40)
Museum of Modern Art, New York (8)
*Paris-Match*, Gilles Vergili, Jeannelle F. de Segonzac (46)
René-Jacques (39)
Réunion des Musées Nationaux, Paris (14)
Sotheby, New York (30)
U.D.F.—Marc Foucault (6)
U.D.F.—La Photothèque (9, 12, 13, 15, 16, 32, 37)
U.D.F.—Roger Parry (33, 38)
U.D.F.—Schneider-Lengyel (31)